CHARLES FOWLER

CAN WE RESCUE THE ARTS FOR AMERICA'S CHILDREN?

CHARLES FOWLER

CAN WE RESCUE THE ARTS FOR AMERICA'S CHILDREN?

COMING TO OUR SENSES —10 YEARS LATER

ACA BOOKS
American Council for the Arts
New York, New York

Edited by Ellen Cochran Hirzy
Book and jacket design by
Celine Brandes, Photo Plus Art

Typesetting by Creative Graphics
Printing by Port City Press

Director of Publishing:
Robert Porter
Assistant Director of Publishing:
Amy Jennings

7 6 5 4 3 2 1
Library of Congress Cataloging-in-Publication Data
Fowler, Charles B.
Can we rescue the arts for America's children
"A sequel to the 1977 panel study report, Coming to our senses: the significance of the arts for American education."
Bibliography: p.
1. Arts—Study and teaching—United States. I. Arts, Education, and Americans Panel. Coming to our senses.
II. Title.
NX303.F69
1988 700'.7'1073
88-16648
ISBN 0-915400-71-5 (pbk.)

This publication was made possible
by the generous support of the
Ahmanson Foundation

Let not young souls be smothered out before
They do quaint deeds and fully flaunt their pride.
It is the world's one crime its babes grow dull,
Its poor are ox-like, limp and leaden-eyed.

Not that they starve, but starve so dreamlessly,
Not that they sow, but that they seldom reap,
Not that they serve, but have no gods to serve,
Not that they die but that they die like sheep.

Vachel Lindsay,
"The Leaden-Eyed"
from Collected Poems
(New York: The Macmillan Company)

CONTENTS

4 THE CHANGING PLAYERS 97

5 THE VIEW AHEAD 125

FOUR EDUCATORS RESPOND 155

FOREWORD

I note with considerable pleasure the republication of *Coming to Our Senses: The Significance of the Arts for American Education* and the publication of its companion piece, *Can We Rescue the Arts for America's Children? Coming to Our Senses Ten Years Later*, ably crafted by Charles Fowler. Demand for the original has persisted over the intervening decade, and a retrospective was surely warranted, if perilous in respect to the accuracy of the original authors' predictions.

The panel which authored *Coming to Our Senses* bequeathed its efforts in 1977 to The Arts, Education and Americans, Inc. (AEA), a publication and advocacy agency which continued until 1987. At that time, AEA transferred its considerable arts education library and republication rights to the American Council for the Arts and ceased independent operations.

AEA has lost to death some dear friends, including panelists O'Neil Ford and Frank Oppenheimer, board member Ewald Nyquist, and staff member Charles Springman. A portrait of each hangs prominently in the gallery of mnemosis.

In recent years, I have been pleased to associate myself with other arts education efforts. These efforts have brought great pleasure to me and, I hope, some gain to the various parties. They include:

— The Rockefeller Brothers Fund Awards in Arts Education program, which recognized 33 schools nationwide for excellence in arts programming. Lonna Jones and Ben Shute administered the program and its rotating selection committee with grace and fairness.

— Harvard and Radcliffe Colleges' Office for the Arts, which, at the personal instigation of President Derek Bok and Matina S. Horner, gave sanction to the role of the arts in undergraduate life, and which has enjoyed the inspired leadership of the current House Master, Myra Mayman.

— The Museum of Modern Art's Education Committee, which produced a research-based document on the connection between visitor knowledge of art and the health of the museum as an institution. Notable in this effort were the leadership and support of June Larkin and the vision and diligence of Philip Yenawine and Nancy Richner.

— Duke University's Nancy Hanks Endowment for the Arts, which brings master artists to Duke for extended periods of time to work with students and faculty. The all-stars here have been Mary Semans, Terry Sanford, Michael Cerveris, Joel Fleishman, and Ben Edwards.

My own view of arts education today is that its future is wrapped in the cocoon of education reform and that—because American education must and will be reformed for the better—arts education will be part of (perhaps a very significant part of) the flourishing of that movement.

In all modesty, the AEA panel saw this coming: "The formulation of policy for the arts in education should flow from and be consonant with the general goal of American education" (*Coming to Our Senses*, p. 259).

Charles Fowler has noted some of the critical forces at work in education reform: the increasing role of the state, the utterances of national leaders, the writings of major reform groups (Goodlad, Boyer, Carnegie, and others) and the work of intellectuals, notably Howard Gardner.

To that list of forces I would add the alarmed attention of business to the effectiveness of pre-collegiate education and the increasing flexibility and vision within high echelons of teacher union leadership.

That which is good for education will be good for arts education: professionalization of the teaching force, attention to the different learning styles of individual students, more flexible student schedules, etc.

As it becomes more accepted that different children learn in different ways, I am confident it will follow that teachers will need even greater support as the professionals they are and must be. And when student testing broadens its radar sweep beyond conventional competencies, the place of arts education will be securely and permanently established at the core of American schooling.

No rumination on the decade since *Coming to Our Senses* would be complete without recognition of Norris Houghton, Nancy Hanks, Kathryn Bloom, and Jack Morrison, who, jointly, initiated AEA's effort; Margaret Howard, Jill Bogard, and John Straus, who led AEA through its research, publication, advocacy, and information phases; and Charles Fowler, Milton Rhodes, Robert Ahmanson, the Rubinstein Foundation, and Linda Goelz, who have kept AEA's message alive.

I wish you happy reading and artful lives.

David Rockefeller, Jr.

ACKNOWLEDGMENTS

More than a year has passed since a meeting in David Rockefeller's office to discuss the reprint of *Coming to Our Senses*, the landmark 1977 report of the Arts, Education and Americans Panel that contained recommendations for the future of arts education in America. At this meeting, Milton Rhodes, David, and John McLaughlin discussed the need for a companion volume to chronicle what has happened to arts education in the ten years since the original report. I would like to thank them for their wisdom in making this decision. My deepest appreciation is extended as well to Robert Ahmanson for securing the necessary funding to bring this project to fruition.

Because Charles Fowler was involved in creating the original report, we asked him to prepare a manuscript that would share his cumulative work in this field over many years as well as his active current involvement in the new wave of reform that seeks to improve the education in the arts for all of America's students. The result which follows, in Charles' flowing and comprehensive prose, has confirmed our original trust. *Can We Rescue the Arts For America's Children? Coming to Our Senses Ten Years Later* makes a significant contribution to the current literature on the reform of arts education.

The ACA Board of Directors, under the leadership of President Milton Rhodes, is to be commended for its continuing support and commitment to arts education. In particular, it is fortunate to have the dedicated support of its Arts Education Committee--Fred Lazarus IV, Ann Reynolds, Terri Childs, Vivian Warfield, Bruce Marks, and Jonathan Katz-- for this and other ACA arts education projects.

I am particularly indebted to Donald Corbett, Betty Allen, Jerome Hausman, and Kathryn Martin for their thoughtful commentary on this new work. Much appreciation is also due to Celine Brandes for her splendid text and cover design; Ellen Hirzy for her editorial work; and Cynthia Wilk and Thomas Becker for their picture research and to all the individuals and organizations who furnished the many excellent photos for use in the text.

Finally, I would like to extend special thanks to the ACA staff who spent endless hours with the myriads of minutiae that helped to make this project a reality: arts education director John McLaughlin and his assistant Thomas Becker and publications director Robert Porter and his assistant Amy Jennings.

John Straus
Chair, Arts Education Committee
Board of Directors
American Council for the Arts

INTRODUCTION

Like most people, I was very fortunate in my life to have had a few really great teachers. One of them, Helen Hosmer, a former dean of the Crane School of Music of the New York State College at Potsdam, advised us, when we were suffering personal difficulties, to ask ourselves, "What will all this mean in 10 years?" She knew that time provides perspective. You don't have to be in the arts very long before you realize that time is often the measure of true value. But it isn't any different with a book such as *Coming to Our Senses: The Significance of the Arts for American Education.* Time is a telling critic.

As a former researcher on the staff of this panel study, I was complimented to be asked to write this response to it in the glaring light of the decade past. Are there revelations in this report that still hold? Is this account of arts education a marker for its time? After a considerable amount of repondering and analysis, I can answer those questions with a very honest yes. But what has happened since this milestone? Are the arts any more significant in education today than they were 10 years ago? Apparently, the arts have not gained much new status in American schooling. The brutal fact is that American education has not yet come to its senses in those intervening years, not nearly. In truth, I believe we are farther away from that august agenda today than we were in 1977 when the panel report was published.

This addendum to the original report is an account of arts education during a decade of transition. It attempts to show the state of arts education then and the state of it today. This document is an up-date on events and developments since 1977. The panel study is used as the impetus to explore the issues of the field openly and I hope squarely. Necessarily, this is a personal and not a wholly objective account, because I must admit to being a participant in the field as well as an observer of it. My intent was to make clear exactly where I stand on every issue. Because I know that not everyone will agree with me and that a certain amount of agitation is good in any field, I have deliberately

included quotes in the margins that contradict my thinking (as well as many that agree with it). Let the reader decide who makes the more convincing case.

What follows, then, is a plea, certainly impassioned, to recognize the value of the arts, to accord them their deserved place in education, and to see and solve the problems that plague the field. This report speaks from the perspective of 35 years in arts education. It represents a catharsis of sorts, a primal scream on behalf of a good friend suffering poor treatment. As I have had the occasion to say elsewhere, the arts are the minority subjects in American education, and they suffer all the indignities of the downtrodden—low status, neglect, poverty, and powerlessness. They deserve better.

Charles Fowler
Washington, D.C.
March 1988

1

A DECADE OF INTROSPECTION

Offhandedly, it might appear that there has been little change or movement in arts education since the publication of *Coming to Our Senses*. But, in reality, there has been more significant movement—with both positive and negative implications—in this decade than perhaps any preceding.

Between 1977, the year *Coming to Our Senses* was published, and 1987, there has been an increasing emphasis on achievement tests such as the Scholastic Aptitude Test. Their revelation of substandard performance has induced a back-to-basics emphasis that has tended to consign the arts to an even more distant place on the educational periphery. Public and corporate outrage at the educational system has resulted in a spate of educational studies, which collectively have spurred a massive education reform movement that,

Ah, to capture a part of the world and come to terms with it! That is the beginning of a life-long relation between ourselves and the world we live in.

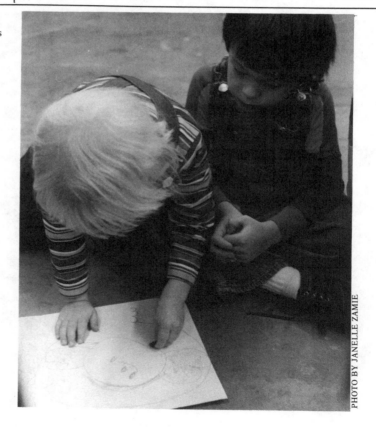

PHOTO BY JANELLE ZAMIE

while not directed at the arts specifically, has swept the arts along with it. At the same time, in direct response to the uncertainties and the possible deleterious effects of these proposed reforms, the arts education field has managed to formulate what is perhaps its most compelling rationale. Desperation may be the handmaiden of wisdom.

In this same decade we have witnessed the demise of the JDR 3rd Fund's Arts in Education Program (in 1979) and the rise of the new Getty Center for Education in the Arts (in 1982). At the federal level, there has been a shift—not by official declaration but in terms of actions—in the authority and responsibility for arts education from the Department of Education to the National Endowment for the Arts (in 1986). This happened at a time when, paradoxically, both agencies argued for a more limited federal role. State and federal support for school-based arts education decreased markedly in the 1980s. There are now far fewer possible programs or options under the various titles of the old Elementary and Secondary Education Act (ESEA) of 1965. From the mid-sixties to the late seventies, states and local school districts received hundreds of millions of dollars in categorical federal funds for arts projects under ESEA Titles I, III, and IV. When jurisdiction of these funds fell to the states as discretionary monies, the arts were seldom accorded any priority.

This is just the beginning. With all the ferment during the past decade, the arts cannot be said to thrive in American education, and overall their position appears to have diminished. Their potential educational value remains underestimated in many school systems, with the result that many American children are not given adequate access to their artistic heritage.

The rationale then

*C*oming to Our Senses addressed "the significance of the arts for American education" and was subtitled accordingly. At the outset of the report, the Arts, Education and Americans panel noted a contradictory trend: "On the one

hand, the arts are flourishing as never before in American society. . . . On the other hand, arts education is struggling for its life" (CTOS, 10-11).* The report referred to a Harris poll indicating that a majority of the public thought schools should offer more courses in the arts.[1] It then stated:

> Thus, the American people do appear to believe the arts are important, but simultaneously they are hard put to reconcile that view with their conviction that the schools should concentrate on reading, writing, and arithmetic (CTOS, 54).

The best hint at an explanation for this discrepancy comes from John Goodlad. He noted in the report that, when ranking subjects according to which ones they *liked the best*, students ranked the arts at the top; but when rating subjects according to which ones *are most important*, the arts placed near the bottom. The report then asked a very important question: "If arts are the things children like the best, who persuades them they are least important?" (CTOS, 52). The explanation offered is that the arts are viewed by some people as mysteriously subversive, as promoting radical thinking and life styles. The panel concluded that "we have to reassure people that there is a need for this kind of innovative thinking" (CTOS, 53).

Ten years later, this basic contradiction between the importance of the arts in society and the lack of importance accorded the arts in public education remains a pivotal difficulty, even though there is more interaction between the arts and education communities than ever before. In his 1984 study, *A Place Called School*, Goodlad probes the question more deeply. Schools, he says, perpetuate certain myths about learning:

> One of these myths, a convenient one, is that there are essentially two kinds of people. Those of one group—perhaps our academically oriented group of early elementary students—learn to use their heads and should go on to work with their heads. Those of another—maybe those who preferred painting—learn to use their hands and should go on to work with their hands. School is where one cultivates the head. Consequently, "headedness" more than "handedness" is needed for and valued in school.[2]

*All references to the original report include the applicable page numbers in parentheses.

In the secondary school, this dichotomy between headedness and handedness sprouts into two curricular divisions. Goodlad observes that

> on one side are the more prestigious academic subjects, largely shunning manual activity as a mode of learning. On the other side are the nonacademics, generally characterized by the trappings of academic teaching but providing more opportunities to cultivate handedness and often featuring aesthetic qualities. My further interpretation is that the cultivation of manual skills frequently becomes an end in itself, not a means to some broader understandings.[3]

Here we have an important distinction. The public as well as many teachers and educational administrators view the main business of schooling as essentially developing the mind and the power to reason. At the same time, they see the arts as mindless, nonacademic fare, more related to the hand than the head. They associate the arts with entertainment and play, academic subjects with the serious business of life and work. On the practical side, schooling in the minds of many parents is vocational preparation. This helps explain why the public continues to maintain one set of val-

Children at Public School 107 in Community School District 15 in Brooklyn, New York "think" with their paint brushes under the guiding direction of visiting artist Olivia Beens.

America is a competitive society, a technological society, and a materialistic society. These conditions contribute powerfully to the development of American values about education. As is the case with art, the majority of Americans view education as a means to an end rather than as an end in itself. One becomes educated primarily in order to pursue a livelihood in a highly complex society. The idea of a life of the mind does not seem prominent either in our educational system or in our overall values about education.

from *K-12 Arts Education in the United States: Present Context, Future Needs*, pp. 6 and 7.

ues for the arts in society and another for the arts in education. When it comes to the serious business of education, they have other priorities.

This helps explain, too, why arts programs are curtailed at the same time that a 1984 Harris poll claims that the public feels otherwise. Ninety-one percent of adult Americans, the poll says, believe that children in school should "be exposed to theater, music, dance, exhibitions of painting and sculpture, and similar cultural events," and a clear majority of the public "believe that the arts should be taught as regular, full-credit courses."[4] The public generally likes the arts, but when it comes to making the difficult curricular choices that tight budgets require—a choice, say, between art in the elementary grades or more science—they will opt for science.[5] By questioning the public with a "what-do-you-want" idealism, the Harris poll elicited an unrealistic "let's-have-it-all" response. The public still values arts education only to a point. Let us not fool ourselves; the support is very soft.

Coming to Our Senses, in a direct reference to the work of Harvard psychologist Howard Gardner, says that "the arts specialize in forms of knowledge that cannot be translated or expressed in any other way." Because the arts utilize symbols that are often nonverbal, skill is required to extract that knowledge. "The educational establishment," said Gardner, "is being derelict and delinquent if it neglects ways of knowing" (CTOS, 53).

At the time the report was written, the arts were generally not being taught as forms of knowledge. Dance, music, theater, and visual arts were taught as acts of production. The public and most of the people connected with schools did not view the arts as "ways of knowing." If they had made that connection, the arts would not have been considered extracurricular, nor would they have been treated peripherally. The arts were not thought of as academic, and therefore they were not accorded the status of academic subjects.

The primary rationale for arts education presented in the study was based on the contribution of the arts to the child's cognitive, affective, and psychomotor development. The report stated that the arts "can enrich and accelerate development during early childhood and every subsequent growth stage." They can "help the child move from a reflexive to a reflective human being" (CTOS, 57).

But in terms of constructing a rationale to support and

justify their study of the arts as basic in education, the Rockefeller panel set the course for the coming decade with the fundamental viewpoint expressed in this widely quoted paragraph:

> This Panel supports the concept of "basic education," but maintains that the arts, properly taught, are basic to individual development since they more than any other subject awaken all the senses—the learning pores. We endorse a curriculum which puts "basics" first because the arts are basic, right at the heart of the matter. And we suggest not that reading be replaced by art but that the concept of literacy be expanded beyond word skills (CTOS, 6).

The report went on to say that the arts "provide unique ways of knowing about the world and should be central to learning for this reason alone." Looking back from the perspective of a decade, this view, if not persuasive, was prognostic. It represented a view that would flower in the years ahead into a full-blown, well-substantiated, and well-articulated rationale for the arts in education.

The rationale now

It was no coincidence that at the same time as the public's back-to-basics thrust was overtaking and overturning some arts programs, a new and more compelling rationale was in the making. Call it an act of self-survival. A disparate group of educational philosophers, art educators, cognitive psychologists, and other proponents of arts education were reanalyzing the function of the arts and their role in human civilization in the full glare of the aims of American schooling.

Today, this new rationale justifies a far more important role for the arts in education. Increasingly during the past decade, the arts have been promulgated as systems of meaning—as living histories of eras and peoples and as records and revelations of the human spirit. The arts may well be the most telling imprints of any civilization. For this rea-

son, some prominent educators are viewing the arts as symbol systems that are equal in importance to the symbol systems of science and mathematics.

Human beings are unique among all forms of life because we capture our experience through symbols. Ernest L. Boyer, president of the Carnegie Foundation for the Improvement of Teaching and a former U.S. commissioner of education, reminds us that "the *quality* of a civilization can be measured by the *breadth* of its symbol systems."[6] Only a variety of such systems permits knowledge of every possible kind to be formulated so that it can be conveyed to others. Symbol systems function as both a means to express understandings and to acquire them. They are ways to cast our own perceptions and to encounter the perceptions of others. The symbol systems of the arts permit us to give representation to our ideas, concepts, and feelings in a variety of forms that are understandable and can be "read" by other people.

U.S. Secretary of Education William J. Bennett says, "Great souls do not express themselves by the written word only; they also paint, sculpt, build, and compose."[7] To this we should add dance, act, and sing, for the arts encompass a broad range of expressive media. Bennett goes on to say that an educated person should be able not only to recognize artistic works, but also "to understand why they embody the best in our culture."[8] In a similar vein, Maryland Superintendent of Schools David W. Hornbeck recognizes that the arts constitute one of the main means by which humans communicate. He says:

> One role, if not the central one, of schooling is the development of communication skills. If we are to meet that challenge, we must stretch beyond the traditional spoken and written word. Human feeling and emotion as well as ideas are frequently more forcefully and accurately portrayed through the arts.[9]

In this way of thinking, literacy should not—must not—be limited to the written word. It should also encompass the symbol systems we call the fine arts. Like verbal, mathematical, and scientific symbols, the symbol systems of the arts were invented to enable us to react to the world, to analyze it, and to record our impressions so that they can be shared. If our concept of literacy is defined too narrowly as referring just to the symbol systems of language, mathematics, and science, children will not be equipped with the

By broadening our conception of literacy and developing those literacies through especially designed curricula, the skills of reading, writing, and computing will themselves improve. Reading, for example, requires an ability to hear the melody of a paragraph, to visualize the scene as portrayed, to feel the pulse and power of a trenchant passage. To write requires the ability to see, to hear, and to feel the world so that the writer will have a content to express and a desire to share it with others. Such achievements are not educationally marginal. Attention to the development of multiple forms of literacy should not be regarded as a diversion from what is important in schools; rather, it is at the very heart of what education requires.
ELLIOT W. EISNER, *Cognition and Curriculum: A Basis for Deciding What to Teach* (New York: Longman, 1982), p. 81.

breadth of symbolic tools they need to represent, express, and communicate the full spectrum of human life.

The symbol systems of the arts enable us to give concrete representation to impressions that might otherwise remain vague and incommunicable. Susanne Langer, the late American philosopher of the arts, called this process the *"objectification* of subjective life."[10] We may abhor the pain that people sometimes inflict upon others, yet how do we represent that abhorrence? Visual artists have expressed their outrage in abstract forms. In *Guernica*, for example, Pablo Picasso painted the horror of a senseless act of war as a warning of the inevitable consequences of inhumanity. In 1937, German planes flying for Franco in the Spanish civil

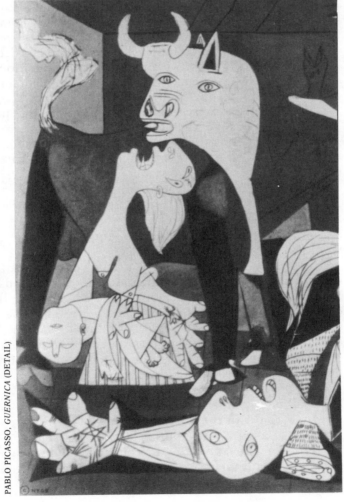

PABLO PICASSO, *GUERNICA* (DETAIL)

war bombed the defenseless village of Guernica as a laboratory experiment, killing many of its inhabitants. In Picasso's massive painting, a vicious bull smugly surveys a scene of human beings screaming, suffering, and dying, of a shrieking horse, fire, and destruction.

Similar themes have been represented in other artistic mediums. Benjamin Britten's *War Requiem* gives powerful musical and poetic expression to the unpredictable misfortunes of war's carnage by juxtaposing the poignant verses of Wilfred Owens, a poet killed during World War I, with the ancient scriptures of the Mass for the Dead. The theme of humans inflicting suffering upon humans has also been expressed through the medium of dance. In *Dreams*, a modern dance choreographed by Anna Sokolow, the dreams become nightmares of Nazi concentration camps. Euripides' play *The Trojan Women* is a fine example of how the ancient art of theater can make us aware of the grievous sacrifices war forces humans to endure. The film *Platoon*, written and directed by Oliver Stone, is a more recent exposition of the "meaning" of war, a theme that has been treated again and again with telling effect in literature throughout the ages.

Each of these art works expresses an episode in a major human drama—a variation on a universal theme. This theme and many others—spirituality, celebration, patriotism, death, nature, triumph, love, humor—have been objectified through artistic symbolization. Artistic representations enable us to share a common humanity by discerning a higher order of truth in the experience of the world around us. What would life be without such shared expressions? How would such understandings be conveyed?How would we aspire to be *more*?

Our new rationale for the arts recognizes that in today's technological world humaneness still depends upon being in touch with our emotions. The arts provide that access. The consequences of neglecting the affective realm could be catastrophic—a society of numbing sameness, predictability, standardization, and detached indifference. To our increasingly impersonal and automated surroundings, the arts offer a welcome and necessary antidote.

The arts reveal human dimensions of life that are both essential and compelling. Dance, for example, can connect us to the power of the human body as an expressive instrument. As it affirms and uplifts the physical self, it elevates the human form, converting it from weak and fear-wracked to noble and authoritative. Dance celebrates and illuminates

There is an alternative path to the reform of schools and the reform of arts education. Let us work toward a concept of education in which the arts, sciences, and humanities are acknowledged as equally important channels of endeavor and equally valuable sources of knowledge about ourselves and the world in which we live. Let that sense of equity in human endeavors be reflected in a revised curriculum that emphasizes all of these areas equally.

Laura H. Chapman, *Instant Art, Instant Culture: The Unspoken Policy for American Schools* (New York: Teachers College Press, Columbia University, 1982), p. 26.

the physical being as the primal instrument of life. Because it involves the self, it explores and discloses the self and the relationship between selves.

For these Mamaroneck, New York high school students, movement serves as a vehicle of human expression.

Science is not the sole conveyance of truth. If humans are to survive, we need all the symbolic forms at our command because they permit us not only to preserve and pass along our accumulated wisdom but also to give voice to the invention of new visions. We need all these ways of viewing the world because no one way can say it all. As Elliot Eisner, professor of education and art at Stanford University, reminds us, we need them because "the apotheoses of human achievement have been couched in such forms."[11]

The arts are *acts of intelligence* no less than other subjects. They are forms of cognition every bit as potent as words and scientific symbols. In his study of brain-damaged people, Howard Gardner observed that humans have at least seven basic intelligences that are located in different areas of the brain and operate independently: (1) *linguistic* (the art of creative writing), (2) *musical* (the art of music), (3) *logical-mathematical*, (4) *spatial* (visual arts), (5) *bodily-kinesthetic* (dance), and (6) and (7) the *personal intelligences*—knowledge of self and knowledge of others (theatre).[12] He points out that the arts relate directly to six out of seven. Clearly,

when we talk about the development of intelligence and the realization of human potential, the arts must be given careful consideration and special attention. While Gardner observes that in today's schools, generally, "spatial, bodily-kinesthetic, and musical forms of knowing will have only an incidental or an optional status,"[13] he acknowledges that

> among those observers partial to spatial, bodily, or musical forms of knowing, as well as those who favor a focus on the interpersonal aspects of living, an inclination to indict contemporary schooling is understandable. The modern secular school has simply—though it need not have—neglected these aspects of intellectual competence.[14]

American schools have systematically devalued certain forms of intelligence in the process of favoring others, thereby *delimiting* the intelligences of students rather than exploring and nurturing all of them. And what are the consequences of this neglect? Gardner says:

> Mastery of different literacies—for example, reading musical scores, mathematical proofs or intricate diagrams—exposes one to once-inaccessible bodies of knowledge and allows one to contribute new knowledge within these traditions.[15]

To be denied the opportunity to develop these various intelligences is a form of mental deprivation.

According to Gardner, our intellectual competencies can serve both "as means and as message." For the child who learns to play a musical instrument, musical intelligence becomes a means of transmitting knowledge of music and what music conveys. But musical intelligence opens those doors only if it is exercised. The processes involved in "reading" the arts and deriving meaning from them cannot be taken for granted. The artistic brain—and we all have the physical mechanism—must be educated if it is to function effectively. If education is the means by which each individual realizes his or her inherent potential, then every student should have the opportunity to develop and use *all* the forms of intelligence. Why should we fix limits on learning?

This view of the arts as forms of human cognition and as systems of meaning important for all students has al-

ready begun to have an effect on the curriculum. Cultural literacy is emerging as a fundamental goal of arts education. Accordingly, students should be given the study necessary to assure familiarity with all of a culture's basic symbol systems, the arts included. New entrance requirements in some colleges and universities and new requirements for graduation in some states recognize the need for, and the value of, knowledge and understanding of the arts.

This way of viewing the arts places them squarely within the academic, cognitive priority of American schooling. But this philosophical view must be translated into practice. If the arts do enlighten, then they must be taught so that they enlighten. If they are to become an important part of the serious business we call education, they must be taught as disciplines that develop skill *and* knowledge. Knowledge of the arts must encompass not just the acquisition of facts, but an understanding of how the arts relate to human feeling, intuition, and creativity, areas of focus that are unique to study in the arts. In this view, the arts are "languages" that open vast doors to the stored wisdom of the ages. They serve as vehicles to engage the mind and the imagination with the inner and outer worlds of each person's existence.

This new rationale for the arts brings the field to the precipice. The arts will either be permitted into the club or, much as they are today in many schools, left to muddle along on the sidelines. Logic dictates that they be given more attention and that they be accorded their fair share of resources. But logic is not always the harbinger of change in American education.

The first purpose of arts education is to give our young people a sense of civilization. American civilization includes many cultures—from Europe, Africa, the Far East and our own hemisphere. The great works of art of these parent civilizations, and of our own, provide the guideposts to cultural literacy. Knowing them, our young people will be better able to understand, and therefore build on, the achievements of the past; they will also be better able to understand themselves. Great works of art illuminate the constancy of the human condition.

Chapter 1, "Overview," *Toward Civilization: A Report on Arts Education* (Washington, D.C.: The National Endowment for the Arts, 1988).

A catastrophe in the making

It is no happenstance that this rationale—perhaps the most compelling ever formulated—emerged during a decade when arts education programs faced some of their darkest threats. Impending disaster motivates the genius to survive. The arts, which include but are not limited to cre-

ative writing, dance, media, music, theater, and visual arts, are a neglected resource in American elementary and secondary education. Their possible significance in the education of America's youth is largely unrecognized, often ignored, generally underrated. Access to this vast treasury of American and world culture is denied to many American children with the result that their education is incomplete, their minds less enlightened, their lives less enlivened. In this educational deprivation, American culture itself is slighted, and whole generations of American youth are permitted to grow up largely unaware of the heritage of human achievement that the arts represent.

In her keynote address at one of a series of regional meetings on arts education held in 1984, chancellor of The California State University W. Ann Reynolds equated the depressed state of the arts in American education today with the state of science during the era of Sputnik. She said:

> The nation is facing a crisis in the fine arts on a level with the crisis in space technology during the fifties and sixties. When the United States decided it wanted to conquer space, it found the financial, intellectual, and institutional resources to achieve that goal. Our lives have been changed and improved through the many discoveries, and the applications of these discoveries, inherent in the space program. I believe that the arts play no lesser role in the survival of our humanness, and therefore we must seek resources to support the components of the national arts effort.[16]

During that same year, the National Center for Education Statistics (NCES), a bureau of the U.S. Department of Education, published an analysis of *Course Offerings and Enrollments in the Arts and the Humanities at the Secondary School Level*[17] from a vast bank of data it had compiled on the high school class of 1982. These statistics reveal a critical lack of arts in the education of these students.

Of the upwards of 3.3 million high school seniors in 1982, more than one million—about one-third—had no instruction whatsoever in any of the arts during their four years of high school. Almost 10 percent of our high schools do not offer a single course in music; 15 percent offer no instruction in visual arts; more than one-half provide no instruction in crafts or dramatic arts; and more than two-thirds offer no creative writing, graphic and commercial arts, dance or design courses.

These talented high school students practice the craft of acting in Tennessee Williams' "The Glass Menagerie" as part of an extensive and intensive theater curriculum at the Interlochen Arts Academy.

The NCES study found that there is marked inequality of opportunity in the availability of arts instruction in American high schools. For example, basic courses such as music appreciation and art appreciation, which might provide students with general understanding of those arts, are offered at about one-half of secondary schools. How would parents feel if less than half of the secondary schools in the United States offered a curriculum in general science?

Then, too, the amount and type of arts courses offered in high schools differ according to region. "Schools in the south were least likely to offer instruction in dramatic arts, design, crafts, and creative writing," while courses in appreciation "were found more often in the northern region of the country."[18] A significantly higher percentage of schools in the North and West offered fine arts courses than did schools in the South. Western schools were more likely to give instruction in dance. A child growing up in the South has consistently less cultural opportunity.

The NCES study revealed that students who attend larger schools have far more opportunities to be educated in the arts than those who go to smaller schools. Larger schools—those with 1,500 students or more—are "more likely than smaller schools to offer instruction in dance, dramatic arts, graphic and commercial art, and crafts."[19] While

100 percent of the larger schools offered dramatic arts and design, only 31 percent of the smaller schools offered instruction in these areas. The differences are significant: "While over one-half of urban and suburban schools offered high numbers of arts courses," the report says, "only one-fifth of rural schools did so."[20] Why should children who happen to live in rural schools or children who happen to attend smaller schools be deprived of the opportunity to study the arts?

The NCES study provides evidence that, for the most part, bright, college-bound students are the ones who are being educated in the arts. The NCES study found that "the percentage of schools with above-average numbers of offerings in the arts . . . was greater when over one-third of their students were in an academic program."[21] Appreciation courses were offered more frequently in schools in which more than 75 percent of the students were expected to go to college.[22]

Opportunities to study the arts also differ according to race and socioeconomic status. Schools with 10 percent or higher concentrations of black or Hispanic students offered fewer arts and humanities courses.[23] Concentrated participation in the arts among white students was twice that of black students. (A "concentrator" is defined as a student who earned a total of more than three credits in any combination of arts courses.)

The NCES study shows that arts courses are not well attended. "Humanities enrollments were four and one-third times higher than those of arts courses," the report states. "Arts enrollments were 70 percent of mathematics enrollments, and 94 percent of science enrollments."[24] Even in exceptional high schools, which might be considered to have ample courses in the arts, relatively few students enroll in those courses. Overall, the study claims, "arts enrollments accounted for about ten percent of total course enrollments."[25]

Couple these statistics with the curtailments arts programs have suffered, and you begin to get some idea of the magnitude of the problems facing arts education today. According to a survey by the Alliance of Independent Colleges of Art,

> as of June 1984, nearly 70% of the [public] schools [surveyed] had experienced reductions in faculty positions, course offerings or program budgets for the

teaching of art over the past three years. In addition, 40% of the schools anticipate additional cuts occurring between 1984 and 1987. . . . Probably the most important single point to be derived from the data is that overall, *sixty-seven percent (67%) of the 1,164 schools reporting experienced reductions in at least one category of the inquiry.*[26]

While statistics on curtailment of arts programs are difficult to come by, what evidence we have points to some serious declines during the 10-year period since the publication of *Coming to Our Senses.* In Illinois (excluding Chicago), there were 3,699 full- and part-time music, art, and drama teachers during the 1976-77 school year compared with 3,211 during 1986-87—a drop of 13 percent over the decade. In Chicago, there were 356 full-time teachers of music, art, and drama during the 1979-80 school year compared with 259 during 1986-87—a drop of almost 30 percent in eight years. In all of Chicago during the 1986-87 school year, there were only 23 full-time teachers of the arts on the elementary level.[27]

If Illinois is typical, these statistics show a distinct downward trend. For many of America's younger generation, particularly those in the inner cities, instruction from specialists in the arts is becoming increasingly rare. In 1986, a Task Force for Fine Arts issued a report on the condition of the arts in the Baltimore City Public Schools. "Sad to say," the report states, "the two words we believe that best characterize the general state of the arts in the Baltimore City Public Schools at the present time are *neglect* and *decline.*"[28] The report details that decline over a decade during which the school system tightened its financial belt and the arts were dealt severe cuts. Here is the situation in the elementary schools:

At present a total of only 24 teachers of art and 24 in music are authorized to service the 123 elementary schools in the Baltimore City School System. This means that optimally . . . each of these teachers must cover five schools on the average and can visit each school one day per week.
What kind of contact do these arts teachers have with elementary students? In the 1984/85 school year, there were about 60,000 elementary students in the system. The guidelines call for students to receive art and music on an every-other-year schedule. This

Figuring out a three-dimensional sculpture can be as puzzling as a mathematical problem, but here there are no right or wrong answers.

PHOTO COURTESY OF SOUTH DAKOTA ARTS COUNCIL

means that half of these elementary students or 30,000 students do not receive any exposure to art and that the same number do not receive any exposure to music during any particular year. It also makes any attempt at establishing a sequential program of arts instruction almost impossible.[29]

Only *half* of these elementary students receive art or music during a particular school year. Add to this the fact that the Baltimore Teachers Union claims that classroom teachers should not teach the arts. Consequently there is little follow-up to the scant arts instruction offered. The task force concluded that "when it comes to the arts in Baltimore's elementary schools, all 60,000 students are deprived."[30]

Similar statistics about the decline of arts programs in Philadelphia, Los Angeles, and other cities could be assembled. The point here is that for the past decade, perhaps longer, arts programs in many American schools have been systematically dismantled. The loss of the arts in these schools is a catastrophe in the making. Given our changing demographics and the vast increase in ethnic populations in our schools, if we do not give these children the arts, how can we have any hope of establishing and maintaining a cohesive culture? The demise of arts programs marks a loss of contact with mainstream society that consigns these future adults to the basement of civilization. This is particularly the case with many of the children who attend schools in our inner cities where, all too often, the arts are assigned the lowest priority. Nor should this be viewed as a racial or ethnic problem; it is an American problem.

This is not to suggest that there are no longer any good or even exceptionally fine arts education programs in America's public schools. It must not be overlooked that many of our outstanding programs of arts instruction are models of their type. Few school systems in other countries, for example, produce the level of musical performance achieved by some of our school bands, choruses, and orchestras. Some school systems can also boast of superlative creative work in the visual arts, dance, theater, and creative writing. Nor are all urban programs deficient. Pittsburgh and Dallas, among other cities, have excellent arts programs. But these tend to be the exception rather than the rule.

What these statistics do provide is dramatic evidence of the extreme variation in how the arts are represented in

The results of years of neglect in arts education are evident in what adults say about their experiences in it. According to the Endowment's 1985 Survey of Public Participation in the Arts, most Americans say they have never had any form of arts instruction at all: 53 percent said "No" when asked if they had lessons or classes in music; 75 percent said "No" to lessons in the visual arts; 84 percent said "No" to lessons in ballet; 82 percent said "No" to lessons in creative writing. Eighty-four percent said they had never studied visual art appreciation; 80 percent said they had never studied music appreciation. Any instruction in music or the visual arts was likely to have occurred between the ages of 12 and 17, and music or visual arts appreciation courses were likely to have been taken only in college.

Chapter 1, "Overview," *Toward Civilization: A Report on Arts Education* (Washington, D.C.: The National Endowment for the Arts, 1988).

the curricula of American schools. Opportunities to study the arts are blatantly uneven across the country. There are strong, high-quality programs, there are weak or nonexistent programs, and there is everything in between. The downside of those conditions spells tragedy for some American children. Depending upon who you are, what part of the country you live in, where you go to school, how well-off you happen to be, you may or may not have access to study of the arts.

This inconsistency of access to arts instruction must be addressed. Our willingness to give some children substantive programs of arts instruction and others little if any is anti-egalitarian. One of the fundamental principles of American education is still equality of opportunity, and that holds true for the arts. You cannot deprive people of a whole realm of human knowledge and achievement without dire consequences. Schools that ignore or slight the arts present a depleted picture of civilization and a distorted view of culture. They abnegate their responsibility to pass on to the younger generation the best of human achievement. When we misrepresent our civilization, we cheat our children. Parents, school board members, and school administrators must become aware that what we *do not* give children is teaching them something as well: that the arts are just for the bright and talented, that they are not really important, and that you can be considered educated without any knowledge of them. American children deserve better. Indeed, they deserved better 10 years ago when *Coming to Our Senses* was published. Will we let another decade go by without taking corrective action?

Few citizens realize that eighty percent of our nation's youth graduate from high school with little or no instruction in the arts. . . . The typical high school graduate has a token education in the arts. About ninety hours of instruction in the visual arts is normally required—all of it compressed into a single art course taken in the seventh or the eighth grade. Requirements in music are essentially the same. The study of dance and theater is rare.

LAURA H. CHAPMAN, *Instant Art, Instant Culture: The Unspoken Policy for American Schools* (New York: Teachers College Press, Columbia University, 1982), p. 1.

2

THE NOD AND NUDGE OF EDUCATIONAL REFORM

There has been good news and bad for arts education within the profusion of education studies and reports that appeared in the eighties. Preceding these reports and prompting them, achievement test scores and the mean scores on the Scholastic Aptitude Test (SAT) had been on the decline for a decade. The public was deeply concerned. In 1983, the National Commission on Excellence in Education, appointed by Terrel H. Bell, then Secretary of Education, tied that public concern directly to the public's pocketbooks. The rhetoric in the commission's report, *A Nation At Risk*, is brisk and alarming:

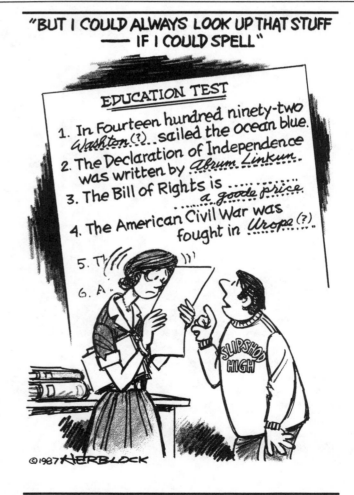

Our Nation is at risk. Our once unchallenged preeminence in commerce, industry, science, and technological innovation is being overtaken by competitors throughout the world. . . . The educational foundations of our society are presently being eroded by a rising tide of mediocrity that threatens our very future as a Nation and a people. . . . We have, in effect, been committing an act of unthinking, unilateral educational disarmament.[1]

Not surprisingly, with the nation edging toward the abyss, the arts did not fare well. One does not fiddle while Rome burns. About the closest the commission came to giving any true educational recognition to the arts was to acknowledge that some observers "are concerned that an over-emphasis on technical and occupational skills will leave little time for studying the arts and humanities that so enrich daily life, help maintain civility, and develop a sense of community."[2] But it was only a nod.

The arts are *not* basic

The commission's recommendations stressed a strengthening of high school graduation requirements to include "the Five New Basics": four years of English, three years of mathematics, three years of science, three years of social studies, and one-half year of computer science. And as an afterthought: "The high school curriculum should also provide students with programs requiring rigorous effort in subjects that advance students' personal, educational, and occupational goals, such as the fine and performing arts and vocational education."[3]

This first study, far more than those that followed, aroused state legislators and education leaders and set the substance and the agenda for educational reform. In many states, requirements in the Five New Basics have been increased. But what about the arts? Collectively, the commission's report and all the subsequent education studies have

left a confused picture about these subjects. Unlike the consistent support that English, mathematics, science, social studies, and even foreign languages and computer science are accorded in these studies, treatment of the arts is haphazard. *Making the Grade*, a report of the Twentieth Century Fund, for example, does not mention the arts, although it upholds the importance of other subjects.[4]

In their haste and shortsightedness in urging American education to serve the cause of employability, a rash of reports supported by American industry all but dispense with education in the arts.[5] Like *A Nation At Risk*, these studies enlist American education in the economic battle to keep America competitive in world markets. While the arts are largely ignored in these documents, a statement in the report of the New York-based Committee for Economic Development indicates just how marginally the arts are viewed. The report states, "Although we believe that the development of solid basic and higher-level academic skills is the primary mission of the schools, we do not agree with some recent suggestions that schools should eliminate *extracur-*

ONE OUT OF
FIVE ADULT AMERICANS IS
UNABLE TO READ THIS
SENTENCE.

Or a warning label. Or a job application. Or a love letter.
You see, more than 27 million adult Americans are functionally illiterate. And their ranks are swelling by more than two million every year.
As a high-technology maker of America's defense systems, we find this trend more menacing than Soviet missiles.
In the year when all Americans celebrate

the two hundredth birthday of the Constitution, millions of us can't even read it.
Experts say curing illiteracy will require the efforts of tens of thousands of us.
That's why General Dynamics has made a grant to help keep the Project Literacy U.S. Hotline operating, toll-free. Call the Hotline, 1-800-228-8813. Find out how you can help someone overcome this terrible handicap.
We think every American ought to be able to read this ad. Don't you?

GENERAL DYNAMICS
A Strong Company For A Strong Country

ricular activities such as athletics, music, drama, newspapers, or student government." And further: "We are convinced that this would unnecessarily penalize *certain students* for whom these subjects and activities form an important part of their education and an incentive for staying in school." And the report goes on to say, "We believe that *these nonacademic activities* not only have intrinsic value but also reinforce scholastic pursuits."[6] [emphasis added] In this, the most positive statement on the arts in any of these corporate studies, the arts are viewed as nonacademic extracurricular activities that are worthwhile only for certain students. They are certainly not viewed as subjects worthy of study by everyone.

By underestimating the educational potential of the arts, these corporate reports further relegate them to the educational sidelines. They are sending an unmistakable message to school boards and educational administrators: the arts are unimportant. In their view, an American citizen (and worker) can be considered fully educated with little or no knowledge of the arts. Employability is the goal, and these business executives would evidently be satisfied if high school graduates are able to read an instruction manual. There is no hint that schools should develop cultural literacy, educate a citizenry that is not only aware of but also comprehends the great traditions and achievements of civilization. When the mission of schools is defined along narrowly vocational and utilitarian lines, its deeper purposes dissolve. The arts and the humanities require—and nourish—a far larger educational scenario.

The arts are basic

Fortunately, a number of other education studies provide that larger scenario. Five substantial studies of American education do support the arts as a basic. John Goodlad in his 10-year study of the schools calls the arts one of the "five fingers" of human knowledge, and he says, "To omit the arts in the secondary curriculum is to deprive the young

of a major part of what is important in their education."[7] Similarly, Ernest Boyer, former U.S. Commissioner of Education, maintains that "the first curriculum priority is language," but he goes on to say that

> the second curriculum priority is a core of common learning—a program of required courses in literature, the arts, foreign language, history, civics, science, mathematics, technology, health—to extend the knowledge and broaden the perspective of every student.[8]

In another report, the College Entrance Examination Board proposes a core curriculum composed of six "Basic Academic Subjects: . . . English, the arts, mathematics, science, social studies and foreign languages."[9] Significantly, the College Entrance Examination Board, an association of about 2,500 schools and colleges, has supported the Scholastic Aptitude Test—a test that includes no questions about the arts—as a tool used by college admissions officers to evaluate applicants. (There is now pressure on the College Board to lend its support to the creation of new college entrance tests based upon the standards set forth in its study.)

Mortimer J. Adler's *The Paideia Proposal* and Theodore Sizer's study of the high school are both highly supportive of the arts.[10] But the best news is the support given to the arts in *First Lessons*, the recent federal report on elementary education. Whereas *A Nation At Risk* treated the arts with a cavalier shrug, this report calls the arts "an essential element of education, just like reading, writing, and arithmetic."[11] The arts are presented here as part of "The Explicit Curriculum"—the common body of knowledge important for all students. In a special section devoted to the arts, the report states that "music, dance, painting, and theater are keys that unlock profound human understanding and accomplishment. Children should be handed these keys at an early age."[12]

Depending on which studies and reports one reads, there is ample support for the role of the arts as basic in the education of every student. But that is not the point. Viewed collectively, all these reports reveal that there is evident disagreement about the value and the priority of the arts in American education. In general, reports written by educationists—Adler, Boyer, Goodlad, and others—support

the arts, while reports issued from the business sector overlook or minimize their educational value. There are still people who view the arts in the curriculum of American schools as frivolous, meretricious studies, and this confronts arts education with a major hurdle. It means that extra effort and persuasion must be brought to bear not just to improve existing arts curricula, but simply to maintain them. It is not simply a matter, as it is in English, math, and science, of a demand for *more*. The arts do not recline in that luxury. For arts curricula in too many American schools, it is a matter of justifying *any* and maintaining *some*.

Still, the educationists present grand designs for the curricula of American schools that deserve our reasoned consideration. It is impressive that, independently, they have viewed the arts as basic. Theirs are not, after all, the biased views of artists or arts educators. And if the arts are to be considered basic disciplines, they must be required of all, just as basics such as English, social studies, mathematics, and science are required of all.

In his explanation of curricular balance in American education, John Goodlad breaks down his "five fingers" of human knowledge into mathematics and science, literature and language, society and social studies, the arts, and the vocations.[13] His recommendation for balance among these areas in secondary schools is as follows:

> Up to 18% of the student's program (over a given year or averaged for the secondary years) [is] to be in literature and language (English and other), up to 18% in mathematics and science, up to 15% in each of the remaining three fingers, and up to 10% in physical education. A variation of up to one-fifth of the percentage of the program allocated to any of these categories would be acceptable. But I would stipulate that the maximum total for all five fingers plus physical education be not more than 90% of a student's program. The remaining 10% or more would be for individual choice.[14]

Unfortunately, in his taxonomy Goodlad errs in separating literature from the arts. Mortimer Adler provides a simpler and more judicious division of the curriculum when he divides the subject matters in basic schooling into three areas—language, literature, and fine arts; mathematics and

natural sciences; and history, geography, and social studies. Why these three? Adler explains that these areas comprise the most fundamental branches of learning. No one can claim to be educated who is not reasonably well acquainted with all three. They provide the learner with indispensable knowledge about nature and culture, the world in which we live, our social institutions, and ourselves.[15]

Adler gives equal attention to each area. If we leave Goodlad's 10 percent for electives, this means that in the Adler configuration, language, literature, and fine arts would comprise 30 percent of the curriculum.

When they are measured according to either of these recommendations, the arts in the curriculum of many American schools are being short-changed. In light of what we know about the arts and their educational potential for every human being, they deserve far better treatment than they are getting in American schooling. Who are the losers when the arts are not treated as basic? The answer is clear: every American citizen, both child and adult. When we slight the arts, we disregard our own human potential and, as a result, we diminish and delimit the quality of American civilization.

Graduation requirements

There is evidence that the arts in some states are beginning to be treated as basic disciplines. One revolutionary change, particularly during the past five years, is the national trend to establish high school graduation requirements in the arts. At the time of *Coming to Our Senses*, only 10.4 percent of the nation's high schools required music for graduation (CTOS, 102). The report noted the pressures for educational reform at that time in response to the reports of the early seventies, the Coleman report on *Youth: Transition to Adulthood* among them (CTOS, 96). It appears that, in education, there is a constant reform movement. The panel also noted that "in response to demands for change, some secondary schools have greatly increased students' alternatives both in content and structure" (CTOS, 97).

Educational reform in the eighties has had both good

TABLE 1
STATES WITH GRADUATION REQUIREMENTS
IN THE ARTS

STATE	NUMBER	SUBJECT
*Arkansas	½	Drama, music, visual arts
California	1	Fine arts (creative writing, dance, drama, music, visual arts), or foreign language
Connecticut	1	Arts (dance, drama, music, visual arts), or vocational education
*Florida	½	Fine arts (dance, drama, music, visual arts)
Georgia	1	Fine arts (dance, drama, music, visual arts), vocational education, or computer technology
Hawaii	1	For academic honors only (art or music)
Idaho	4	Fine arts (creative writing, dance, drama, music visual arts), foreign language, or humanities
Illinois	1	Art, music, foreign language, or vocational education
Indiana	2	For students seeking an honors diploma
Louisiana	½	For students in the Regents Program (typically, the college-bound)
Maine	1	Fine arts (visual arts, music, drama), or forensics
*Maryland	1	Fine arts (dance, drama, music, visual arts)
*Missouri	1	Music or visual arts
Montana	1	Fine arts, recommended for college-bound students
Nevada	1 eff. 1992	Fine arts or humanities
*New Hampshire	½	Arts education (art, music, visual arts, dance, drama)
New Jersey	1	Fine arts, practical arts, or performing arts
New Mexico	½	Fine arts (visual arts, music, dance, drama), practical arts, or vocational education
*New York	1 eff. 1989	Dance, drama, music, or visual arts
North Carolina	1	For students enrolled in the Scholars Program
Oregon	1	Music, visual arts, foreign language, or vocational education
Pennsylvania	2	Arts (dance, drama, music, visual arts) or humanities
Rhode Island	½	For college-bound students only. Dance, drama, music, or visual arts
*South Dakota	½	Fine arts (dance, drama, music, visual arts)
Tennessee	2	For students seeking an honors diploma
Texas	1	For advanced academic program students only. Drama, music, or visual arts
*Utah	1½	Dance, drama, music, or visual arts
*Vermont	1	General arts, dance, drama, music, or visual arts
Virginia	1	Fine arts, (art, music, dance, theatre) or practical arts
West Virginia	1	Music, visual arts, or applied arts

*States that require some study of the fine arts by every high school student

This table is an extension of one first published in *Arts, Education and the States: A survey of State Education Policies* (Washington, D.C.: Council of Chief State School Officers, 1985), p.23.

and bad effects on the arts in many secondary schools. If schools had begun to offer more elective or short-term courses 10 years ago, the trend has now reversed. And in reducing electives, the arts have suffered. In numerous states in which graduation requirements in the Five New Basics were increased, the arts were made the victim. With a fixed amount of time in the school day, raising requirements in English, math, science, and social studies and adding computer science meant that time for electives was eliminated. Something had to go, and it was the arts. Whereas prior to these new requirements, students could plan to spend four years in the high school band or chorus, they now no longer had time in a six-period day to do so. Performing groups had prospered because of the growing expertise students were able to accumulate, but no more.

Fortunately, in some states the arts were also made a requirement. In Florida, for example, all students must complete one-half unit in the fine arts (dance, drama, music, or visual arts) for high school graduation. That may sound like a boon to the arts, but with all the requirements in other subjects, the arts were about to go the way of the dinosaurs. Students simply had no time left for them. Fortunately, most of Florida's school districts have now opted for a seven-period day, restoring the option for electives.

By the end of 1987, 30 states had opted for some kind of arts requirement (see Table 1). It is important to realize, however, that states exercise control over arts instruction in public schools in a number of other ways. Some mandate a certain amount of instruction in the arts in elementary and secondary schools. At present, 42 states have such a requirement, though mainly in visual arts and music. Only 12 states require that dance and/or theater be offered at the secondary level. Minnesota, for example, requires that all high schools provide a minimum of two credit hours in music and two credit hours in visual arts, with at least 240 class hours in each. This kind of requirement guarantees that schools offer a minimum number of arts courses, not that students must take them.

Table 1 shows three other ways that states mandate the arts in public schooling. Most of these 30 states have adopted the graduation requirements during the past five years. (The exception is Missouri, which since 1960 has required one unit—one year—in fine arts, defined as either and *only* art or music.) The requirements differ considerably in the demands they make on the individual high school stu-

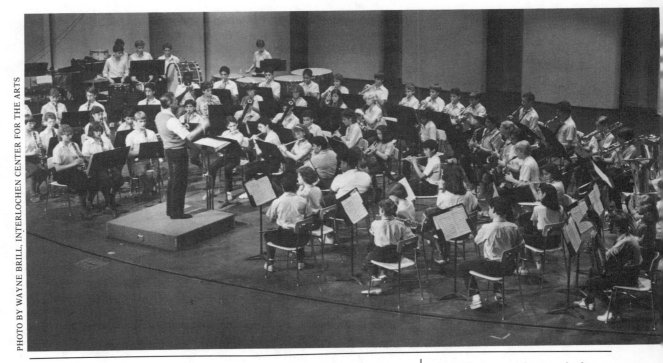

dent, and they differ dramatically in their implications for arts curricula.

The orchestra at the Interlochen Arts Academy gives students the opportunity for serious study of music through group performance.

Eight states out of the 30 require study of the fine arts for just those students who are college-bound or who are in the advanced academic program. Rhode Island, for example, requires these students to take half a unit of study in dance, drama, music, or visual arts; Texas requires them to complete one unit of study in drama, music, or visual arts. These states, along with Indiana, Louisiana, Montana, Nevada, North Carolina, and Tennessee, have not established requirements in the arts for students in the general academic or vocational programs, those not interested in going to college.

Deceptively, 11 of the states in Table 1 require a specific number of credits in the fine arts *or other subjects*. These subjects range from foreign languages and the humanities to computer technology, forensics, and practical or applied arts (shop and home economics). Such requirements may have little or no effect on the arts. In Connecticut, for example, any course in dance, drama, music, or visual arts may be used to fulfill the one-unit requirement. But so may any vocational course, which can include almost any course

so designated by the local districts. Accordingly, few students are actually affected by the legislation, and no special arts offerings have been deemed necessary.

In Idaho, a humanities requirement of four units embraces the arts. The requirement states that the credits "may be from any of the following: fine arts (including performing classes), foreign language, or humanities." Study in humanities, the accrediting legislation states, "is to be considered as an integrated program of studies which will incorporate the interrelationship of art, music, world religions, architecture, science, philosophy, and literature." But a student may substitute two credits in practical arts (vocational, prevocational, or consumer homemaking) for humanities. Conceivably, such a student could then complete the requirements by taking two credits in foreign language, avoiding the arts altogether. Perhaps this is why the Idaho State Department of Education is not recommending a new course in general music, but rather broadening the curriculum in the performance classes to include significant components in language and structure of music; skills in performing, creating, and listening; understanding music history; appreciation and evaluation of music. These classes satisfy the graduation requirement for the humanities.

Similarly, Pennsylvania requires two credits in the arts *or* humanities or both. In response, the Pennsylvania Department of Education has issued guidelines for local districts that suggest possible linkages between the arts and humanities. It is too early to see what effect these new regulations will have on the district level.

When you get down to it, only nine states (starred in Table 1) now require *every* high school student to complete some study of the arts in order to graduate. Four of these states require a half unit and four require one unit, while Utah requires one and one-half units. In at least eight of these states this is a new and positive development, a direct outcome of educational reform.

Seven of the nine states permit students to fulfill the requirement through a comprehensive program of dance, drama, music, and/or visual arts. One state, Missouri, requires students to complete one credit in art and/or music; and one state, Arkansas, gives students the option of taking a half credit in one of three arts—drama, music, or visual arts. Since most states permit school systems to determine their own courses, using their own ingenuity and local resources in complying with the new graduation require-

ments, it remains to be seen what kind of arts courses students will take. Maryland, New York, and Utah have issued directives that require school districts to invent new general courses of substance in the arts. These are the states that are taking real leadership in the arts reform movement. In many of the other 30 states, what may first appear to be reform in the guise of new graduation requirements may be more an effort to save the arts from total obliteration and placate arts proponents.

Still, ten years ago, *Coming to Our Senses* noted that "69 percent of the students take no music at all in the four years of high school" (CTOS, 102). Now, in nine states, there is a firm mandate to alter that condition, and in many other states students are being prodded to take some arts as part of their high school education. When required for graduation, the arts gain a new academic respectability that should open them to the main resources of the schools. Monies should be available for curriculum development, new materials, and in-service education—budget items that other basic subjects have long taken for granted, but which have been denied to the arts in some school systems. That is a significant step forward.

Another development along these same lines is also pressuring schools to provide more arts curricula, to count them important, and to encourage students to take them. Universities in some states are now requiring some arts for admission. This is true in Ohio and, as of the fall of 1988, will be the case in the California State University (CSU) system. CSU will require all entering freshmen students (enrollment is more than 335,000 students on nine campuses) to have completed a one-year course in the fine or performing arts. This gives considerable new impetus to the arts in high schools throughout the state and, by implication, to the arts at other levels as well. So far, however, these new requirements have not prompted high school students to elect additional courses in the arts. According to Carolyn Tucher, vice-president of the Board of Education in the Palo Alto (California) Unified School District, it remains to be seen how deep the impact of these new admission requirements will be. She says:

> At present, students are likely to fill an arts requirement and that's the end of it. They don't elect to go further in the arts because, as they see it, they've met that requirement. But at least they've had a year of art instruction which they didn't get before.[16]

If the arts come to be regarded an nonintellectual or as essentially emotive in character, they will be considered merely a kind of diversion from the hard subjects having only the potential for cultivating avocational interests. The realization that the arts represent one of the ways through which humans construct and convey meaning and that the creation of art forms requires the use of judgment, perceptivity, ingenuity, and purpose—in a word, intelligence—seems to have escaped most of those who have commented upon the state of education, not the least of whom are university professors sitting on admission committees and shaping admission policies for universities.

ELLIOT W. EISNER in *Cognition and Curriculum: A Basis for Deciding What to Teach* (New York: Longman, 1982), p. 74.

Granted, a year of fine arts is far better than none, but it is scarcely enough, given the range of the arts, the intricacies of their various techniques, and the complexity of their many messages.

Other ramifications of reform

But the calls for educational reform cut far deeper than just the elbowing for room in the curriculum, for line items in the school budget, or for status. They call for greater academic emphasis in general and for standards of excellence that accrue from studies that are both demanding and substantive. The reports represent a reaction against the leniency and permissiveness of schools in the seventies. The arts exist in this milieu. Indeed, the National Commission on Excellence in Education recommended that the arts require "rigorous effort" and that "they should demand the same level of performance as the Basics."[17] The expectation that educators make more demands upon students has been applied to arts teachers as well. It is impossible at this time to assess the effect this crusade for higher standards is having on arts curricula, but it is safe to conjecture that it will alter how the arts are taught, perhaps considerably.

What is the general condition of the arts today in light of the educational reform movement of the eighties? As W. Ann Reynolds has suggested, the situation does indeed appear to be similar to what the arts experienced in the educational crisis that followed Sputnik in 1957. Thirty years ago, President Dwight Eisenhower called upon the nation's intellectual elite to invigorate math and science instruction, the first massive mobilization of education for the sake of the nation's economic leadership and prestige. He approved a $1 billion, four-year program of federal aid to education "to meet the pressing demands of national security in the years ahead." This employment of education to solve the nation's economic problems set a precedent that has been repeated continuously ever since. The back-to-basics movement, with its narrow and practical view, defined education

along totally utilitarian lines. This movement has caused us to lose sight of the major rationale of what constitutes a general education—*breadth*. Accordingly, the arts were either brushed aside or ignored, their practical aspects having been overlooked. Today, generally, economic interests continue that same drive, ignoring the fact that three decades of such efforts to confine the curriculum have not succeeded in producing the results they seek. Ironically, if the employable "product" of American schools must be more self-motivated, literate, and creative, the arts might well be part of that as yet unattained solution.

By and large, corporate leaders, the public, and the vast majority of educators, administrators, and school board members are not familiar with the new rationale that supports the arts as basic in American education. They remain unconvinced. Most have not had the opportunity to see or experience substantive programs in the arts. Unfortunately, the arts at the elementary level are increasingly consigned to classroom teachers who are already overburdened and often unable or unwilling to teach them. There are far too few models of what a quality arts program ought to be. Even where arts specialists are still on hand, they are often stretched to exhaustion and could not assume further responsibility, especially for building a new, basic curriculum, unless provided with special curriculum planning time, opportunities for in-service education, and the special dispensations so generally afforded other disciplines. The educational hurdles for the arts are now solid and high, perhaps as formidable as they have ever been.

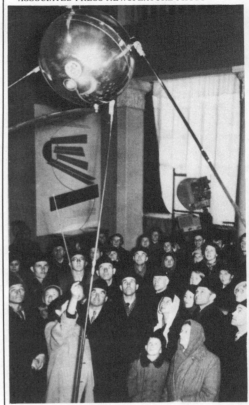

The appearance of Sputnik brought admiration from these Russian citizens viewing a replica in 1957 and motivated Americans to improve education.

The changing conditions of schooling

A host of other serious problems face all subjects in today's schools. Students are vastly different now from students a decade ago. Schools throughout the United States, particularly those in America's inner cities, are ex-

periencing a growing proportion of disadvantaged students. Although almost two-thirds of all poor children are white, black children are nearly three times as likely to live in poverty as white children.[18] These disadvantaged children, who generally live in single parent households, tend to do worse in school than those with two parents, and their dropout rate is nearly twice as high.[19] Of those living in female-headed households in 1985, nearly half of all white, 66 percent of black, and over 70 percent of Hispanic children lived in poverty. While one out of every six white children lives in a single-parent home, 50 percent of black children live in homes headed by single women. In 1986, 74.5 percent of all black children were born to unwed mothers, half of them to teen-agers.[20] The plight of these disadvantaged youngsters and their growing numbers are staggering. This new underclass often suffers debilitating deprivations that seriously impair their ability to learn.

By 1990, minorities and immigrant populations will constitute more than 30 percent of the total school-age population in the United States. Most of the larger states are showing higher percentages of minority students—46 percent in Texas and 32 percent in New York, for example.[21] Many of the immigrant children have difficulty speaking English. You can literally tour the world in many urban classrooms. In Community School District 10 in New York City as many as 67 different native languages are spoken. The multilingualism of the students poses a serious challenge to teachers, arts teachers included.

In numerous schools, drugs and violence are the downfall of many children, particularly urban youth. In Washington, D.C. and other cities, young people kill each other over boom boxes, leather jackets, sun glasses, and other symbols of status. Crime in school yards and corridors is sometimes commonplace. Assaults on teachers is on the rise. Urban and suburban youth often need special help to develop good self-concepts that permit them to resist the temptations that appear to be ever-present.

Another of the more serious problems confronting American high schools is their failure to keep all the students enrolled. The seeds of dropping out are planted early, and "at risk" youngsters can usually be identified in junior high school by their erratic attendance, poor grades, behavioral and personal problems, and language difficulties. One out of every three students in the United States is leaving high school without a diploma.[22] In many cities, the situa-

tion is worse. The 1983 *Dropout Report* of the New York City Board of Education estimated the rate at about 45 percent.[23] As if this is not scandalous enough, ASPIRA of New York ("aspira" is the Spanish words for "hope") has claimed that as many as 68 percent of students entering ninth grade in New York City public schools never graduate.[24] In any case, America's high schools are losing upwards of one million students a year, an educational failure of extraordinary magnitude.

Like all the other subjects in the curriculum of American schools, the arts must function in this context. They have as much responsibility as other subjects to make certain that the talents and the human potential of these children are realized, not squandered. As schools struggle to find ways through the deprivation and despair to improve the environment, the processes, and the traditional structures of learning, they might wisely look to the arts to make a major contribution. If schools are to have any chance of succeeding in educating the disadvantaged, they cannot simply force more of the same three Rs upon these students.

Educational administrators and school boards need to be reminded that schools have a fundamental obligation to provide the fuel that will ignite the mind, spark the aspirations, and illuminate the total being. The arts can often serve as that fuel. By engaging one capacity, others can emerge. Given the current dropout rate, whether the entry vehicle to learning for a particular human being happens to be the arts, the sciences, or the humanities is less important than the assured existence of a variety of such vehicles. For many students, the schools are compulsive about too narrow a range of subject matters. The arts can provide windows to other worlds, and they can liberate the positive energies of young people. As long as a human being becomes tuned to his or her capacities, excited by personal possibilities, and stimulated to want to learn, the schools have won the major battle. What possible difference could it make that the arts provided that window? Science and English and social studies will be among the beneficiaries. So will American business and American culture.

The measure of a great civilization is not just the monuments that are built but rather the quality of individual lives. The arts are life enhancing. True, they can help us create better environments in which to live and work, but their greater asset is their capacity to enrich our internal furnishings. They can invade our self-centeredness and, by

This student figures out "variations on a theme" through graphic representation, a way of thinking about and looking at the world.

touching our emotions, remind us to sympathize and to care. They can turn our imaginings to worlds beyond that give us renewal, purpose, and hope. They can help to make us functional humans.

The first wave of the current education reform movement focused on improving the quality of public education by raising standards and introducing more challenging course requirements at the high school level. The second wave has focused on improving the quality of the nation's teachers. The third wave should concentrate on the students—how to activate and inspire them, how to induce self-discipline, and how to help them to discover the joys of learning, the uniqueness of their beings, the wonders and possibilities of life, the satisfaction of achievement, and the revelations that literacy, broadly defined, provides. The arts are a central and fundamental means to attain these objectives.

The necessity
for accommodation

By far the most serious and tragic consequences of the blatant minimalization and diminution of the arts in many American schools is the effect that hiatus is having and will continue to have on the lives of the students. This next generation is devoid of the humanizing force of the arts. They are lost to the insights and the pleasures that the arts afford. They have been effectively cut off from a significant part of their cultural heritage. And in the act of that severance, the nation disavows the brilliant achievements of their artist-ancestors, disregarding them like so many worthless shards. Lacking any depth of knowledge about the artistic culture of the past or even of their own time, these students are undereducated and miseducated. The United States will not prosper on the backs of their depleted lives.

What is arts education for? Maxine Greene, William F. Russell Professor in the Foundations of Learning at Columbia University, has observed that young people, if they are to renew their worlds as the days go on, must live fully and be interested in the possibilities of life. She said:

> For this to happen, they have to be enabled to break with confinement in the domains of popular culture, mass entertainment, televised realities, and private cynicism or hopelessness. Offered concrete and significant alternatives, windows through which to see beyond the actual, they may refuse their own submergence in the typical and the everyday. . . . It is not only the thought of *having* more that moves the young to reach beyond themselves; it is the idea of *being* more, becoming different, experiencing more deeply, overcoming the humdrum, the plain ordinariness and repetitions of everyday life.[25]

Here we begin to get a hint at what the arts, at their best, are all about. They are the application of human imagination, thought, and feeling, through a range of "languages," for the purpose of illuminating life in all its mystery, misery, delight, pity, and wonder.

In the case of the "at-risk" student—the culturally deprived youngster whose home provides little preparation or support for classroom learning—we can expect a repeated urging of the "back to basics" prescription we've heard in various forms for decades: eliminate all the curricular extras, and bear down on the three Rs!

Yet for many children struggling with reading, writing, and arithmetic, this may be precisely the wrong medicine. Learning has its emotional and psychological aspects as well as its strictly rational ones, and what many at-risk students need above all is a taste of success—proof that they *can* perform well in a school-related endeavor. . . . As many principals and teachers have noted, the self-confidence and renewed aspirations a child develops by doing well in painting, drama, singing, or playing an instrument often carries over into the more traditional scholastic areas of the curriculum.

SAMUEL G. SAVA, Executive Director, National Association of Elementary School Principals, *Music Educators Journal*, Vol. 73, No. 4, (December 1987), p. 54.

American author I.F. Stone has spent a good number of his 80 years culling the works of Greek poets for their honest, human insight. He told of a little poem found on a tombstone in Corinth, an epitaph to a friend named Sabinos. "I must tell you, to understand it," Stone said, "that when the dead came to the Underworld across the river they came to the Fountain of Lethe, which means forgetfulness. They drank the water and forgot their past. That's a key to this poem." Then Stone related the poem in his translation:

This memorial, noble Sabinos, is just a stone and a small one at that for so great a friendship as ours. I shall always search for you and of you I ask only, if it be proper down there among the departed, for my sake, do not drink even a drop of the waters of forgetfulness.[26]

"Isn't that beautiful?" Stone asked. It is that same revelation of the human condition that, at their best, all the

This "Little Slugger" takes time out to investigate the art of poetic expression, another important side of her developing intellect.

PHOTO COURTESY OF SOUTH DAKOTA ARTS COUNCIL

arts radiate. But, just as there is a key to understanding this poem, there are keys to understanding the languages of all the arts, and that is the purpose of arts education—to supply those keys.

Those of us who believe in the importance of the arts in American education are not fighting for the arts alone. We believe in a value system beyond materialism, beyond pop culture, beyond crass commercialism. We believe that the arts generate the mechanisms of human perception and understanding, of creativity and communication, and of thought and feeling that are essential to the conduct of life and society. They are fundamental enablers that can help us engage more significantly with our inner selves and the world around us.

In this technological age, perched on the edge of star wars, the arts are needed more than ever because they reaffirm our humanity. In many ways the arts are the glue that holds society together. Technology does not feed the human spirit. With satellite TV transmission encircling the globe and jet aircraft placing us within 24 hours of the farthest reaches of the human family, the peoples of this planet grow closer and closer. We must open the avenues of human understanding. To do this, we need every possible means at our disposal. The arts are not peripheral to those interests. They are a central and basic means of hope and salvation for the human race. For these reasons, every American youth should be guaranteed access to study of the arts, and every American school should provide that access.

Schools enrolling large numbers of economically disadvantaged students often appear obsessed with teaching fundamental skills in routine ways. They are under great pressure to bring up achievement test scores, a practice that frequently results in narrow "no frills" curricula that stress mathematics and the language arts and repetitive, rote approaches to learning. . . . The schools must substitute for economic impoverishment a wealth of educational experience in all the domains of knowledge and all the ways of knowing. To neglect the arts in childhood is to impoverish not only the child, but the child become adult.

JOHN I. GOODLAD, Director, Center for Educational Renewal, University of Washington, *Music Educators Journal*, Vol. 73, No. 4, (December 1987), p. 52.

3

THE PERENNIAL ISSUES

Anumber of fundamental dilemmas—choices, if you prefer—stand right at the center of any possible advancement in arts education today. While most of these issues pervaded the field a decade ago, the conditions of education today have intensified their urgency and the need for their resolution.

What arts will be taught?

When we consider the arts in public education, to which arts do we refer? What arts make an arts program? Some schools have been consistent in their intent to provide students with course work in visual arts and music. Others, perhaps prompted by the comprehensive arts movement of the seventies, have striven to enlarge that framework to include creative writing, dance, theater, and media (the latter is sometimes seen as part of visual arts, as is architecture).

The Arts, Education and Americans panel found that the state of these various arts in the schools differs considerably:

> Of all art forms, dance fares worst in the schools. In junior and senior high schools, folk and social dancing are taught as short-term units within the regular physical education classes. In large metropolitan high schools, girls may be offered modern dance. . . . Although dance performances have become more popular than ever, and though small dance companies are springing up all over the country, dance teachers at the secondary level represent less than 1 percent of all teachers (CTOS, 108-09).

According to the report, creative writing, theater, and media arts were in just about as tenuous a state as dance (CTOS, 104-11). Creative writing, oddly enough, may be the most neglected of the arts. As a separate course, creative

writing was only offered in about 21 percent of rural, 29 percent of urban, and 41 percent of suburban schools during the 1981-82 school year.[1] Since writing is so closely related to the sanctified area of language arts, one would expect it to be given special emphasis, and that may well be the case. As an art form, creative writing is harder to track than the other arts because it is often tucked into the language and literature curricula. Because of this, it may be given more emphasis than we realize. Many poets and writers give copious credit to their teachers of English. In this sense, creative writing may serve as a model for the other arts being integrated appropriately into the humanities curriculum.

Media, encompassing the arts of radio, television, photography, and film, were given special emphasis in the report, particularly the possible role that television could and should play as a vehicle for learning (CTOS, 203-09). But there is little evidence that television has advanced as an educational tool in the years since the report. In spite of its ubiquitous presence in American homes, the television set has scant usage in most American classrooms.

Coming to Our Senses spoke of plans for comprehensive arts education programs on the state and local school

This student is learning how to focus his video camera, an integral part of Mamaroneck (New York) High School's performing arts curriculum.

PHOTO BY L.S. HASKO

Sixth grade students at the Center for the Arts in Montgomery County, Maryland, learn a court dance during a unit on historical dances.

district levels (CTOS, 224). The intent of these programs was to encompass more than the usual art and music curricula. In a section of the recommendations entitled *Beyond "music and art,"* the panel stated that "the traditional curriculum consisting only of courses in visual art and music is no longer sufficient." They amplified this by declaring that "the curriculum [should] be expanded to include the disciplines of dance, film, drama, poetry, design, and so forth" (CTOS, 249).

Have we made progress in establishing comprehensive arts programs in the past 10 years? By the early eighties, almost every state had elaborate plans for establishing comprehensive arts education programs, but those plans, by and large, have not been implemented on the local school district level. We know that some school districts have been able to give their arts education programs a semblance of comprehensiveness through short-term residencies by dance movement specialists and dance companies, dramatic artists, media experts, poets, craftsmen, and other artist-teachers through the Artists in Education program of the National Endowment for the Arts (NEA). A comprehensive arts program, however, must provide sequential curricula in these art forms if students are to acquire both skill and understanding.

The idea of establishing a major curricular area for the arts comparable to that of the sciences or the humanities is gaining momentum. State education leaders, school administrators, and school board members are beginning to talk more in terms of "the arts" than "music" or "art" or "dance." The identity of the individual arts need not—and should not—be lost in defining them generically, any more than general science, biology, chemistry, and physics lose their distinctions under the banner of "science." But the *idea* of a comprehensive arts curriculum and the *reality* of its existence in American schools is far from realization.

Whose culture shall we teach?

Another section of the panel's recommendations, entitled "Many rivers, many bridges," addressed the diversity of American culture. Here the panel noted the generation of artistic activity for specific audiences—the homogeneous audiences served by major cultural institutions, the single ethnic groups served by many community-based arts organizations, and the neighborhood or regional needs served by still other arts organizations. They saw the ethnic arts movement as "a central force in American culture," and they urged granting agencies to fund good community arts programs and the schools to "take advantage of such programs to improve their own arts education efforts" (CTOS, 255). They said:

> American culture is a quilted fabric with numerous national minorities interspersed. The artistic creations of our ethnic peoples are the most visible expressions of this variegated culture, and they can provide an invaluable resource for arts education (CTOS, 255).

America's culture is a complex mosaic of arts of multiethnic and multinational origins. But which arts—whose culture—should be taught?

What many schools offer to children is little more than a token exposure to the visual, performing, and literary arts. Even this exposure is offered grudgingly, as if learning about the visual arts, music, dance, theater, and literature were a bonus or luxury. The instruction offered in some schools is so casual or wasteful of time and resources that many children actually are miseducated in the arts. Many of our young people graduate from high school with the impression that art is undemanding, unless one has talent, and irrelevant to contemporary life, unless one has the wealth and leisure to indulge in it.

LAURA H. CHAPMAN, *Instant Art, Instant Culture: The Unspoken Policy for American Schools* (New York: Teachers College Press, Columbia University, 1982), p. xiv.

The explosion of arts in the inner cities since the mid-1960s tells us that Afro-Americans and Hispanic-Americans have their own uniquely characteristic cultural heritages. The panel expressed reservations, however, about the possible limitations of arts programs designed for those who share the same social or economic conditions:

> Such programs can become isolated and segregated from the rest of the society, thus running the risk of stagnating without the interchange of ideas. And programs directed at particular ethnic or racial groups may only temporarily satisfy the need to strengthen a sense of self or to articulate fully the messages and forms which derive from social and historical heritage (CTOS, 189).

What was not said here, and needs to be said, is that arts programs that tend to isolate people from the totality of American culture not only repudiate that culture, but also, by the sin of omission, perpetrate cultural deprivation. This is true whether the narrow vision of the world emanates from the minority sectors of society or from the white Anglo-Saxon majority. Such programs put blinders on children and teach them to see only their own footsteps.

As part of a study of the American Indian in a primary school in Little Rock, Arkansas, a kindergartner forms an earthenware pot that she will decorate with an Indian motif.

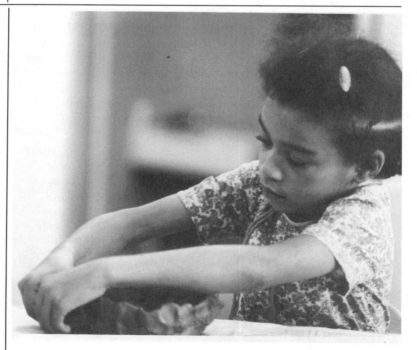

We must be careful not to move toward cultural separatism, particularly in our cities. Here, where many children attend schools that do not provide adequate arts instruction and where they are not introduced systematically to prevailing traditions and practices of artistic culture, they are apt instead to be engulfed in the particular culture afforded by their community. For many children, this is the culture of the ghetto, often rich in its individual way, but certainly not representative of the larger society outside. Those who teach the arts have an obligation to assure that the many ethnic elements of our culture do not separate us, at the same time that they guarantee students access to the universal elements of culture that bind us as a civilization.

What we do not want in the United States is a dissolution of our many ethnic cultures or a fusion of them into one indistinguishable mass. The diverse riches of mind, spirit, and imagination make a dynamic whole, *but only if there is a shared culture at the base.* If we are not to be a country of many separate peoples, we must establish commonalities of culture as well as some understanding across our many distinguishable artistic legacies. E.D. Hirsch, Jr., author of *Cultural Literacy: What Every American Needs To Know*, believes that, above all, schools should teach the commonalities of mainstream culture, but he says:

> To acknowledge the importance of minority and local cultures of all sorts, to insist on their protection and nurture, to give them demonstrations of respect in the public sphere are traditional aims that should be stressed even when one is concerned, as I am, with national culture and literacy. . . . It is for the Amish to decide what Amish traditions are, but it is for all of us to decide collectively what our American traditions are, to decide what "American" means on the other side of the hyphen in Italo-American or Asian-American. What national values and traditions really belong to national cultural literacy?[2]

No doubt Hirsch would agree that the inculcation of national cultural literacy should take precedence over any ethnic considerations, but not that these subcultures should be homogenized or obliterated. On the contrary, people need to wed their personal cultural identity to a strong sense of national cultural identity. They must come to view their own uniqueness as an important slice of the whole, to see them-

selves in the context of the larger world. (Sometimes, we humans have to be reminded that we are far more alike than we are different, and it is the like qualities that are so often overlooked.)

What Hirsch does not acknowledge is that children should be introduced to the *un*commonalities of artistic culture—humankind's extraordinary achievements in architecture, ballet, chamber music, drama, jazz, modern dance, opera, painting, poetry, prose, sculpture, symphonic literature, and so forth. But we must not make the mistake of believing, as does Allan Bloom, author of *The Closing of the American Mind*, that the distinguished elements of American culture derive entirely from the traditions of Greece and Western Europe. Eurocentrism is as unsuitable a view of American culture as the relativistic pandering to everything and anything. Nor is our culture tied primarily to literature and philosophy—words—as both Hirsch and Bloom would evidently have us believe. All of the arts, including literature, are at the core.

By their nature, the arts in their totality give significant representation to a culture. They exude civilization. From this point of view, it may be more important for a largely Hispanic community to stress other aesthetic manifestations of cultural diversity than just the Hispanic element. The black person who knows only Afro-American music and the white person who knows only European painting and architecture are equally deprived. Yet it must be acknowledged that this country has its roots deep in the Western traditions that emanated from Greece, Rome, and Europe. Every citizen of this nation has a right and an obligation to that heritage, just as we all have a right and an obligation to jazz, ragtime, and gospel. In this regard, our artistic eclecticism is an American fact of life, and the cross-fertilization between types and styles of art is the underlying basis of much of our creative vitality. What helps to bind us as a nation and as a people are the universal elements of our pluralistic artistic heritage.

What, then, do the schools do? Should they pass on all the existing manifestations of art as though all are of equal value? To the extent that all these artistic expressions are part of our heritage, yes, they have a viable claim to a share of arts education. Indeed, the main function of arts education is to transmit to new generations the breadth and richness of American culture. But constraints of time and resources force arts educators to make certain choices.

The ethnic differences we see in the United States are but decaying reminiscences of old differences that caused our ancestors to kill one another. The animating principle, their soul, has disappeared from them. The ethnic festivals are just superficial displays of clothes, dances and foods from the old country. One has to be quite ignorant of the splendid "cultural" past in order to be impressed or charmed by these insipid folkloric manifestations (which, by the way, unite the meanings of culture—people and art). And the blessing given the whole notion of cultural diversity in the United States by the culture movement has contributed to the intensification and legitimization of group politics, along with a corresponding decay of belief that the individual rights enunciated in the Declaration of Independence are anything more than dated rhetoric.

ALLAN BLOOM, co-director, John M. Olin Center for Inquiry into the Theory and Practice of Democracy, University of Chicago, from *The Closing of the American Mind* (New York: Simon and Schuster, 1987), pp. 192-93.

PHOTO BY LONNA JONES

What, then, do we pass on, and what do we pass over?

There are great differences among children in what arts they have been exposed to and what they have come to understand. From this standpoint, communities and schools will differ in what they need to stress. People should understand their own ethnic culture as well as the cultural traditions of the nation. But arts curricula do not need to stress what students already know and like. Young people do not need the schools to introduce them to popular culture. They quite often *do* need the schools to give them an opportunity to understand their own ethnic artistic heritage and to introduce them to the artistic heritage of other cultures, including the European traditions that are the basis for so much of our artistic expression. To these ends, arts education is the irreplaceable conduit for conveying the artistic heritage of Afro-, Asian-, European-, Hispanic-, and Native Americans to citizens of the next generation. If these arts are not a part of arts education in the schools, many American children will not have access to them at all.

A second criterion of delimitation and choice involves the degree of abstractness or difficulty of the artistic "lan-

Sixth grade students in German Central Elementary School in McCllellandtown, Pennsylvania present their version of the musical, "Fiddler on the Roof," conveying their sense of ethnicity through the art of theater.

guage.'' If a particular example of an art form is simple to perform (or readily understood), students may not benefit from studying it. Some popular and folk art is immediately decipherable. These artistic codes are deliberately in the public vernacular. In comparison, understanding African sculpture, Asian dance, Greek theater, Hispanic literature, or European artistic traditions poses challenges comparable to learning a foreign language. These codes tend to be more complex, more highly structured and developed, or sometimes more subtle, profound, or sublime in content. From this standpoint, they demand more *attending to* in education. We have to know more to get the message, like the extra trouble it takes to understand Shakespeare or Spenser or Milton.

The fact of our pluralistic artistic culture, then, does not translate into equal claims on the educational curriculum. Every citizen should have the means to understand the greatest artistic traditions of America, those that represent the ultimate human achievements. Students should be given all the pieces of the cultural puzzle, not just those to which they easily relate, with which they are already familiar or in which they are readily interested. Some of those pieces are especially representative of the range, character, and concentration of American arts; some are difficult to understand. The curriculum must be adjusted accordingly.[3] As citizens, we are all heirs to both the majority and minority cultures of the nation. That is a uniqueness of American citizenship that cannot be taken lightly in today's schools.

Who should teach the arts?

On the subject of who should teach the arts, the Arts, Education and Americans panel asked a number of provocative questions, among them: should the arts be taught by specialists or by generalists? Should the age level of the student determine this? If so, at what age should a change occur? At the elementary level, the panel saw the role of the generalist as central. When backed up by a consultant or specialist, the report states, the elementary classroom

teacher "can do as good a job in the arts as in other areas of learning" (CTOS, 139). And the report explains that

> for elementary arts programs, then, there is a need for classroom teachers with training in the special problems of young children, and some knowledge of music, art, movement, and verbal arts (CTOS, 139).

At the secondary level, the panel noted that the arts teacher tends "to be more of a specialist, but may also teach other subjects" (CTOS, 139). Perhaps they had in mind the theater teacher who also teaches English (or is it the other way around?) and the dance teacher who also teaches physical education. Few music or visual arts teachers teach other subjects. At the college level, "the college arts teacher is likely to be an artist who has been hired to teach." The progression from generalist to specialist during the span of kindergarten through college is further articulated:

> At the precollege level the arts teacher is generally an educator first, and an artist second, while on the college level, just the opposite is usually true (CTOS, 140).

Statistics are cited to show the amount of arts instruction by generalists in elementary schools. The panel reported that, although a number of elementary schools have the services of arts specialists, 90 percent of the arts at this level are taught by classroom teachers and that 37 states give them the primary responsibility for arts instruction.

The situation today is the same or more so. A study published in 1983 found that elementary schools commit only four percent of their school week to art instruction, with only a quarter of that provided by trained art teachers.[4] Similar conditions prevail in music, while dance, theater, and creative writing receive even less attention, although more of the instruction in those areas may be credited to an arts specialist.

Who should teach the arts? What appears obvious here is the need for the roles and responsibilities of classroom teachers, arts specialists, and artists to be clarified, particularly on the elementary level. On this level, especially, many arts programs are shaky, sporadic, and unsubstantial. After another decade of reliance on generalists to teach the arts, we must admit that, overall, elementary schools have failed to deliver adequate programs of arts instruc-

What other disciplines, outside of the fine arts, define their entire fields purely in terms of Western history, practice, theory, and terminology? Because of this difference in fundamental approach, there is a tendency for the fine arts to find themselves disenfranchised in the context of our society. While the artistic product is valued, the vantage point from which arts institutions present themselves is too narrow to inspire the confidence of all. I do not mean to suggest that all fine arts institutions should strive to become multicultural and multiethnic. Although there should be more multicultural institutions than presently exist, the mainstream of activities in America will naturally continue to retain a Western focus. What I would prefer to argue is that this Western focus must be set in a global context and that such a focus must not be construed as a definition for the whole.

ROBERT GARFIAS, Dean of Fine Arts, University of California at Irvine "Music in the United States: Community of Cultures," *Music Educators Journal,* Vol. 69, No. 9 (May 1983), pp. 30 and 31.

tion. Roles and responsibilities at this level should be re-evaluated if only because the system does not appear to be working.

The Classroom Teacher

In his vast report on American schools, John I. Goodlad asks, "Why specialists in the arts and physical education, if not in English, mathematics, and social studies?"[5] The answer to that question is very simple: classroom teachers, who are supposed to be experts at teaching English, mathematics, and social studies, are noticeably non-experts at teaching the arts and physical education. While many prospective elementary teachers enter college well versed in other subjects, they are almost totally ignorant of the arts. They are behind before they begin, and too few ever catch up. And why are they behind? Because *their* elementary teachers too often failed to provide adequate instruction in the arts. It is a self-perpetuating cycle.

The near-universal lack of sufficient arts in the preparation of classroom teachers is historic practice bordering on scandal. This prevailing deficiency was precisely why arts specialists were called for in the first place. The argument to maintain arts specialists in the elementary schools has credence as long as elementary teachers are unprepared to teach the arts. That is the irony. If arts specialists fight for better arts preparation for classroom teachers and achieve it, they seemingly do themselves out of their jobs. Given the pressures for achievement in reading, mathematics, and other subjects in the compulsory curriculum, classroom teachers simply do not value the arts sufficiently enough to give them priority attention. Too many educational administrators and school board members seem quite content to look the other way. They dump the full responsibility for arts instruction on classroom teachers in spite of their inadequacies, and they quite consistently fail to understand the indispensable role of the arts specialist in assuring that this responsibility is realized.

There is another irony as well: in many school systems, union contract provisions governing planning time make it imperative that classroom teachers are released from their duties for some part of the school day. Arts and physical education teachers often cover that time. Some school systems have had to hire additional arts specialists to meet these conditions. This appears to bode well for the arts, but

it does not. Classroom teachers are not present to see the arts program, let alone integrate or extend it. In many of these schools, the arts are valued not as subjects to enrich curricula but as convenient baby-sitting "fillers" contracted to meet union obligations.

In spite of this, the situation in most elementary schools today does not preclude the greater involvement of classroom teachers in arts education. One of the main reasons that the arts remain peripheral is that they exist outside the framework of what the elementary teacher is required to teach and is truly held accountable for. But most classroom teachers have enough good sense to know that children should have the arts. They will pitch in and give a hand, if they know how. But the truth is they are too rarely provided with the support they need. When they are backed up by arts specialists, classroom teachers can do some credible work in the arts. Given adequate background and assistance, classroom teachers can become expert at integrating the arts into the teaching of their regular subject matter.

A kindergarten teacher introduces her students to the art of tie-dying which combines art, nature study, and an introduction to chemistry.

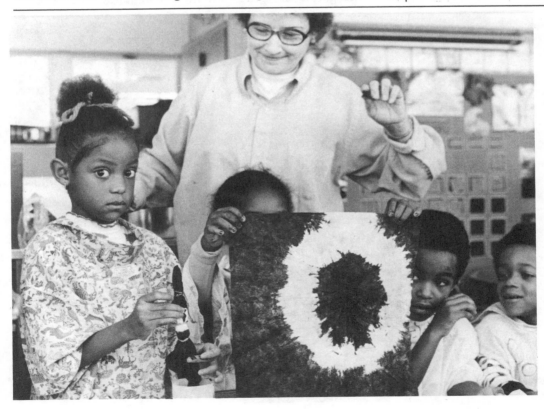

They can learn to use community arts resources effectively. They can enlarge and extend the ongoing arts program and make the work of the specialist far more significant. However, they are generally *not* effective in assuming full responsibility for an ongoing, sequential arts program with components in the several arts. For this reason, their role in the arts should be viewed as essential and collaborative, not self-sufficient, optional, or supplementary.

The idea of striving for greater substance in arts education has many implications for teacher education, both for the specialist and the classroom teacher. The greater the emphasis on substance, the less likely it is that classroom teachers can teach the arts curriculum. They simply do not have the background, nor does it appear that their education, whether inservice or preservice, will provide it. Along these lines, the Getty Center for Education in the Arts, no doubt as a test, has deliberately chosen to rely on the generalist to teach its new discipline-based art curriculum. This move has galled some art educators who believe that quality

Students in a high school drawing course benefit from the instruction of an arts specialist.

requires the involvement of arts specialists, certainly not the circumvention of their role. But classroom teachers in the Getty program are receiving considerable inservice education, as well as follow-up observation and consultation. It remains to be seen what they can do under somewhat ideal conditions.

One fact remains: in general, classroom teachers are ill-prepared to teach the arts. In Michigan, for example, less than half of the institutions that prepare classroom teachers require a methods course in any of the arts.[6] In Illinois, only one credit in the arts is required for certification as an elementary teacher. While states assign responsibility for the arts to classroom teachers, they too seldom account for their education in these areas. Then, too, few districts will provide the incentives and the expertise over the long haul that would be required to give generalists the necessary background in the arts through inservice education. In this regard, one of the panel's recommendations in the area of teacher preparation and inservice training was for "all prospective teachers [to] have experience in a variety of arts and learn to relate them to each other and to other disciplines" (CTOS, 251). Along similar lines, the Interlochen Symposium, "Towards a New Era in Arts Education," recommended that "every prospective classroom teacher have at least 12 semester hours of credit in methods and materials for teaching the arts."[7] Quite obviously, we still have a long way to go before we solve this one.

The Arts Specialist

If we acknowledge that many arts programs at the elementary level are inadequate, the solution would appear to be simple. The role of arts specialists at that level should be restored. But arts specialists do not have to return to do *all* the teaching. They can function in the various capacities of cultural coordinator, supervisor, demonstration teacher, curriculum developer and coordinator, and inservice educator—as well as arts teacher.

Some classroom teachers may be more capable of handling instruction in visual arts than in music. So be it. If excellence in the arts is the goal, the school system will have to supply expertise where it is needed. Depending on its size, the school district should have a fine arts department with sufficient numbers of specialists in music and visual arts to assure a sequential curriculum in those subjects and, in ad-

dition, at least one expert in creative writing, dance (perhaps through physical education), and theater to assure that every student is provided with experiences in those areas at some time during the elementary grades. The quality of a school system's arts program relates directly to the number and variety of arts specialists employed. There can be no quality without expertise.

Ideally, arts specialists are prepared in college to be expert teachers of a particular art form. In most states, they must meet degree requirements and certification standards to teach in a special subject area. Some states, such as Texas, administer exams as part of the qualification process.

The best arts educators are skilled both in their art and in education. In the past, many school systems relied exclusively on such professionals to deliver whatever arts instruction the system offered. But arts specialists today, particularly at the elementary level, are expected to do more than just teach. They are professionals who are often required to administer programs in the arts, develop curricula, serve as cultural coordinators between schools and community arts enterprises, work with classroom teachers in the arts, provide in-service education to classroom teachers in their art form, serve as advocates for the arts in their community, and, lest we forget, teach their art to students on one or more levels.

So, too, is more demanded in arts education management. Comprehensive arts education programs call for a new kind of leadership in the arts at the district level. Managers in arts education help to develop and facilitate comprehensive curricula so that students have substantive programs in all the arts. They integrate community cultural resources into the ongoing program at all levels. Some school administrators have already recognized this new role of cultural manager/coordinator, but others need to pay heed; and colleges and universities will need to make provisions for graduate programs in arts education management.

Artists

During the past two decades, the National Endowment for the Arts single-handedly has made the concept of artists in schools (visiting artists or artist residencies) a legitimate and acceptable delivery system for arts education in the nation's public schools. Before the NEA's involvement, the oc-

PHOTO BY MILLIE BURNS

casional field trip or school assembly program offered American youth only rare access to artists and artistic enterprises. There was little other choice but to provide arts instruction through arts specialists, assisted at the elementary level by classroom teachers. Now, the policy and the support of the NEA and the state arts agencies have made artists in schools commonplace. Whether such residency programs represent a complementary or a competitive system, a supplement or substitute for ongoing sequential arts education has been widely debated. By the NEA's own reckoning, exposure to the arts was never intended to constitute a total arts education curriculum. But some school systems without ongoing programs have been permitted to have residencies, and this has riled some arts educators who see the residencies as a subterfuge to circumvent and undermine school-based programs.

Whether educators like it or not, there are certain aspects of the arts that artists convey better than anyone. They can illuminate the creative process in their art form, dem-

Children at Public School 305 in Community School District 13 in Brooklyn create three-dimensional art with the help of visiting artist David Vereano, one of a number of artists who provide inner city children with arts experiences through a program called Arts Partners.

The pride of creation and completion glows through her first fiber sculpture.

onstrate the quality involved in professional production, and give students the real-life experience of the arts as they exist in society. Without artists, arts educators would be hard put to accomplish such objectives.

The big (and occasionally vehement) debate centers on whether the arts in the schools are better represented by artists who teach or by teachers who happen to specialize in an art. The Arts, Education and Americans panel said it this way:

> Teachers who work in the classroom and who have been trained as educators often believe that they alone know the best kinds of activities for instruction, especially for younger children. However, many artists feel the arts can be taught best by those who know the arts best—those who produce them (CTOS, 189).

Their conclusion: in the delivery of any arts education curriculum, expertise in both the art *and* teaching are prerequisite to excellence. It is not a case of either/or. No doubt the sole jurisdiction or responsibility for arts education in the public schools will never belong to artists, any more than the province of science education will belong to scientists or math education to mathematicians; their subject matter, not teaching, is their fundamental focus. Artists in education should function primarily as artists. In contrast, arts educators are certified full-time teachers. They may also be—and probably should be—artists-in-the-making, but they accept teaching as their career. Setting up, delivering, and maintaining a substantive and sequential curriculum in any of the arts is a full-time professional responsibility. Such a curriculum cannot be administered by part-time dabblers, however skilled and dedicated. Perhaps the real debate should center not on the mode of delivery, but on the question of what is delivered and to whom.

In any well-planned comprehensive arts curriculum, there are legitimate roles for arts education specialists, artists, and classroom teachers working as allies. None of these could do the job as well alone. In viewing the delivery of arts instruction today, then, the clear-cut progression from generalist to specialist is not supportable. Classroom teachers, arts specialists, and artists—all three—are needed at the elementary level. They should insist on each other for the sake of the students and the good of the arts. And school systems should mark the absence of any of them as a sign

of inadequacy. Indeed, in their recommendations, the panel said that within schools "classroom teachers [should] be supported by an arts resource team composed of artists and specialists in such fields as music, dance, drama, creative writing, visual arts, and the environmental arts" (CTOS, 252). They evidently were a bit ambivalent about the role of the generalist.

The mind, emotion—or both?

Given the current "mean and lean" bent of educational reform, should the arts give greater emphasis to their intellectual aspects? John Goodlad believes that, for the most part, classroom teachers believe that their job "is to develop minds and that this is best done through the academic subjects and an academic kind of teaching." Teachers "tend not to see manual activity as both intimately connected with the mind and an alternative mode of learning." For this reason, he says, "arts and crafts tend to become supplemental, a relaxed, undemanding relief from the reading, writing, and arithmetic that really count, but of little value in themselves."[8] There is evidence to show that the American public generally perceives the arts as being more of the hand than the mind. Unwittingly, perhaps, arts teachers have abetted this thinking by teaching the arts as almost totally a hands-on activity.

Creation Versus Appreciation

In the arts, there has been a long-running conflict between making art and appreciating it, with the vast majority of practitioners favoring the former. Music has largely been taught as performance; art, as creative expression. This ingrained national penchant for developing artistic skills ("doing" art) at the expense of attaining understanding ("learning about" art) may well account for the lack of status afforded the arts in public education. (At the same time, we

First we decided that we ought to teach self-expression in art. Then we decided that we had to make whatever we taught relevant to the kids, so we taught them popular culture. Then we decided that we didn't have time even to do that, because we had to teach the basics. That's where we are at the moment. Having decided that we can't do anything, we now throw in some entertainment experiences for the kids, and that's what we call the artist residency programs. On this last point, I think nearly everybody shares my opinion, except those who run the programs. They think they're wonderful.

SAMUEL LIPMAN, Publisher, *The New Criterion* and member, National Council on the Arts, "The High Road to High Culture," *Vantage Point*, No. 8, 1986, p.11.

should not assume that the lack of prestige afforded the arts is due necessarily or entirely to the way the arts have been taught; the overselling of science may have obliterated the public sensibility toward less pragmatic realms.)

Still, addressing this dichotomy between the manual and the mental, between emphasis on the mastery of technique and emphasis on the acquisition of knowledge, is critical to the future of educational reform in the arts. We can continue to head in the same direction or we can attempt to make some adjustments in our course in response to the educational reformers' call for greater substance and higher educational standards in general. To go on the same would appear to court disaster. Altering the way the arts are taught, while presenting some risks, offers the possibility of attaining a higher level of educational legitimacy. The arts are being nudged, and they stand at an exciting juncture between what they have been and what they might become. The stakes are very high.

On a visit to New York's Metropolitan Museum of Art, high school students sharpen their visual perception by striking poses that echo the work they are studying.

Making Arts Programs More Academic

The Getty Center for Education in the Arts set out in the 1980s to find out why arts education is accorded such low status in most of the nation's schools. In its preliminary review of art programs, the center identified the features that characterized art education content and practice:

> Chief among these is the traditional emphasis in visual arts education on fostering creative expression and developing artistic skills, such as drawing, painting and sculpting. This approach is evidenced in programs that stress hands-on production activities to the virtual exclusion of teaching children about the cultural and historical contributions of art or how to value, analyze, and interpret works of art.[9]

Their criticism of these programs:

> While recent reports on the quality of education cry out for courses with greater substance and rigor, and while traditional "academic" courses stress thought, reason, and ideas, art courses have sought traditionally to engage children's imaginations, feelings, and emotions.[10]

The Getty solution: to develop visual art programs that encompass art history, art criticism, and aesthetics, as well as art production—to make the curriculum "discipline-based."* The center has set out to make art programs more academic, to develop courses in art that "stress thought, reason, and ideas." In other words, the intent is to counter the public notion that the arts are mindless play and pleasure.

In music education, a similar condition persists. We know that some music teachers are completely satisfied if their band or chorus performs the music well. But other music educators are beginning to question whether technique should be an end in itself or whether some broader understanding of music should be the goal. According to educational philosopher Harry S. Broudy, the issue today is

*The term "discipline-based," originally used to denote a broader and more academic approach to education in art, is now being applied across the arts. For a more complete account of this concept, see W. Dwaine Greer, "Discipline-Based Art Education: Approaching Art as a Subject of Study," *Studies in Art Education*, Vol. 25, No. 4 (Summer, 1984), pp. 212-218.

"whether performance is an end in itself or whether it is ancillary to something else."[11] Are we asking enough when the dancer executes the steps correctly? Arts educators are beginning to say no. In Idaho, Maryland, New York, and other states where arts credits are being required for high school graduation, specifications for production courses in the arts are being broadened and deepened (students learn about theory, history, style, and criticism) and appreciation-type courses are being made available for nonperforming students.

Is the lack of academic credence the reason that the arts are not valued more highly in public education? Perhaps, but in extending arts education to encompass academic aspects, there are those who are cautioning us not to sell our souls in the name of academic respectability. The danger in this period of transition is that we will over-correct. Already, Thomas Ewens, professor of philosophy at the Rhode Island School of Design, has raised this issue in regard to the Getty program. He points out what he calls the "philosophic bias" that underlies the Getty reasoning. "Understanding, substance, rigor, thought, reason, ideas, and intellectual capacities are good," he says, while "engaging children's imagination, feelings, and emotions, if not bad, is at least woefully inadequate." This rhetoric about "rigor," he says, reveals the "old split between the intellect and emotions" which underlies the Getty philosophy, "a bias in favor of intellect which undergirds the principal reasons given in favor of discipline-based art education."[12] He further states:

> The attempt to lay the blame for the low priority accorded art education in our schools on the fact that it is oriented to art production is misguided. There may be a lot of things wrong with contemporary art education but the fact that it is primarily concerned with making art is not one of them.[13]

Still, a correction is now underway. The danger is that arts educators will misinterpret "discipline-based" and that, rather than enhance the traditional and refreshing emphasis on involvement with the arts, we will begin to sock students with a grueling menu of note-taking and memorization of facts that will obliterate such involvement. There are two streams here, the creative and the factual. Both are important, but it is the former that makes the arts unique. In the

act of creativity, students are forced to think through and to fashion their own solutions. As Elliot Eisner points out, in this mode students are not solicited for parrot responses or simplistic true-false, right-wrong answers that so often prevail in other subjects.[14] In the act of creation, there is no one blueprint, no uniformity of solution, no standardization of response. Students have to learn to rely upon their own inner resources.

Ideally, students should be able to make art and appreciate it, too, or perform music and acquire knowledge of it at the same time. We know that in the hands of better teachers, the arts can encompass academic aspects— considerations of style, history, culture, theory, and criticism that reveal the intent and the message of the work. And taken to the ultimate, such tending to thought, reason, and ideas, if rightly directed, will culminate in the engagement of children's imaginations, feelings, and emotions, those elements that have been sought traditionally. And that is as it should be. Let us not take the heart out of the arts. But let us not be satisfied with just goose bumps, either.

Becoming Too Academic

There is a great danger that the term "academic" will be misappropriated and misapplied. This is an imminent possibility at the high school level if arts teachers take the advice of The College Board's booklet, *Academic Preparation in the Arts*. This so-called "Red Book" pictures students in band and orchestra classes keeping project books that are "filled with reports, critiques, and musical analyses." And it goes on to promote the "relationship between a mastery of the arts and the development of the broad academic competencies that students will need in all college subjects—reading, writing, speaking and listening, mathematics, reasoning, studying, using computers, and observing."[15] We are told that "it is important to study the arts for their own sake; it is also important to recognize that they provide additional opportunities to enhance these basic skills."[16]

But The College Board's Arts Advisory Committee, in a preface directed "To Our Fellow Teachers of the Arts," says this:

> As arts teachers, we often occupy a special position with respect to our students. The art room, the auditorium, and the rehearsal studios are often regarded as "safe havens," places where school ends and enjoy-

ment begins. With some students, that enjoyment turns into an almost passionate commitment to working creatively. For other students, it may take a less constructive form—a time for relaxation and socializing.

And the committee goes on to say:

Another of our great challenges in teaching the arts is to convince all students that the arts demand *the same kind* of serious study that is required in their other subjects [emphasis added].[17]

The Red Book goes too far. True, all students should be convinced that the arts demand serious study, but not *the same kind* of serious study required in their other subjects. The danger here is that we will misinterpret "academic" to mean all those insufferable routines we had to endure in school, thus losing the one edge we have—that the arts are refreshingly different in the way they are taught and learned.

In John Goodlad's observations of arts classes, he noted that "students in junior and senior high music classes spent an inordinate amount of class time on rehearsals for performance at the upcoming football game or some other event."[18] He observed, too, that "the cultivation of manual skills frequently becomes an end in itself, not a means to some broader understandings."[19] But he also stated:

I am disappointed with the degree to which arts classes appear to be dominated by the ambience of English, mathematics and other academic subjects. Arts classes, too, appear to be governed by characteristics which are best described as "school"—following the rules, finding the one right answer, practicing the lower cognitive processes.[20]

If we can agree with Goodlad, conformity with other academic subjects is no ideal for the arts; neither is a concentration on performance and production. Still, we must recognize that the arts have their own academic aspects, that we can be academic and experiential at the same time, and that by no means do we give up one for the other. What we really seek, then, is balance.

What children desperately need is relief from the relentlessness of rule-governed algorithms. What they need is the space, the place, and most of all, the permission to follow the beat of their own drummer, to take risks and, at times, to fail. What children need is *lebensraum*—room for living. The arts must not become the lifeless, mechanistic, and dry academic study that has befallen so much of what we teach at all levels of education.

ELLIOT W. EISNER, Keynote Address, National Conference, *Discipline-Based Art Education: What Forms Will It Take?* (Los Angeles, California: The Getty Center for Education in the Arts, 1987), p. 9.

PHOTO BY WAYNE BRILL, INTERLOCHEN CENTER FOR THE ARTS

The Issue Ten Years Ago

How did the Arts, Education and Americans panel deal with this issue? Although the problem has intensified in the intervening years, they seized upon the issue early in the report. They said:

"Reason" is a word we are apt to put up in opposition to the senses, associating the former with the activity of the mind, the latter with the feelings and emotions. We might speculate, then, that the fact that our nation was born in an age of reason directed our national attention away from things of the spirit and the senses at a critical moment in our history. To some extent this is probably true. But insofar as the Enlightenment turned our eyes toward the past of Greece and Rome, it was bound to make us more appreciative of a need for balance between mind and spirit—that being the essence of the classical world (CTOS, 24-25).

The report quotes Lowell Mason, the pioneer of public school music, who spoke of the problem in 1836, two years

These talented high school theater students from the Interlochen Arts Academy are practicing their skills and expanding their repertoire with this Shakespearean play.

before he succeeded in getting vocal music introduced into Boston's public schools:

> Now, the defect of our present system, admirable as that system is, is this, that it aims to develop the intellectual part of man's nature solely when, for all the true purposes of life, it is of more importance, a hundredfold, to feel rightly than to think profoundly (CTOS, 32).

As the nation entered the twentieth century, the wealth and power that had been accumulated gave some hope that, in fulfilling the materialistic prophecy, the imbalance between matter and spirit might be righted (CTOS, 36). But as Americans grew more hospitable to the arts, they maintained their utilitarian view of education. The practical benefits of the arts—except, perhaps, as vocations—do not weigh heavily alongside the importance of mathematics, science, and social studies.

The panel definitely and directly recognized the dichotomy between appreciation and participation. They said:

> "Appreciation" is not enough. At its best, the entire mode of "appreciation" teaching is only an awakening of the sensibilities to a limited perception of beauty; at its worst, it is little more than the slavish dictation of taste. But "participation" is not enough either. At its best it involves the student directly in the creative process, and at its worst it is undisciplined indulgence in self-expression (CTOS, 130).

While this discussion pertains to the college level, the panel recommended "both participatory and appreciative involvement in the arts" (CTOS, 130). The panel recognized that "making a work of art is a powerful act of learning which should be available to all people" (CTOS, 249). They recommended that opportunities for creative work be made available "to all students at every level, not just to the very young, the talented, or the aspiring professional" (CTOS, 249). They obviously felt that not enough creative opportunities were being provided, particularly to general students at the secondary level.

Edmund B. Feldman, a panel witness, was quoted on this same subject. He said:

> There is no convincing evidence . . . that a school arts program devoted exclusively to studio performance

develops the sort of visual literacy, aesthetic under-
standing, and critical insight which ought to be the
goal of instruction aimed at the total school popula-
tion as opposed to the minority of pupils who will be-
come professional artists (CTOS, 141).

Feldman tied the problem directly to reaching the en-
tire student population not just the talented, and in place of
technical proficiency, he suggested the broader goal of vis-
ual literacy.

The panel recognized that arts programs should serve
two broad categories of individuals: "those who will take a
serious interest in the performing or creative aspects of the
arts, and those who will become audience members or ap-
preciators" (CTOS, 100). The first should know how to cre-
ate or perform and also acquire knowledge about the art.
The second may attain minimal competence in creating or
performing, "with understanding 'about' art the true goal."
In both cases, the panel suggested that the experiential and
academic aspects of the arts complement each other and
should coexist.

The Issue Today

By noting the "problem of 'coming to our senses' in a
world dominated by reason" (CTOS, 26), the panel recog-
nized the almost impenetrable dichotomy between emotion
and thought in public education. What is of particular in-
terest here is the reversal of logic represented by today's
rationale for arts education. Now, the thought is not so
much "coming to our senses" as it is "coming to our minds."
The rapid growth of research in cognitive psychology that
has established the relationship of the arts to language has
also established the arts as a function of the mind. We now
believe that the defect of the educational system is not that
it has developed solely the intellect (as Mason claimed), but
that it has ignored whole chunks of that intellect. We now
see that, if we developed the whole cognitive potential, the
arts would have a natural and substantial place in educa-
tion. Since feeling, like thought, issues from the mind, the
argument about feeling and thought resides in the quality
and extent of human cognition—whether the intuitive-crea-
tive-emotive potential of the mind will be given the same
status in education as the logical-mathematical-verbal as-
pects. We now promote the arts (and the senses) not as sep-

arate worlds, but as neglected components of the larger world of reason. That is a considerable and startling change, and it could prove to be an effective wedge in opening the higher-echelon doors of education. If American schooling is primarily concerned with teaching children the potential of the human mind, then the arts belong front and center along with the other great streams of thought and knowledge.

Learning Through the Arts

It is indicative of the changes of the past decade that a view of the arts as cognition did not exist in these terms at the time of *Coming to Our Senses*. As in so many other cases, however, the panel sensed the need for more than just artistic performance and production or appreciation and opted for a broader, disciplined approach:

> This Report, then, seeks to demonstrate that direct creative and re-creative experience—learning *in* the arts—is of unique educational value. It asserts that learning *about* the arts is learning about the rich world of sensation, emotion, and personal expression surrounding us each day. It claims that learning *through* the arts has the potential to enhance one's general motivation to learn and to develop one's respect for a disciplined approach to learning (CTOS, 8-9).

To learning *in* and *about* the arts, the panel added a third dimension: learning *through* the arts. This area, too, has been fraught with controversy. Some arts educators resist the arts being "used" to teach other disciplines. They believe that this negates the idea that the arts are worthy disciplines in their own right. They see the concept of infusing the arts into other subject matter teaching, of using them as vehicles for teaching, as a form of abuse.

The JDR 3rd Fund supported projects that developed this approach, but only in the context of a comprehensive program that included discrete arts curricula. Although it has been accused of it, this approach was never intended to be a substitute for direct teaching of the arts. It was developed to move the arts intensely into the everyday priorities of elementary education and make them truly important to

elementary teachers. If the arts could become the means by which teachers could successfully engage children in learning, then their place in the curriculum would be assured, and students would be learning about the arts at the same time. That was the theory.

Since the concept is still hotly debated, the idea of learning *through* the arts warrants some discussion. Some arts educators refuse to see the arts in any other context except as separate disciplines taught by specialists. To them—if not to certain school administrators, school board members, and Harvard professors—it is quite clear that the arts are disciplines worthy of study in their own right. Even most Harvard professors would acknowledge that the existence of the arts in education need not be justified solely on the basis of their capacity to convey and enliven other disciplines. At the same time that we recognize this, we must also admit that the arts can, quite legitimately, be vehicles for conveying certain other knowledge. The arts, after all, are not just about arts. Assuredly, the musical *A Chorus Line* is about musical theater, but it is also about people. Is

In Montgomery County, Maryland, third grade students use movement to "feel" the difference between national and manmade boundaries as part of a social studies unit on geography.

Potentially most controversial is [the Getty Center's] effort to identify with the current drive for academic rigor. While high academic standards in such areas as art history and criticism are essential, an excessively academic approach, particularly to young children's artistic activities, could repel rather than attract.... Requiring students to write essays about their artistic productions could hurt some for whom visual arts offer a nonverbal alternative to shine. The joy of doing art could be smothered by too much concern for grades and prescribed course work.

FRED HECHINGER, Education Editor, "Report Tries to Remedy Neglect of Art in School," *New York Times*, April 2, 1985, p. C6.

When integration is aimed at, the special features of a subject are often compromised in the process. On balance, I lean toward a stronger boundary strength for the arts in order to protect their special characteristics from being swamped by subjects often regarded as being more important.... Yet, I do recognize that any approach has its tradeoffs. I value integration, coherence, and unity. I would urge that connections between the arts and the other subjects be made when they can, as long as the values of art are not diminished in the process.

ELLIOT W. EISNER, Keynote Address, National Conference, *Discipline-Based Art Education: What Forms Will It Take?* (Los Angeles, California: The Getty Center for Education in the Arts, 1987), p. 15.

music only about music? Some historians and theorists have led us to believe that music is pure abstraction. *This is not so.*

That we learn about life from reading a good novel does not malign the purity of literature. The arts all convey knowledge beyond themselves. Even emotion can be viewed as a form of knowledge and understanding. In this sense, all music is programmatic. It is telling us something about ourselves, something about life, something about the people who created it, something about the culture from which it sprang. The arts are a natural adjunct to the study of history and peoples. Rather than corrupting their integrity, such a use of the arts realizes their intrinsic expressive qualities. In this view, then, to use the arts as vehicles for gaining important understandings about ourselves and the world, to recognize that the arts provide some of the best ways to enliven learning and make students responsive, is to realize their true educational potential and importance. Using the arts as an adjunct to history immediately takes them out of the category of mere enrichment and entertainment and puts them solidly in the academic corner. Oddly enough, it accomplishes exactly what the detractors of this approach advocate: it helps to establish these subjects as worthy studies in their own right.

At the same time as we acknowledge that there can be value in learning through the arts, we must recognize that such an approach, in itself, does not constitute a sufficient curriculum in the arts. Arts curricula must focus on study of the arts. To the extent that learning history or cultural understanding through the arts requires study of the arts, it is a worthy part of the comprehensive arts curriculum, even if such learning is embedded in the humanities. But in conjunction with such study, we must insist upon a curriculum that provides discrete study of the arts.

How much artist, how much teacher?

In 1977, the panel stated that any arts teacher "should be both an artist and a teacher; but this double role is sel-

dom recognized in existing teacher-training programs" (CTOS, 140). The implication was that such programs over-stress the educational aspects to the neglect of the artistic.

The panel was fully aware that classroom teachers "may have but a limited interest in the arts" and that many of them are inadequately prepared to teach the arts (CTOS, 140). They noted that "prospective classroom teachers in 30 percent of the nation's colleges may receive certification without having taken a single course in art or music, and yet they will be expected to teach these subjects" (CTOS, 140). Does this sound familiar?

The latest statistics on requirements in the arts for elementary classroom certification reveal that about one-half (26) of the states require specific hours or units in the arts.[21] Some, such as Idaho, Indiana, and Louisiana, require a three-hour course in art *or* music. In Wyoming the choice is among art, music, or drama. Hawaii requires four to seven credits in music, with drama and creative arts being optional. Other states, such as Arizona, Georgia, Maryland, New Jersey, Oregon, South Carolina, and South Dakota, have a general requirement in "arts." Most of the rest require a course in both art and music. Puerto Rico requires two credits in visual arts, two in drama, and two in music appreciation.

In addition to the states that require specific courses and credits in the arts, three require arts content in the teacher's background and 11 states (30 percent) require "competencies" in the arts. This latter group, almost 25 percent of the states, relies on teacher preparatory programs to confer certification based on unspecified course content and competencies in the arts.[22]

Certification

The panel made the highly controversial recommendation that "teacher certification standards be waived for all artists in residence and visiting artists participating in academic programs" (CTOS, 253). Of course, there had been tacit agreement in the states to permit artists to teach on a temporary basis without certification. The implication of this recommendation was that the standards applicable to the teaching profession should be deferred in the case of artists even if they chose to work full time. The reaction of the arts education field to this recommendation was one of shock. Why should artists be exempted from meeting the

The role of arts teachers should go beyond that of transmitting their discipline. Over and above the success of teachers in their own classrooms, arts specialists should be prepared to exert a powerful influence over the ambiance of the school. They should be forceful spokespersons for an approach to teaching and learning that transcends mere skill acquisition. Their teaching should be models for developing critical thinking and insightful evaluation cutting across fields. The schools are in desperate need of ways to vitalize and personalize themselves as institutions. The arts can provide the means. Classroom experiences for *all* in understanding the art product as having real meaning, of making a statement about life, of not only reflecting life's values but often forming them, can help to transform the otherwise drab existence of "school" into a lively, and often provocative, time.

JERROLD ROSS, "The Holmes Group: Implications for Arts Education," *Design for Arts in Education*, September/October 1987, p. 22.

requirements that qualify a person to teach if they were intent on functioning as teachers? The recommendation would have been more palatable if it had specified that such standards be waived for artists who are employed part-time. In their haste to instill the expertise of artists in America's classrooms, the panel tried to bypass the established system, and their judgmental error in this case won them a raspberry.

Forty-two states have standards for certification of arts educators covering K-12 levels in two or more arts subject areas. And 26 states require specific hours or units in the arts as part of the certification for elementary classroom teachers.[23] One can argue a good deal about these standards—whether they are adequate, high enough, applied properly, and so forth. The key here is that certification standards are usually met automatically if a college or university arts program is accredited and the students take the courses specified by the state, a system critics say is akin to letting the fox guard the chicken coop. In a few states, teacher exams have become a part of the certification process.

Latin teacher Kathy Porter gives one-on-one instruction to her students at Cold Spring Harbor High School, New York.

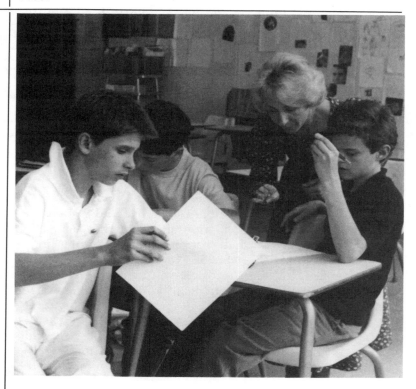

Recently, two groups have dealt directly with standards of teaching. In 1986, the Carnegie Forum on Education and the Economy established a National Board for Professional Teaching Standards, an independent body, similar to the specialized board in medicine, that would observe and test teachers and offer varying levels of credentials based upon their ability to perform in the classroom.[24] The system is designed to put pressure on schools of education to turn out graduates who can qualify for the new credentials. In a similar attempt to upgrade teacher education, the Holmes Group, consisting of about 100 major U.S. research universities, has proposed an undergraduate program of liberal arts followed by a two-year, master's-level program concentrating on education. The Group has urged a closer connection between the university and the school classroom and a stronger relation between content and methodology.[25] They are questioning exactly what the relationship between the liberal arts and teacher preparation should be.

A report issued in 1987 by National Endowment for the Humanities chairman Lynne V. Cheney and her advisory group notes that "finding ways to circumvent regular certification is a limited solution to the problem of attracting bright and knowledgeable teachers."[26] The report further states:

> The issue of certification must be faced head on, the group felt, if good teaching in the humanities, as well as other disciplines, is to thrive. As it is now, colleges of education and state education agencies are the strongest forces in determining who gets to teach in public schools. Horror stories growing out of this situation abound, and they almost always play on a single theme: that knowledgeable people with teaching skill cannot teach because they have not taken certain education courses—even when those courses are of no demonstrable use in making better teachers.

It surely is not *what* you know as a teacher that makes you successful, but you had better be well versed in your subject matter. And it is not simply knowing how to teach that gives you the command you need, although certainly you need to know how to motivate young people. It takes *both*: knowing your subject matter and having the means to transfer it.

Lee Shulman, professor of education at Stanford Uni-

It is clear that the "nuts and bolts" approach is not enough— managing a classroom, handling discipline, using the bulletin board, working with the principal. All those things are important, but at least as important is the ability to take the content they're teaching and find the examples, the analogies, the demonstrations, the metaphors and the comparisons that will bring alive what is otherwise dead material. That is something you cannot do without having a very deep and rich understanding of the subject, as well as an understanding of teaching methods.

LEE SHULMAN, Professor of Education, Stanford University, from "Building a Community of Shared Interests—A Wingspread Conference," June 21-23, 1987.

versity, says that there are two cardinal sins in teacher preparation: "The first sin is the sin of technique: the assumption that a good teacher can teach anything. The second is the sin of knowledge: the assumption that if you know quadratic equations really well you can teach them to anyone." Both assumptions, he said, are false.[27]

The artist who teaches cannot escape the need to master teaching technique any more than the arts teacher, whether classroom teacher or specialist, can escape the need to master understanding of the art form. In this aspect of arts education, there are no one-way streets. Certification standards, however enforced, should assure that both knowledge of subject matter and knowledge of teaching technique are sufficient. In each case, paper and pencil tests do not provide the complete answer, nor does the mere taking of certain courses assure such mastery. Student teaching or apprentice programs are a far better way to ascertain levels of proficiency through actual practice, and numbers of states are already involved in such programs. It is not unreasonable, then, to ask that *anyone* who teaches in public schools be subjected to the scrutiny of certification and that the requirements for certification maintain standards worthy of a profession.

The media—friends or foes?

At the time of *Coming to Our Senses*, one member of the panel said he had heard more than a decade ago "that the media and television were going to revolutionize education" (CTOS, 199). It had not happened then, and it has not happened yet. Could American children stand any more television, even if it were of the less passive type? Probably. The report contains this well-known and disturbing statistic: by the time the average child has graduated from high school, he will have spent some 11,000 hours in a classroom, but more than 15,000 hours in front of the TV (CTOS, 201).

When it comes to education, the media are suspect. Their association with entertainment has bruised their educational potential. Panelist Frank Stanton, former presi-

These children are engrossed in exploring the features of interactive cable.

dent of the Columbia Broadcasting System, had proclaimed the need for "mediacy," which he defined as media literacy—the ability to access contemporary modes of expression, communication, and information transfer (CTOS, 201). Only a decade later, the computer has emerged as another formidable medium of communication. Its association with the workplace has given it immediate status in the schools. This is not yet the case with television. Perhaps the way through for television will be in combination with the computer.

Where television is concerned, teachers maintain a high degree of skepticism. They have seen some of the negative effects of TV on young people—the pop culture values, the passivity, the need to be entertained, and the sheer inertia for doing anything constructive. As the panel noted, arts educators sometimes have built-in suspicions that the arts and technology, by their natures, must clash. Then, too, teachers have suffered in comparison with television in the students' minds, and teachers often feel, quite rightly, that they are competing with the tube. In this regard the panel said, "Schools must now compete with the media—television, films, radio, and records" (CTOS, 97). But they went on to observe that "since young people are constantly learning from the world around them, educators would be wise to make use of that world" (CTOS, 97). While the panel noted

that there were a number of programs nationwide that focus on the newer media, "most educational settings are still primarily print-oriented" (CTOS, 204). That is still very much the case a decade later.

The panel felt strongly enough about this area that it devoted a section of its recommendations to new technology and mass media, suggesting that educators "should recognize as art forms radio, video, film, and still photography" and treat them "both as resource and subject matter" (CTOS, 257). They recommended that teachers take "courses which examine mass communication technology" and that teachers make more use of video in teaching (CTOS, 258). And they suggested that "a national television arts program on the 'Sesame Street' model be produced by a major network." The latter is now being undertaken by the Getty Center for Education in the Arts and the National Endowment for the Arts.

The arts education field remains fundamentally paranoid about the media. A briefing paper for the arts education community, produced by eight of the major professional associations in the field,[28] refers to the significant dropout rate among the millions of children who start private lessons in the arts disciplines. While increasing economic pressures on the American family are given as part of the reason, the paper suggests that the "largest factors" may be pressures on students and parents from other more powerful elements of the American cultural matrix: television, movies, sports, and electronic games.[29] They see themselves in competition with these media, and perhaps they are. "At worst," they say, "arts education is declining as matters of serious art generally lose position in the overall American value system." This statement shows the paranoia. Is serious art generally losing position in the overall American value system, or is it gaining? Television has had an enormous impact upon the public's interest in dance, opera, orchestral music, and even, perhaps, theater. If, on the one hand, television can corrupt taste, on the other hand, it can elevate it.

Pop culture has an enormous pull on the young; indeed, it is created of, by, and for them, and every sales gimmick is used to win their allegiance. As Allan Bloom has observed, rock music speaks to all the urges of youth's emerging sexuality. What can public school music offer in comparison? We used to speak of "high" and "low" culture. Now we talk about "serious" art and "pop." In a democ-

racy, contending groups live together by a continuous process of accommodation and compromise. Yet serious art can only be maintained over the long term if certain masterworks are transmitted as the central body of culture from one generation to another. Such transmissions have been the basis for the perpetuation of culture in all societies. It makes good sense: we pass on our best.

The overwhelming presence and command of popular and commercial culture give the schools an even greater responsibility to convey the finest cultural achievements to new generations. This is the essence of arts education. If it is presented through an adequate curriculum, regarded with academic respect, and taught with expertise and vitality, arts education can provide credible and commanding cultural alternatives that will win just as much allegiance from the young. And in the process, students acquire knowledge, skill, and understanding that permit them to become part of and to take their place in the traditions of their society.

> There is a danger of art becoming confused with entertainment. Art can be entertaining, but that is not all that it is. It is important for all of us in the professional area of the arts to try to make this distinction as clearly as possible. The artist's role traditionally has been to lead us down the path, and to see things in a different way. If we learn something and get some sort of emotional or intellectual response from art, the art is successful. Decoration and entertainment have a much less important role in what art is about.
>
> **LINDA SHEARER**, Curator, Museum of Modern Art from *ARTSREVIEW*, Vol. 4, No. 3 (Spring 1987), p. 61.

Can we be excellent and democratic, too?

The panel faced this issue up front. They quoted that sharp-eyed critic Alexis de Tocqueville, who compared the French aristocracy with our fledgling young democracy:

> When none but the wealthy had watches, they were almost all very good ones; few are now made that are worth much, but everybody has one in his pocket. . . . The productions of artists [in a democracy] are more numerous, but the merit of each production is diminished (CTOS, 28).[30]

They then asked a question that haunts us still: In the arts, as elsewhere, how can we reconcile the demands for quality with the necessity for quantity? And they probed further:

> Is it wise to contend that a *little* art (*or* education, *or* arts education) provided for everyone who would

> The universal presence of the pop-music industry is inundating us all. It has a lot of money, and it's hard to fight. We have begun equating art with entertainment, and I think that's a dangerous road. Art has intellectual roots; entertainment is a sensuous, necessary experience. It's important not to lump it all into one pot.
>
> **JOSEPH W. POLISI**, President, The Juilliard School, from "Harmonizing the Vid Kids" by Heidi Waleson in *Keynote*, October 1987, p. 16.

have it is better for society than an in-depth experience for the few whose talent and brains can best profit from it and thereby most benefit their fellow men? "All the arts for every child," says The JDR 3rd Fund. . . . "Can we be equal and excellent too?" queries John W. Gardner. Tocqueville thought not. This was one of the most critical issues this Panel had to deal with 140 years later, for the intervening decades have not resolved it (CTOS, 28-29).

At the time of the report Kathryn Bloom, then director of the Arts in Education Program of The JDR 3rd Fund, claimed that of the approximately 14 million students in the 24,000 public high schools in the United States, not more than 20 percent elected even one course in music or art. That means that some 11 million high school students had no exposure whatsoever to the arts. She said, "The other 80 percent fail to experience the importance of the arts in their own education or their own lives" (CTOS, 116).

The analysis of course offerings and enrollments in the arts compiled by the National Center for Education Statistics, cited in chapter 1, presents a somewhat different picture. Among the nearly 3.3 million seniors who were attending school or who had graduated from high school in 1982, 69 percent had enrolled in at least one arts course between their freshman and their senior years.[31] The highest enrollments, as we might surmise, were in music and visual arts. About one in three students had enrolled in these programs at some point in their high school careers. These statistics are not as bad as they might have been, but they are certainly bad enough.

Almost one-third of the seniors in 1982, or more than one million students, had no arts whatsoever during their high school years. These statistics do not account for high school dropouts, which add another million students a year. This means that one half of high school-age students in the United States receive no education whatsoever in the arts. These statistics do not tell us, either, what one course some of these high school students took. If it was band or chorus or art 1, we have to ask exactly what knowledge and understanding about the arts they might have acquired. For many, this one-time exposure may have proved unsatisfactory and superficial. The panel claimed that "for every one of our teen-agers who is participating in 'arts experiences' one way or another, three are not" (CTOS, 117). This may be truer

than we want to believe today. In any case, the vast majority of students are clearly not emerging from high school with even a modest background in the arts.

There was considerable discussion of quality in *Coming to Our Senses*, just as there is concern about it in reports of more recent years. Francis Keppel, a former U.S. commissioner of education and member of the panel, pointed out the shift that had taken place in educational funding. Funding was no longer justified in terms of growth or quantity, but on the grounds of *quality* (CTOS, 214). Today, the pattern remains much the same, but the word is *excellence*. But can we be excellent and democratic, too? The arts education profession must decide, fundamentally, whether they intend to reach the many or go on being satisfied with the few. If they choose the few, then their programs will be geared toward the talented (much as many elective high school arts programs are today), and they will consign themselves to the ranks of vocational education. They will by their own choosing define the arts as outside the basics.

To be a basic subject is to be a necessity for all. If the arts are basic, they are essential studies of benefit to all students at every level of education. But where does the field itself stand on this issue? The recent briefing paper from the major arts education associations states that

> some members of the arts education community are trying too often to increase the number of committed individuals through mass marketing methods, not realizing that unless they are very sophisticated in their approaches, they can be working against their long-term objective of individual participation and commitment. Unless the arts education community recognizes that the mass and individualist approaches to cultural formation are fundamentally antithetical, that they tend to cancel each other out, and that they tend to produce perpetual status [*sic*, stasis] rather than real growth, its mass marketing methods can create as many problems as solutions.[32]

Does this mean that the field questions the attempt to reach more people on the basis that they will not be as committed to the arts as those who are already thoroughly involved? Is this an attempt to justify a talented elite? Is it not possible to treat the mass as individuals? By giving the art to all, we eliminate one of the worst problems we encounter—school administrators and classroom teachers

who had little or no arts background and who therefore see no need for it. If we make the arts a part of all students' lives every day, the suggestion is that the arts should go on being a part of their lives thereafter. Isn't that cultural formation?

It is highly doubtful that the above quoted high-flown banter represents the beliefs of the field. In 1987, an ad hoc group comprised of representatives of many of the same organizations published the following concise and straightforward statement: "The arts should be taught as disciplines to all students. This includes student involvement in creating, studying, and experiencing the arts."[33] This statement suggests a substantial program of arts for every student—quality in quantity. Believing in the best for all is still the ideal of a democratic education. That is why the study of works of artistic greatness cannot be condemned as elitist. This is not an undemocratic imposition of elitist stan-

The art of choral performance introduces these high school students to music of various ages and peoples, giving them historical perspective and cross-cultural understanding.

dards, but an invitation to embrace greatness. By such high visions are we sometimes elevated.

Magnet Schools

There is a trend to develop an arts high school in every city and a summer governor's school for the arts in every state. The number of magnet schools in the arts has grown from 80 such institutions in 1980 to an estimated 250 such elementary and high schools today, although the Network of Performing and Visual Arts Schools currently lists 121 member schools. These schools provide talented and gifted students in the arts with exemplary arts curricula taught by an exemplary arts faculty. Their in-depth vocational focus gives prospective artists the kind of background they need to succeed at further study and to become a professional.

While there is no doubt that such schools serve their students well, they sometimes pose a problem for other less talented students. By skimming the most artistically gifted students from all the schools in the system, they leave the rest of the students with few models of artistic excellence. Average students are the victims. These exclusionary schools also sometimes give boards of education an excuse for a depleted arts program in other schools. The system looks with pride upon what their most talented students accomplish and tends to forget what happens to the remainder of the students in the regular schools. Obviously, magnet schools were not developed to justify serving the few at the expense of the many, but if this becomes the pattern, they should be eliminated.

There is a lesson here for arts education. The arts do not exist in the curriculum of American schools for the sole purpose of creating artists and teachers of the arts. Many arts teachers spend an inordinate amount of their energies trying to clone themselves in the next generation. That is one of the major problems of the field. If the arts are basic, the corollary to that is that they must be for everyone. What is basic, by definition, must be for all. Accordingly, then, arts educators must come to the realization that students should not study the arts any more to become artists than they study math to become mathematicians. The field must make peace with its obligation to serve all students, the talented being but one small part of the whole.

Community resources—what role?

Schools can try to exist in isolation, taking on the full responsibility for educating the young, or they can acknowledge the role of other agencies—families, religious institutions, the media, museums, libraries, and so forth—in the educational process and welcome help where it can be provided. For children, the schools have never been the sole educational agency, though it is one they all share. Trips to museums, concert halls, and theaters, and lessons with practitioners of the arts provide another dimension of arts instruction. How far should schools go in incorporating such community resources in the school program?

Artist Residencies

We have already discussed the view of some school administrators that artists provide a less expensive, less time-consuming way to provide an arts program. In this view, artist residencies serve as an alternative to, rather than a component of, an ongoing arts program. But this conception of artist/teachers need not, and should not, prevail.

Panelist Thomas P. Bergin, who at the time of the report was chairman of the Arts Endowment's Artists-in-Schools Advisory Panel, presented the program in this perspective in 1974:

> At a time when the United States Office of Education has disbanded its arts and humanities program, when the National Institute of Education's attention seems elsewhere, and when many schools are dropping art and music teachers from their staffs as they slash their budgets, the Artists-in-Schools Program takes on an even greater significance (CTOS, 156).

It was his belief that this program could demonstrate to the public and to the education system "the great value and necessity of incorporating (not excluding) the arts into school curricula" (CTOS, 156).

Despite the great potential of such programs, the panel also heard the clearly voiced skepticism of critics like Elliot W. Eisner, professor of education and art at Stanford University, who asked such questions as: "Is this a fad or a significant educational breakthrough? Are the failures as well as successes carefully enough analyzed? Is elitism an inevitable corollary for a program that reaches such a small percentage of schools? Are the producers of art the best teachers of art?" (CTOS, 159). The panel faced the problem squarely:

> [Arts educators] who work with 500 students per week without adequate materials or equipment find their work compared unfavorably to that of the professional artist who has been assigned twenty children and given all the necessary supplies. No wonder, perhaps, that some artists sense teachers' lack of support (CTOS, 160).

As already noted, the controversy surrounding this notion among arts educators concerned whether schools were using such programs as a cheaper and less time-consuming alternative to an ongoing, sequential arts program manned by a staff of on-site specialists. At this juncture, with NEA's new educational regulations, it appears that the artists-in-schools program will soon take a back seat to other educational initiatives which support the mainline, on-site program.

Still, the artist has functioned as the main model for arts education programs across the country. Indeed, the "doing" of art was recognized by the panel as the fundamental approach to teaching:

The artist-in-schools program in Sioux Falls, South Dakota, gives teenagers the opportunity to explore visual arts in depth.

PHOTO COURTESY OF SOUTH DAKOTA ARTS COUNCIL

> In the visual arts, the emphasis is on performance: the active artist is the career model, with the model of art critic or art historian considered only within the context of "humanities courses." In music, performance is reserved for those already showing some talent and persistence, with training for critic and historian reserved for students who participate in "General Music" or a humanities seminar. In the areas of writing and dramatics, the emphasis is again on performance, while criticism receives more attention in literature classes (the content of which is rarely coordinated with creative writing or drama) (CTOS, 100).

There is evidence now that this emphasis is being adjusted. The concept of discipline-based art education encompasses the study of aesthetics, criticism, history, and production. For many years, better teachers in the field of music have incorporated theory, analysis, and the study of style and history into their performance classes. Today, as states adopt graduation requirements in the arts, courses tend to be broadened to balance skill development with acquisition of knowledge. This means that the historian, the critic, and the theorist are taking their places as models alongside the artist.

Expenditures for NEA's Artists-in-Schools Program (renamed the Artists in Education Program in 1980), begun in 1969, had grown to about $4 million in 1976. During the 1975-76 school year, more than 2,000 artists worked in 7,500 schools with nearly one million students in all 50 states and five special jurisdictions (CTOS, 222). Ten years later, during the 1985-86 school year, NEA's budget for artist residency grants was $4.4 million, and that money supported 7,120 artists in 9,790 schools—in actual dollars, a decrease in funding.

The panel went far in its support of using artists as teachers in public schools. They said: "Artists should be far more widely employed in all aspects of education." Why? Because "practicing artists can invigorate a student's interest and understanding of the arts and other disciplines as well as improve the student's technical skills." They recommended that NEA's Artists-in-Schools Program "should be enlarged and encouraged" (CTOS, 252). In fact, they went so far as to recommend that "artists be encouraged to join the teaching staff of schools, museums, community centers, and the public media" (CTOS, 253).

Cultural Institutions

The panel strongly supported cooperation between schools and the cultural resources outside. They said: "Few would dispute the benefits of a cooperative program that enables a school to schedule preparatory and follow-up activities which help integrate visits to museums, and other arts resources, into the curriculum." But the panel also noted the "gulf between schools and other institutions, a gulf that sometimes breeds suspicions," and they acknowledged that "to date, linkages are not forged with sufficient frequency" (CTOS, 192).

One problem is a difference of perspectives. The educational goals of a cultural organization may actually conflict with those of an in-school arts education program. Few boards of education, for example, will buy audience development as a legitimate goal for arts education, although they may accept it as a possible residual benefit. Since the development of federal-government support for the arts in the mid-sixties, many cultural organizations have intensified their efforts at audience development, but the reasoning has run counter to logic. The National Endowment was brought into being to subsidize certain valuable performing arts that had priced themselves out of reach of all but the rich. Because the intended low-income beneficiaries never took advantage of the opportunity, the real result was to subsidize the arts for the well-to-do. Then came the call to subsidize "audience development," and cultural organizations have been on that wavelength ever since. There is considerable distance between an education in the arts and the desire to fill empty seats, however worthwhile the arts experience might be. That distance must be traversed if cultural re-

With the help of Lincoln Center Institute teaching artist Miranda Hentoff, third grade students at the Denton Avenue School in Herricks, New York perform their own original musical compositions for their classmates.

sources are to work effectively with the schools.

The panel was firm in its conviction that, in the arts, "students should have school-sanctioned access to regional theaters, community orchestras, museums, dance companies, neighborhood arts centers, architectural offices, and individual artists of all kinds" (CTOS, 97). They said, "The schools and their neighboring arts resources must be intertwined" (CTOS, 11).

On this front, there has been considerable movement in the past decade, particularly in the cities where museums, performing arts centers, dance and theater companies, and other cultural resources are taking their responsibility for arts education more seriously. As arts education programs around the country have suffered cutbacks and curtailments, the professional arts community has begun to pitch in more earnestly in the educational process. Many opera companies, symphony orchestras, theater and dance companies, museums, and other arts institutions have education directors, sponsor educational programs, and regularly work with schools. Most schools welcome such efforts.

The panel recognized that "specialized performing and arts production equipment such as kilns, easels, dance floors, and print shops are usually too expensive for most schools, particularly for elementary schools" (CTOS, 194). They indicated that one possible source for such equipment might be community arts enterprises. They inferred that "cooperation between schools and non-school institutions may be a promising route for increasing the funds that are available for arts education, as well as providing new ways of learning" (CTOS, 195).

In a set of recommendations under the title "Sharing the Wealth," the panel set forth the mechanisms they thought were necessary to stimulate interaction between the schools and community arts resources. They recommended, for example, that "responsibility for coordinating the use of local arts resources in arts education be assumed by the state arts council in cooperation with local arts councils" (CTOS, 256). Today, state and local arts councils are taking more responsibility to provide such resources and to work with schools.[34]

They also recommended that "the appropriate arts agency in each area compile a roster of available artists capable of working in schools and make it available to school administrators and arts specialists" (CTOS, 257). This, too, is being done, but not always by the arts agency. Young

Audiences, state departments of education, and state Alliance for Arts Education committees have compiled such lists.

"Is the job of integrating the arts into education on a nationwide basis too big for the schools?" the panel asked (CTOS, 195). The answer now, like the answer then, appears to be yes. The schools need help. The National Ad Hoc Arts Education Working Group stated that "these resources must be identified, integrated, utilized, and expanded."[35] Such resources continue to hold the promise of enabling the schools to attain comprehensive arts education programs. Much has happened on the community cultural front in the past 10 years as far as schools are concerned. One reason is that such resources give the schools a way to make up for some of their inadequacies. But it also marks a recognition by the schools that the job of educating the young is too big to be handled well alone. Recognizing this fact, colleges and universities will want to teach prospective teachers how to make the best use of such resources.

By working together more effectively than ever, the arts, arts education, and education communities are demonstrating what can be accomplished through collaboration. To the degree that these forces interlock in one vast system, arts education will tend to prosper in a way it has never been able to in the past.

Evaluation—will it be done?

The panel spoke of the "growing concern for accountability." These statements might have been written yesterday:

> In recent years, the accountability movement—stemming from the taxpayers' demand for a fair return on their tax dollar—has distressed the teachers who are being held accountable for what is learned in the classroom. Arts educators have special problems with this approach. While they have sought to re-

spond to demands for accountability by painfully restructuring curricula to make results measurable, they find that their subject areas—dealing with such phenomena as feeling, aesthetic sensitivity, and musicality—are exceedingly difficult to measure (CTOS, 145).

Competency-based teacher education (CBTE) was then gaining momentum in the states. Today, the demands for evaluation in every area of public schooling have intensified, and arts educators are even more uneasy about how to make satisfactory applications to the arts. Several states have instituted teacher exams as part of the certification process.

A survey by the Council of Chief State School Officers (CCSSO) reveals that 55 percent of the responding states were concerned about the negative effects of increased standardized testing. The most negative trend cited for arts education was the "back to basics" movement with its penchant for testing:

> As this testing has come to be tied more securely to the identification and testing of discrete skills mastered at particular grade levels and through individual courses, the knowledge and accomplishments of an arts education have been slighted.[36]

Many states, caught up in the competency-based education movement, have become more and more involved in evaluation and assessment in the arts. Large-scale efforts to measure comprehensive achievement in the arts—such as the National Assessment of Educational Progress, which has been administered in art, creative writing, and music—have met with criticism from arts educators. Reform efforts in various states have resulted in newly revised arts curricula that give equal importance to the development of skills, the acquisition of knowledge, and the ability to judge and value, and these efforts are leading to the development of corresponding assessment programs. But, seemingly, there are no readily agreed-upon answers for evaluation in the arts. Even the chief state school officers recognize the special problems:

> Historically, there has been disagreement among arts educators regarding measurement of values, attitudes and aesthetic understanding that, contrary to most academic subjects, are central to a comprehensive arts education.[37]

（側注）PHOTO COURTESY OF CULTURAL COUNCIL OF SANTA CRUZ COUNTY

One of the consequences of an artistic orientation is a set of aesthetic goals. Such goals are rarely specific and are generally too amorphous to test, yet they are often preciously regarded by teachers of the arts. For example, a choral teacher might strive to teach aesthetic sensitivity in the way students approach the rise and fall of a musical phrase. To the teacher, this is a legitimate goal. But how can such sensitivity be evaluated?

Arts educators fear that the indigenous goals of arts education will be altered to favor lesser, but more specific and more readily testable goals—that the cognitive aspects of their subject will be emphasized at the expense of the affective. In this view, the whole process of evaluation begins to invade not only the process of teaching, but also the philosophical underpinnings of arts education itself. Some arts teachers resist the notion that the arts can or should be treated the same as science or mathematics. They insist that the arts are unique precisely because there are no "right" answers, and they believe that evaluation takes away that dimension.

The application of science to the arts is feared by artists and arts educators, who tend to trust feelings and in-

Through the Cultural Council of Santa Cruz' SPECTRA program, these children are learning the art of silk-screening.

THE PERENNIAL ISSUES **91**

tuition and to suspect logic and objectivity. But as concerns for educational standards become more pressing and schools begin to stress academic pursuits, arts proponents face more urgent demands to prove the educational credibility of the arts. Many who are familiar with evaluation believe that when the arts are tested as seriously as other subjects, they will be perceived as more important by parents, school administrators, and other educators. Many arts educators are beginning to understand that areas that seem impossible to evaluate do not excuse them from assessing the wide range of areas in which evaluation is possible. Skills, knowledge, and attitudes are measurable in the arts, just as they are in other subjects.

There are those who believe in the need for standardized testing in the arts, if only because it puts the arts on a par with other basic subjects and implies a well-organized, sequential curriculum. But arts educators are also very concerned about standardization. Widely applied standardized testing in the arts will have the effect of standardizing the curriculum in the various arts, a residual effect that is steadfastly resisted. As the panel study noted, the diversity of arts education curricula is one of its commendable characteristics:

> As we have noted, the great diversity of our culture and the tradition of local control over education are valuable parts of our national heritage. They virtually guarantee that there can be no single answer, no national model or program, that will apply to all schools in all districts (CTOS, 245).

However, it must be acknowledged that local control has not prevented districts from adopting a high degree of standardization in English, history, mathematics, and science.

The panel's other argument—the great diversity of our culture—may be more an excuse than a true reason to resist the adoption of more uniform standards. Shall we uphold a school district's right to teach mainly black arts, or Hispanic arts, or Asian arts, or European arts because of the particular ethnic demographics of the local population? E.D. Hirsch, Jr., says, "Our diversity has been represented by the motto on all our coins—E PLURIBUS UNUM, 'out of many one.' Our debate has been over whether to stress the *many* or the *one*." He further amplifies the argument for a balanced view of American culture:

If we *had* to make a choice between the *one* and the *many*, most Americans would choose the principle of unity, since we cannot function as a nation without it. Indeed, we have already fought a civil war over that question. Few of us accept the extreme and impractical idea that our unity can be a purely legal umbrella, which formally contains but does not integrate our diversity. On the other side, the specific content of our larger national culture is not and must not be detailed, unchanging, or coercive, because that would impinge on our equally fundamental principles of diversity, localism, and toleration. A balanced, moderate position is the only workable American position, and it is bound to be the one that will prevail.[38]

We must know ourselves as both the many *and* the one. So the argument against standardization based on the diversity of our culture is at best fragile.

According to the CCSSO survey, 10 states in 1985 employed statewide or standardized testing in the arts—Connecticut, Delaware, District of Columbia, Hawaii, Louisiana, Maryland (sic, they do not), Michigan, Minnesota, Pennsylvania, and South Carolina.[39] Such tests are generally limited to visual art and/or music and are administered at the traditional academic testing levels—grades 4, 8, and 11. The instruments are modeled on those used for the National Assessment of Educational Progress. The survey noted that "the increasing number of states actively pursuing statewide assessment programs indicates a definite trend toward standardized testing in the arts."[40]

The difficulty arts educators face with standardization is the need to know what to test in each art at every level. This means that there must be a dialogue between all the levels of education. It implies a sequential, perhaps national, curriculum, at least in the broad outlines. Evaluation thus necessitates a whole approach to curriculum planning and development. It is not simply a device that is tacked on at the end. And evaluation must leave room for spontaneity in the arts, or its effect will be to stifle and cramp arts instruction. The innate nature of the arts resists straitjackets.

The fact remains, however, that few states have established mandated, standardized curricula in the arts. Curricular programs not only vary considerably from state to state, but also from school district to school district, even from school to school. Evaluation practices in the arts differ just as widely, but arts educators, despite their seeming ret-

icence, probably do more evaluating than most other teachers. They simply do not yet have adequate mechanisms to make their evaluations public.

If standardized tests of educational progress in the arts appear to be problematic at present, so, too, are tests for evaluating teaching methodology and techniques in the arts. There are no available instruments. Again, standards would be difficult to establish. But the accountability of arts teachers is as valid an issue as it is for teachers of other subjects.

The problem of evaluation in the arts is not going to go away. Arts education suffers a lack of credibility when it cannot answer questions with facts. The field would profit from being able to measure learning and document the impact of teaching on students. Without such measurements, arts education's potential self-esteem is diminished and the general improvement of arts programs is impeded.

Evaluation is a tool. In the intensified race to claim the minds of American youth, it could serve as one means to make certain that the arts command an equable share. As a tool, evaluation can convince. More than mere rhetoric, it promises to provide the hard data needed to persuade the skeptics as to the value, role, and educational significance of the arts in American education. It is therefore a critical area that requires far more concentrated study and attention than it now receives.

Teachers often express to me their frustration about administrators and school boards failing to take the teaching of music seriously. They believe their programs are treated as an "activity" rather than a course where credit is given. And yet, I often find music being taught as though it were an activity. Teachers continue to demand little more out of music students than to ask that they come to class and behave. Even worse, students are graded on attendance and behavior rather than on any kind of proven achievement. What other academic class places such marginal demands upon students? How challenging and stimulating is this for the best students?

DONALD L. CORBETT, President, Music Educators National Conference, *Music Educators Journal*, Vol. 74, No. 1 (September 1987), p. 81.

Resolving the problems

If the educational potential of the arts is to be realized, the major dilemmas of arts education must be solved. These dilemmas, coupled with procrastination, uncertainty, and disagreements about how to handle them, paralyze action and forward movement. These basic issues pervade the whole operative structure of arts education, and they are often the root of the internecine battles that plague the field. Only through concentrated focus on these problems can the field come to terms with what it believes and what it must work toward in order to achieve resolution. These matters,

then, are crucial if the field is to achieve consensus about its goals and objectives and develop a more unified voice on both the national and local levels. In a word, they are the key to *progress*, and because of this, they should command all the attention and all the resources the field can marshal.

4

THE
CHANGING
PLAYERS

A profusion—some would say confusion—of forces are at work in the field of arts education. Leadership emanates from a diverse and sometimes bewildering array of agencies and individuals. Among the more obvious of these are the professional arts education associations* and the Education Program of the John F. Kennedy Center for the Performing Arts, which includes the national Alliance for Arts Education. Others are less obvious: organizations such as the American Association of Museums, American Symphony Orchestra League, American Institute of Architects, OPERA America, Smithsonian Institution, and Teachers & Writers Collaborative, to name a few. All of these national organizations maintain active educational programs. While there is stability within arts education, there is also flux, the latter being part of the dynamism that energizes the field. These sometimes transient and metamorphic forces are the focus of this chapter.

At the federal level

The year 1965 was significant for arts education. Two important pieces of federal legislation were passed. Both the Elementary and Secondary Education Act (ESEA) (CTOS, 219) and the National Endowment for the Arts were brought into being. It is estimated that during the first five years of ESEA, $267 million in arts-related projects were funded under Title I (disadvantaged children) and $80 million under Title III (innovative educational programs) (CTOS, 220). That same year, the Office of Education's Arts and Humanities Program grew in size and influence, primarily in its role of administering ESEA's Title IV funds for research and de-

*These include the National Art Education Association, the National Dance Association, the Music Educators National Conference, and the American Association of Theatre for Youth (successor to the American Theatre Association).

velopment in arts and education. This was a time when arts programs began to be seen in the larger perspective of "arts education" and "comprehensive arts."

During its first few years, the National Endowment for the Arts did not have an education program as such. Then, in 1969, the Artists-in-Schools program was begun. The significance of this program and the controversy surrounding it have already been discussed (see chapter 3, "Artist Residencies"). Perhaps more important than what it accomplished—or even what it may have failed to do—is the fact that this program initiated the endowment's involvement in arts education and nurtured a sense of educational responsibility at the endowment that would not otherwise have existed. In this sense, the NEA's Artists-in-Schools program opened the doors and paved the way for today's more broadly based educational program.

Changes at the Office of Education

In 1972, the National Institute of Education (NIE) was established and assumed the specific research-oriented mandate of the Arts and Humanities Program at OE. Then, in 1973, the first congressionally mandated program of support for arts education came in the form of the Arts in Education Program of the John F. Kennedy Center for the

PEANUTS / By Charles M. Schulz

Performing Arts and the Office of Education (CTOS, 47). The Alliance for Arts Education (AAE) implemented the program by organizing state AAE committees throughout the country (CTOS, 224).

During the last half of seventies, the arts still had a considerable base of support in the federal government. *Coming to Our Senses* tells us that

> out of the total NIE 1976 budget of $70 million, approximately $1.5 million supported arts education-related projects, such as CEMREL and Harvard's Project Zero, which were formerly funded by the Office of Education's Arts and Humanities Program (CTOS, 223).

With the endowment's Artists-in-Schools Program and the Kennedy Center's nationally mandated arts education program, there was federal action on several fronts. Still, the panel's observations of this activity on the federal level in 1977 were notably critical:

> The federal government is able today to exert significant influence through its funding requirements and decisions. However, it has not attempted to demand basic changes in existing arts education programs. Much of the power to shape those programs still rests with governmental agencies on the state and local levels (CTOS, 226).

There was concern for the lack of coordination in arts education at the federal level. Arts educators were betwixt and between, often being shunted back and forth between the Office of Education and the NEA. Then, too, educational issues often got lost in the huge bureaucracy of the massive Department of Health, Education, and Welfare, where OE was housed.

During the years immediately following the panel report, OE's newly constituted Arts in Education Program had modest funds to support projects in the arts that were comprehensive in scope and had a cooperative, community base. In the 1978 reauthorization bill for ESEA, Congress for the first time stipulated that "the arts should be an essential and vital component for every student's education." This bill also said that "the arts should provide students with useful insights to all other areas of learning," and that "a federal program is necessary to foster and to maintain the

interrelationship of arts and education."

As the bill stated, the intent of this reauthorization legislation was to initiate "a program of grants and contracts to encourage and assist state and local educational agencies and other public and private agencies, organizations, and institutions to establish and conduct programs in which the arts are an integral part of elementary and secondary school curricula."

Much has changed in the eighties. In 1979 the old Office of Education was extracted from the huge Department of Health, Education, and Welfare and given the status of a separate department. But even though education now had its own spotlight, the arts counted for little within it. The Reagan administration's singular focus on a military build-up of unprecedented size and cost threatened all federal domestic and social programs with massive cutbacks. President Reagan recommended that the Department of Education (DOE) be dissolved and that appropriations for the National Endowment for the Arts (NEA) be cut in half. The arts and education had to scramble for their lives.

If federal programs in arts education were found wanting in 1977, they were effectively eliminated four years later. The Education Consolidation Act of 1981 lumped together all categorical aid programs, including the arts-in-education grant monies and the various programs under ESEA, and recast these funds as block grants, with 20 percent going to the states and 80 percent to local school districts. The Reagan administration was determined to transfer as many decisions as possible from the federal to state and local levels. With that move, DOE's Arts in Education Program faded into the file cabinets. States and local school districts could put these newly designated discretionary funds into any educational programs they chose to, the arts among them. But, for the most part, the priorities lay elsewhere; the arts were largely ignored. A 1983 bipartisan congressional report reveals what happened:

> In reality, the federal mandate for arts education was dropped in 1981 when 29 separate programs were folded into a basic block grants program. States were given full discretion on how the funding should be reallocated. An investigator for the House Intergovernmental Relations Subcommittee of the Committee on Government Operations said they had discovered that educational block grant monies were now

PHOTO BY JOHN MCLAUGHLIN

Kindergarten students at the Roosevelt Elementary School, Allentown, Pennsylvania work on a social studies project using art skills which reinforce basic curriculum.

being spent primarily on purchasing computers and library books. The 29 separate programs, including the arts, were no longer considered a priority by state or local school districts, the investigator said.[1]

The report went on to say that "the federal government is assigning a lower priority to overall spending for education, in general, and the arts, in particular." The recession had left many states with alarming budget deficits. The new administration put its emphasis not on education and the arts, but elsewhere. The report further states:

Without the vital encouragement of the arts at the federal level, the arts in the schools have quickly disappeared as a necessary part of the educational process at the state and local levels. For many children, the schools constitute their only exposure to the arts since their families lack the financial, educational, intellectual and physical resources to provide such opportunities.[2]

While this statement clearly exaggerates the impor-

tance of the federal role, there is little question that by 1983 arts education was suffering a decline in importance due at least in part to the withdrawal of federal funding and support.

In this climate that same year, the new Department of Education, under the leadership of then-Secretary of Education Terrel H. Bell, published the report, *A Nation at Risk*. Given the prevailing priorities, it is not surprising that the arts counted for little in the scheme of education as outlined in the report. The low priority and low profile afforded the arts was federal educational policy. But this report, upon which the school reform movement of the eighties was built, accomplished something else of equal or greater significance. It silenced DOE's detractors and established the new department as a permanent cabinet-level agency in the federal structure.

Then, in a reshuffling within the DOE in 1985, the National Institute of Education (NIE) was dismembered and its work was assumed by an Office of Research, the National Center for Education Statistics, Programs for Improvement of Practice, and an Office of Information Services. Fiscal 1987 allocation for these four offices was $63.6 million, considerably less than NIE's 1976 budget of $70 million—which included $1.5 million in support for arts education—and none of it went to the arts.

Today, the arts at the Department of Education are but a faint memory. The mandated national arts education program administered by the John F. Kennedy Center for the Performing Arts continues to be funded through the DOE. While Bell's successor, Secretary of Education William J. Bennett, has had kind words for the arts, his verbal support has not been translated into new programs or funding, with one exception. In 1987, the Department of Education, in a joint venture with the National Endowment for the Arts, created a national Arts Education Research Center with two divisions, one headquartered at the University of Illinois and the other at New York University. The total funding for the first year was $807,000. This center, one of several established by the DOE in specific subject areas, will study what students learn in the arts, how they are taught, and how student learning is assessed for the purpose of achieving "more serious, sequential learning in the arts for all students."[3] Under the terms of the project, the NEA is expected to extend its leadership role in the area of education by overseeing operation of the center and assuring that the

center's research findings are widely disseminated, thus contributing to the knowledge base on teaching and learning in the arts.

The Educational Role of the NEA

During the past decade at the federal level, the momentum in arts education, if not the financial responsibility, has shifted from the educational sector to the National Endowment for the Arts. The Arts Education Research Center is one more manifestation of the educational metamorphosis of the NEA under the leadership of Frank Hodsoll. One of Hodsoll's first actions as chairman was to canvas leaders around the nation about the state of the arts. Their greatest concern was the deteriorating condition of arts education in America. The chairmen of state arts agencies in particular believed that the further erosion of arts education programs in public schools in the eighties (due, no doubt, to the public's back-to-basics fervor), on top of the curtailments suffered in the seventies, imperiled the development of future artists and audiences. Hodsoll took the message to heart and made education a major priority within the endowment. It is one of the ironies of the federal bureaucracy that in 1981, the same year that the Department of Education abandoned arts education, the National Endowment for the Arts began to lay vigorous claim to its cause.

In 1983, the bipartisan congressional report went out of its way to show that the NEA's responsibilities, as set forth in its legislative mandate, were at least in part educational. And this report recommended that the NEA's mandate in arts education "should be affirmed in national budgeting considerations by the Office of Management and Budget (OMB) so that [it] can be carried out."[4] This bipartisan advice fell on deaf ears at OMB, which was then juggling the greatest federal deficit in U.S. history. But even without additional funding, the NEA continued to warm up to arts education. During Hodsoll's tenure, there has rarely been a meeting of the National Council on the Arts, the NEA's advisory body, without significant discussion of arts education.

Out of these discussions, many of which involved representatives of the arts education associations as well as working professionals from all levels of the educational system, the Endowment staff became aware—in a way they had

never been before—of the enormous needs of the field. They came face-to-face with many criticisms leveled at them by arts educators. Some, like Laura H. Chapman, thought the endowment was part of a conspiracy to de-school arts education:

> Through the Arts Endowment and its various lobbies, the idea of placing artists in schools was elaborated into recommendations that artists not only be employed in schools, but also be engaged in curriculum design, teacher education, and other dimensions of policymaking for schools. In the movement to de-school arts education, one also finds suggestions that the arts education offered to youth might be planned and implemented by arts councils or other "independent" agencies. By the mid-1970s, almost all of these ideas had been charted through pilot programs and promoted through a number of channels.[5]

A more likely explanation of what had been happening in Washington was that the lack of priority accorded to school-based arts education programs at the Department of Education and at the NEA prior to the tenure of chairman Hodsoll simply reflected other priorities. The DOE was con-

Performing in a musical, dance, or theatrical ensemble teaches students responsibility and self-discipline at the same time that it gives them understanding of the importance of human artistic expression.

centrating on such matters as desegregation, bilingual education, declining test scores, and improvement in teaching the so-called "basics," while the endowment focused on promoting the cause of the arts and artists.

Whatever the case, the NEA was now ready to try to respond to the increasingly shrill calls for action to rescue and support arts education. The problem was how much of this responsibility the endowment could or should assume. Although he clearly supported the NEA's increased involvement, Hodsoll had reservations that he expressed forthrightly in his speeches to arts educators. He stated, for example, that one of the criteria for NEA's involvement in arts education was that "it must be justified in terms of our central mission of support for the arts, and for access to the best in the arts."[6] In this same speech, he declared that "the endowment's role [in arts education] must remain a modest and humble one." Why? Hodsoll reasoned that education is "essentially a local responsibility." Then, too, he said that "while the federal government obviously has a legitimate interest in the education of our students, the Arts Endowment is only a minute part of [that government] and somewhat remote from the local scene." In other words, in his view, there were other agencies of government that carry more responsibility for education than the endowment. To make that point absolutely clear and unequivocal, Hodsoll further said that "the endowment is not an education agency, and we are not educators."

Hodsoll's ambivalent attitude reflected the ambiguous language surrounding the subject of arts education contained in the original legislative mandate for the endowment. The "Declaration of Purpose" in the 1965 Act that established the National Foundation on the Arts and the Humanities stated that "democracy demands wisdom and vision in its citizens and that it must therefore foster and support a form of education designed to make people master of their technology and not its unthinking servant," and that "it is necessary and appropriate for the Federal Government to help create and sustain not only a climate encouraging freedom of thought, imagination, and inquiry, but also the material conditions facilitating the release of this creative talent"—these were fairly vague allusions to support for arts education that previous chairmen had found relatively easy to ignore. But Hodsoll, too, was cautious.

Something had to be done, lest the next chairman of the NEA interpret this vague legislative mandate and again

take little or no responsibility for arts education. During the endowment's 1985 reauthorization hearing, Senator Edward M. Kennedy posed the following question of Hodsoll:

> Your leadership is essential, especially since the Education Department has no extensive policy on art education. In the absence of such interest in art education, would you welcome new or additional authority at the Endowment to pursue new programs and assume this leadership role?

Hodsoll's reply: "The law, as presently written, provides ample opportunity and authority to advance the cause of arts education." But the fact remained that, depending upon their particular viewpoint and insight, future chairmen might not interpret the law as broadly as chairman Hodsoll, again leaving arts education in a state of abject neglect.* For this reason, the language in the reauthorization legislation was amended to make the NEA's responsibility for arts education an explicit mission. Congress added the following new statement to the NEA's declaration of purpose:

> that Americans should receive in school, background and preparation in the arts and humanities to enable them to recognize and appreciate the aesthetic dimensions of our lives, the diversity of excellence that comprises our cultural heritage, and artistic and scholarly expression.

According to this legislation, it is the purpose of the Endowment "to implement these findings." This new mandate not only assigns major responsibility for arts education to the NEA, it assures that the next chairman cannot interpret the endowment's mission otherwise.

That same year (1986), the NEA took its newly crafted mission to heart. At the behest of arts educators and in con-

*In a letter to Kathleen Kruse, one of Senator Kennedy's legislative assistants, dated July 29, 1985, the author wrote: "NEA's responsibility for arts education should be made unambiguous in the Act so that program commitment can be made thorough, consistent, and no longer dependent upon a particular Chairman's interpretation. It is to Chairman Hodsell's credit that his interest in arts education and his activation of efforts in this area have exposed the possibilities. But the vision of establishing a federal home base for arts education remains to be realized."

sultation with an ad hoc arts advisory committee, the endowment established new regulations governing its arts education program. Heretofore, the program funded two components—Artist Residency Grants and Special Projects. The former provided funds to state arts agencies to place practicing artists in educational settings; the latter provided grants to assist in the design, implementation, and/or dissemination of programs that have state, regional, or national implications for the field.

The NEA's new Arts in Education Program has three components and marks a significant turning point in the relationship of the NEA to the arts education enterprise. In addition to artist residencies, State Arts in Education Grants (formerly Artist Residency Grants) now make federal funds available for a wide range of activities and programming to help make the arts a part of basic education. Arts in Schools Basic Education Grants help states and communities ensure that all students graduating from high school possess basic knowledge of and skills in the arts. The category of Special Projects supports high-quality arts education projects of regional or national significance that advance progress toward the arts becoming a basic part of education in grades K through 12. Through these new initiatives, the endowment, which for the better part of two decades had deliberately stayed on the fringes of arts education, made a firm commitment to involve itself directly in curriculum-based arts instruction, including curriculum development, preservice and inservice teacher education, development of teaching materials, use of media in teaching, and development of evaluation and testing methods.

Then, too, at the behest of Congress, the endowment prepared a report in 1988 on the state of arts education in the United States and what the federal government can do to help. The study found that there is

> a major gap between commitment and resources for arts education *and* the actual practice of arts education in classrooms. Resources are being provided, but they are not being used to give opportunities for all, or even most, students to become culturally literate. . . . The vast majority of today's adults say they had no real education in the arts when they were in school. Then as now resources for arts education were used primarily to produce performances and exhibitions by talented and interested students for the enjoyment of parents and the community. They are

In a Young Audiences presentation in an elementary school in Bakersfield, California, professional trumpeter Charles Brady shows a member of the audience how to blow his first note.

PHOTO BY CHARLES FOWLER

not being used to help young people move toward civilization. This is a tragedy, for the individual and the nation.[7]

In order to alleviate the gap between the promises and the reality of arts education in schools, the report recommended steps that school districts and state education agencies should take to improve time allocations for the arts, curricular materials, evaluation, certification, research, and advocacy. The report proposed

> that 15 percent of the school week or year be allotted to the arts in elementary, middle and junior high and two full years be allotted in high school. This last may require a seven period school day.[8]

The report clearly, though cautiously, articulated a much more active leadership role for the endowment in arts education. It stated, for example, that the endowment will

> now seek, first, to change basic attitudes about the arts in education and, second, to provide information and models for the schools to use in moving forward with arts education as a basic and sequential part of the K-12 curriculum.[9]

Among the many positive actions suggested in the report is the appointment of an ongoing Advisory Board to counsel the endowment on such matters as the ways the recommendations might be achieved and how exemplary arts programs might be recognized and rewarded.

But, unfortunately, the report fails to sufficiently delineate distribution of responsibility for arts education between the Department of Education (DOE) and the NEA, a problem that has crippled arts education at the federal level for two decades. While the endowment suggests that the DOE involve itself with research and testing in the arts, responsibility for arts education between the two agencies remains almost as confusing as it did 10 years ago (CTOS, 243). Because of this failure in the federal bureaucracy, arts education still bears the status of second cousin. It remains to be seen whether the endowment and the DOE, working cooperatively, will assert the dimension of intensified leadership that is so desperately needed. The NEA's report, even though it had to be prodded by Congress, is a definite step in the right direction. Now, if the endowment is to address

The Endowment is prepared to help. Where can we help the most? We would like to see *some* schools move toward sequential arts education as a basic. *Some* school districts are interested. How can state associations of art educators help us identify those that are interested, in order to establish models of commitment, transition, and implementation? Let's bite the bullet somewhere so as to avoid the indigestion of trying to do everything everywhere. But let's bite it to show the way.

> FRANCIS S.M. HODSOLL, Chairman, National Endowment for the Arts, Address, Texas Music Educators Association, July 1985

Let me emphasize that the role of the Arts Endowment and state arts agencies in all of this must be distinctly limited. We are not education agencies. If serious and sequential arts education is to become rooted in basic American education, it will have to be accomplished in school districts.

> FRANCIS S.M. HODSOLL, Chairman, National Endowment for the Arts, Keynote Address, National Conference, *Discipline-Based Art Education: What Forms Will It Take?*, Los Angeles, California: The Getty Center for Education in the Arts, January 1987, p. 107.

the difficulties of arts education effectively, the Congress will have to back its initiatives with additional funding.

Changes at the state and local levels

In 1987, state arts agencies, with the impetus of the NEA, began to launch broader-based initiatives in arts education. Instead of concentrating solely upon artist residencies, state arts agencies are becoming involved in curriculum-based arts education. While the monetary support levels for efforts in arts education remain relatively constant, if too modest, the fact that they can now be used across the field stimulates increased activity and a considerable amount of new incentive.

Under the new NEA grant provisions, 16 states received Arts in Schools Basic Education Grants in 1987 to support joint planning between state arts and state education agencies for the specified purpose of making the arts basic. The fact that 42 states applied for these grants shows the interest that has been stirred. Some of these states will proceed on their own using state monies; others will reapply.

The National Assembly of State Arts Agencies (NASAA) is encouraging the state arts agencies (SAA's) and state educational agencies (SEA's) to enter into cooperative efforts to improve arts education.[10] The opportunities for mutually beneficial joint undertakings are extensive. Indeed, it may be safe to conjecture that this country will achieve no major new level of excellence in arts education until the expertise of the arts and education communities, working together, can be brought to forceful focus on the field.

Developments in the state education agencies are also promising. Today, 41 have at least one representative for the arts on their staff. During the past five years, 28 state legislatures have established requirements in the arts for high school graduation. (California and Idaho already had arts requirements.) The effect of these have been both dramatic and traumatic. While on the one hand they have re-

sulted in new general courses in the arts, on the other, the extent of other course requirements imposes severe limitations on electives in the arts. Given the educational impetus of the state arts agencies, state education agencies may be encouraged to assert stronger leadership on behalf of arts education. State level guidance can be an effective mechanism for initiating change in local school systems, but the processes by which decisions are made need to be better understood, and the arts need to be included among the constituencies involved.

Projects come, projects go

It is fascinating, somewhat nostalgic, and a bit disconcerting to see the number of pages in the 1977 report devoted to special programs and projects in the arts. There was IMPACT (Interdisciplinary Model Program in the Arts for Children and Teachers), the Aesthetic Education Program of CEMREL (Central Midwestern Regional Education Laboratory), the art program developed by SWRL (the Southwestern Regional Laboratory), and the Arts in Education Program of the JDR 3rd Fund. All are gone. Of the larger projects mentioned in the report, only Project Zero at Harvard survives.

And there were many local programs: an Arts Events Program in Mineola, New York; the ASPIRE program in Burlington, Vermont; Children's Art Carnival at the Museum of Modern Art and the Open City Project in New York City; the Opening Doors Program in Oklahoma City, a unified arts program in Central Valley, New York called PAM—Practical Arts, Art and Music; neighborhood arts programs in Akron and San Francisco; Reading-Through-the Arts in Irvington, New Jersey; New York State's pilot project SEARCH (Search for Education through the Arts, Related Content and the Humanities); and Urban Arts in Minneapolis, to name a few. Again, many of these projects no longer exist.

While not as plentiful, new projects continue to materialize. One example is Arts Partners in New York City, an

PHOTO BY JACQUELINE MUDGE

As part of Minnesota's Comprehensive Arts Planning Program (CAPP), composer Mary Ellen Childs instructs fourth grade children at the Alice Smith School in Hopkins, Minnesota on how to create their own musical tones.

inter-agency program funded by NYC's Board of Education, Department of Cultural Affairs, and Youth Bureau that since 1985 has grown to serve a modest 23,000 of the 936,000 students in the nation's largest school system. In 1987, this program incorporated the efforts of 139 visual, performing, literary, and media artists from 19 arts agencies to work in upwards of 178 schools in the five boroughs—a promising mist in a cultural desert.

Another example of a relatively new program in arts education is Minnesota's Comprehensive Arts Planning Program (CAPP), an effort jointly administered by the Minnesota Department of Education, the Minnesota Alliance for the Arts in Education, and the Minnesota State Arts Board. CAPP works with selected school districts to establish sequential K-12 curricula in all arts disciplines. In 1983, 30 Minnesota school districts were selected to participate. Each district received seed money and intensive training and assistance over the course of two years. The first year of activity focused on planning; the second, on implementation.

These sites have now become models to help other schools become involved.

As a result of an extensive lobbying effort by the Minnesota Alliance for the Arts in Education, the Minnesota State Legislature appropriated $125,000 to initiate the program. Due to the success of the first two-year effort, $200,000 was appropriated in 1985 to extend CAPP to 30 new districts. This appropriation was part of a larger funding package that allocated $4.9 million for arts education in the state. The program has continued to expand ever since, with participating districts serving as resources for other districts that want to establish comprehensive arts education programs. The New York State Legislature has also established a statewide arts in education program with special funding, but in general such statewide programs are rare.

Some of the local programs of 10 years ago have prospered. Chicago's Urban Gateways: The Center for Arts in Education, founded in 1961 (CTOS, 185-186), has now grown to perform and teach the literary and performing arts to upwards of one million students, teachers, and parents in Chicago and the surrounding counties each year. With an annual budget of nearly $2.5 million, more than half of which is earned, Urban Gateways has a special commitment to the development of interdisciplinary and multicultural arts programming. Its Principals' Coalition for the Arts serves as an effective advocacy group within city and suburban schools, and its new Center for Curriculum Planning and Development, established in 1987, serves as a ready resource to schools in the Chicago area.

Ten years ago, Performing Tree, a service organization in Los Angeles (CTOS, 153-154), provided multicultural experiences in the performing arts to upwards of 200 elementary schools throughout southern California, operating on an annual budget of about $100,000. During the 1987-88 school year, Performing Tree served nearly 600 schools with a yearly operating budget of $968,000, a remarkable show of growth. About 45 percent of its income comes from the private sector, a clear example of how such agencies serve as an important bridge between arts education and the business community. Without the existence of Urban Gateways, Performing Tree, and other similar organizations, arts education would not have the benefit of these funds or this degree of corporate support.

Some national programs have prospered during the past decade, too. Young Audiences, Inc., formed in Balti-

more in 1951, has grown into a nationwide network of 40 chapters that provide over 4 million children yearly with in-school programs of dance, music, and theater by professional artists.

Ten years ago, there were dozens of experimental interdisciplinary and multi-arts programs, alternative programs, and model programs. At the time of the report, there was much ferment and invention in the field. The panel made note of the proliferation of these efforts and their value:

> Fortunately, during the few years that the nation's schools have been investigating and experimenting with arts education, a good deal of practical wisdom has been accumulated. As a result, we have access now to a storehouse of facts and figures, as well as subjective evaluations, which are extremely helpful (CTOS, 243).

It appears that much of the collected wisdom is hidden away in file cabinets and has not been made available to the

Students from the Westwood Elementary School in Los Angeles learn dramatic improvisation through a Performing Tree theater program.

field in any systematic way. (The panel study benefited from a group of researchers who rooted this information out.) Therefore, much of the possible residual benefit of these projects to the field as a whole has been largely lost.

From time to time, the arts education field has published information about model programs and held conferences that showcased them.[11] But rather than inspiring others to move in similar directions, pilot or model programs sometimes intimidate the field. Where they have been used successfully to initiate change—CAPP is a good example—the pilot project is usually just one part of an elaborate strategy. To their credit, the panel recognized that pilot projects are not the whole answer: "Beware of the project mentality," Jerome Hausman warned (CTOS, 214). They recognized that experimental pilot projects and model programs were a legitimate approach to altering education, but they also saw that this process of change was a long and difficult one (CTOS, 214-17).

The panel tended to look to the government to initiate change. That mentality has changed considerably in recent years as the federal government increasingly has turned responsibility over to the states. While some incentives can come from outside the school, scholars on the subject of educational change point out that the majority of factors that induce change are internal to the school or school district.[12] In any case, the federal government continues to stimulate and seed educational change with reports and grant programs, however modest. NEA's report on the state of arts education says that

> federal or national entities, such as the U.S. Department of Education and national education membership organizations, have less influence on schools than state level authorities and membership organizations, and these in turn are less influential than local schools and school boards.[13]

But certain problems—welfare, desegregation, and unemployment are prime examples—are more effectively solved when the initiative is taken at the federal level. It may well be that federal educational policies have been contributing to the perception that the arts are not important school subjects, for the simple reason that they have spotlighted some subjects in the school curriculum but not the arts. Arts education is too important a national issue to be left entirely to the whims of state and local decision makers.

The need for additional funding

Within the world of foundations, the arts no longer have the priority they once commanded. The Ford and Rockefeller Foundations, once mainstays of support, no longer provide major funding for the arts. The Rockefeller Brothers Fund, after administering a modest program of awards to outstanding arts programs in public schools, is also moving away from arts education. As the federal government has withdrawn support for social programs, people have turned to foundations and corporations to fill the gap. Richard Mittenthal, former program officer for the arts and now vice president of programs for the New York Community Trust sums up the reasoning in the private sector: "It's pretty hard to justify crayons while we're dumping illiterates [into the society]." As America gets poorer, the arts may be in for a very difficult time. But then again, when times get bad, people often realize that their souls need as much refurbishing as the rest of their lives. The arts that flourished through the Works Progress Administration (WPA) during the Great Depression are a fitting example.

Certain principles remain constant over time. *Coming to Our Senses* reasoned that in the educational change process, for example, significant new ideas are probably still far more important than more money (CTOS, 216). The attitude of the field is that it is probably not going to command a lot more money. Terry Baker, associate dean of the School of Education at Hofstra University, points out the "scavenger mentality" of many arts educators. If there is to be a new day for arts education in the United States, the field must no longer be satisfied with minimal funding and scrambling for leftover crumbs. If new initiatives are to be taken, appropriate and adequate funding must be provided, just as it is for other major areas of the curriculum. Project funds and seed monies will not alone suffice. Curriculum development and teacher retraining are extremely costly enterprises. Extensive new funds will be required.

Unfortunately, the expanding educational activity at the NEA has not been matched by an expanding budget. The appropriation for fiscal 1987 for the Arts in Education por-

These youngsters find their first experience with the art of dance absolutely awe-inspiring, one of the reasons the arts hold such potential for education

tion of the NEA's budget was $5.3 million, about what it has been for the past several years. Funding for the Arts and Education program of the Department of Education, which is transferred directly to the Kennedy Center's Education program and includes the AAE and Very Special Arts, was increased from $3.1 million to $3.3 million. But overall, federal funding support for arts education is down considerably from what it was a decade ago.

In contrast, the National Science Foundation announced in January 1987 a $50 million program to expand and upgrade science education for elementary school children over the next four years.* No less of a major drive on behalf of arts education is a national necessity. Unlike the NEA and its heretofore diffident involvement with arts education, the NSF takes federal responsibility for science education along with its funding of scientists and the profession of science.

Significant new funding may eventually come from the NEA, depending upon how the new mandate for assuming greater responsibility for arts education is interpreted. The NEA's state of the arts report is disappointing in this respect. In its recommendations for a general policy governing the endowment's expanding involvement in arts education, the report concluded that while it is not an education agency, the Endowment should pursue current initiatives and, to some degree, operate in the arts education area as do the National Endowment for the Humanities and the National Science Foundation in humanities and science education. Such a role would not necessarily require substantial additional funds for the Arts in Education Program.[14]

Yet, three paragraphs earlier, the report also stated that "resources for arts education, both staff and money, need to be enhanced and continued over a period of at least ten years."[15] Which is it, more funds or not?

The distinctive impression here is one of hedging and foot-dragging. If the endowment is intent on following the model of the National Science Foundation—a hopeful sign— increased funding for education will be imperative. In 1987 the NSF's budget for precollege education was $60.6 million. The NEA's funding for arts education is less than 9

*For an in-depth discussion of the treatment of education at the National Science Foundation as compared to the National Endowment for the Arts, see the author's "Arts Education—A New Role for the NEA?" *Musical America*, July 1984, p. 9, and the Letters column in the August and September issues.

percent of that amount. In addition, the NSF spends considerable monies on higher education. During its 35 years of existence, the NSF has spent $2.5 billion on education, some 12.5 percent of its total appropriations. Robert Watson, deputy director of the NSF's Division of Precollege Science and Mathematics Education, says pointedly, "We support education in everything we do." A huge sign in his office reads, "Tomorrow's scientists are in today's schools."

In contrast, the endowment, in its own words, "has traditionally focused on professional arts creation, production, presentation, exhibition and preservation, rather than education."[16] Significantly and unfortunately, the endowment's report on arts education did not place a price tag on its recommendations. Will the U.S. Office of Management and Budget (OMB) permit chairman Hodsoll to request increased funding for arts education? Hodsoll's political savvy will be put to its ultimate test on this issue. Indeed, the NEA has moved, but many would say the support is still too tenuous. It is like throwing a peanut to a ravished army. And where, oh where, is the Department of Education?

The NEA's responsibility to the arts is no less nor greater than the NSF's responsibility to science. How can the NEA assure that the arts, our artists, and our cultural institutions flourish without giving concomitant attention to education? The schools can and should provide the infrastructure that locates new artistic talent, launches it, and develops sufficient general interest in and understanding of the arts to assure the necessary broad base of support. If the NEA is intent on following the NSF model, it will take aggressive action to solve the problems that thwart excellence in arts education in the United States today, and it will find the funds necessary to achieve those ends.

New players

There are some newly committed agencies in arts education. The American Council for the Arts (ACA), which for many years has taken a modest interest in arts education, has now hired a full-time director of arts education. The

organization is holding research seminars and other conferences on the subject of arts education, including the co-sponsorship, with the Music Educators National Conference, of the Ad Hoc National Arts Education Working Group.

The Getty Center for Education in the Arts, formed in 1982, is an arm of the $2 billion J. Paul Getty Trust. One of the center's main activities has been the development of discipline-based art programs in the schools, but as the name implies, the center intends to embrace programs in all the arts. Well-funded and well-connected, the Getty Center wields the power and the prestige to create major changes in arts education throughout the nation. Its commitment to a broadened conception of curricula in the arts, embracing creation and performance, analysis and evaluation, and historical and cultural understandings, is having a persuasive effect on the entire field of the arts, whether one subscribes to the specific outlines of the discipline-based model or not.

The National Endowment for the Arts and the state arts agencies must also be listed as new players in arts education. Whereas they once limited their support and their interest to bringing the cultural resources that reside outside the schools in touch with the curriculum inside, they now have committed themselves to support curriculum-based arts education as well. This is a significant development for arts education.

Any discussion of new entities in arts education must recognize the American Association of Theatre for Youth (AATY) which has arisen from the smoldering embers of the American Theatre Association (ATA). The demise of the ATA in 1986 on the eve of its fiftieth anniversary was one of the sadder chapters in the arts in recent years, especially for arts education. Here is a prime example of the shortsightedness of a group of theater educators and practitioners so headstrong that they were willing to sacrifice their national organization rather than alter their own narrow purposes. For many years, the internal wars waged in this organization reached such an abysmally low level of nasty and disgraceful excess that they provide a gross model of how quickly some arts people can turn their backs on the humanizing influence of their own art. AATY and other organizations that arise to take ATA's place have the burden of leading this field back to the first order of business, the larger issues of the field—the fact, for example, that far too few students in American schools have the opportunity to study this life-revealing art.

Filling the leadership vacuum

Assuredly, the arts will not attain any new level of significance in American schools until all the forces of the arts and education begin to work concertedly toward such ends. There is evidence that the arts and the arts education communities are more willing than ever to join efforts to forge new inroads to the educational sector. Such efforts must be coordinated and concentrated if they are to be effective. This requires a new awareness of the importance of leadership on every level.

Heretofore, the countless projects launched on behalf of arts education were seldom guided by nationally agreed upon aims for arts education. Each local project did largely what it wanted, based upon local notions and local needs. The results, consequently, were haphazard, making little if any impact on arts education as a whole. The need to establish broad national educational goals and priorities for the arts is beginning to be addressed by the endowment, the professional arts education associations, and by the Ad Hoc National Arts Education Working Group mentioned earlier. That is an assertion of new leadership, long overdue.

To effect educational change favorable to the arts, it will become increasingly necessary to persuade school administrators that the arts have substantial educational merit. Like their classroom colleagues, most administrators have little knowledge of the arts and scant academic experience in any of the artistic areas. For the most part, principals and superintendents of schools are cut out of the same cloth as classroom teachers. They have the same general background and the same undergraduate education. Indeed, many school administrators started as classroom teachers. Considering their general lack of schooling in the arts, it is not surprising that they sometimes do not bring their influence to support the development of vibrant and comprehensive arts curricula at every grade level. For too many of these school chiefs, the arts are low man on the educational totem pole.

The leadership of school administrators is crucial if efforts to revitalize arts education are to be successful. Ob-

viously, minimal background in the arts should be required of anyone considered qualified to serve as an educational administrator. That is generally not the case today. For those already serving, the nearly 100 Principals Centers now established throughout the United States could help to provide such arts background where it is lacking. It is these centers that are helping to write the next chapter in the history of American education, the one titled "Reform." And these centers, knowingly or not, may also be writing the future of American culture. Will they neglect the arts or give them the special attention they need?

If nothing more, this book is a call to leadership from those most directly committed to arts education. Back in 1977, the panel had something to say about that, too:

> There is considerable evidence to suggest a serious leadership gap in arts education and a failure to deliver good programs even to the willing learner (CTOS, 253).

They spoke out for a new style of arts education leader "who can inspire, encourage, and educate—persons who are not only committed to the arts in education, but skilled in developing and mobilizing the talents of others . . . " (CTOS, 253). In one of their most important recommendations, they called for the creation of a national task force "to assess current arts education leadership and to recommend ways to infuse the field with the necessary leadership skills, including management, political action, and human relations" (CTOS, 253). That is an idea still worthy of implementation.

To make arts education an educational priority and a part of general education reform in the United States requires leadership from individuals and organizations in each of the four sectors [of arts education—governance, education, arts, and business]. To do this, they must (1) have a consensus on the nature of arts education and how it can be accomplished, (2) understand the factors that will lead to change, and (3) work together to effect that change. Individuals and organizations within each of the four sectors must transcend their special interests and work together if arts education is to become a basic and sequential part of the curriculum.

Chapter 1, "Overview," *Toward Civilization: A Report on Arts Education* (Washington, D.C.: National Endowment for the Arts, 1988).

New realities

The major manifestation of the arts education field must be met head-on: how the multiple forces operating in the field can be coordinated for maximum impact. No other field has so extensively incorporated the concept of partnerships. Now the field needs to decide how these various organizations can best interact, what kind of influence they can bring to bear, and what individual responsibilities they might most effectively shoulder. The stakes are clear:

CENTER">PHOTO COURTESY OF ARKANSAS ARTS CENTER

These children are expanding their experiences with dance through an artist-in-residence program organized by the Arkansas Arts Center.

whether the arts in America will be able to extend their present educational and cultural reach.

At the time of *Coming to Our Senses*, America seemed to be going through a renaissance in the arts. The report quotes an editorial in *The New York Times*: "The cultural bubble of the 1960s has never really burst; contrary to rumor and recession, the arts are flourishing in America" (CTOS, 241). For years, the NEA could boast that there were many more opera companies, symphony orchestra, theaters, dance companies, and new museums and arts centers. That growth has apparently slowed in the late 1980s. Will it affect arts education?

Samuel Lipman, member of the National Council on the Arts, said in 1987: "I'm convinced that we have come to the end of the cycle of audience expansion for the arts in this country."[17] He quoted Ernest Fleischmann, retired managing director of the Los Angeles Philharmonic, who pointed out the "terrible decline in the sophistication of the audience for great music." According to Lipman, one of the consequences of this fall-off in attendance is going to be "to

push arts institutions into adult education."

The consequence may also be to urge arts institutions into a greater interest in and involvement with arts education in the schools, particularly general education in the arts. We are already seeing this. During the sixties and seventies, when the arts enterprises of the nation were expanding rapidly and audiences seemed to materialize out of nowhere, education was not a priority. Now that the arts face the prospects of zero growth or decline in audiences, their financial stability and future are at stake.

These arts enterprises will be interested in educating the broad mass of children, but not just that better-educated segment of the population that forms their audiences now. To establish new audiences for the arts, they are going to have to reach beyond the bright and the talented. Their best chance is through programs that reach all the students, and that is precisely what is accomplished by making the arts basic. When the arts are made an essential part of the education of every child, the arts in American society are assured a better future, and so are the arts in American schools. But even more important, the lives of countless Americans can be stretched to new and more rewarding dimensions.

Today, there is greater pressure on the curriculum of American schools than perhaps at any time in our history. As the nation aspires to maintain its position as a world power, its dominance in the economic sphere, and its high standard of living, Americans are learning, like Alice, that we must run harder to stay in the same place. The arts may seem frivolous in the hard-nosed, work-a-day world of keeping-up-with-the-Japanese; but the fact of the matter is, if we work to make a living, the arts are an important part of the living we work to make. In our haste and intensity to achieve, dominate, and acquire, it does not behoove us to lose sight of the spiritual, mental, and emotional amenities that the arts can provide. What does this mean for the curriculum? Simply that our very real economic concerns need not—should not—obliterate the larger cultural goals of the society. The schools have an obligation to serve both means *and* ends—to invest children with the skills they will need in the workplace and, at the same time, introduce them to a broad view of life's possibilities. It follows, then, that in the current battle to command the territory of school curriculum, the arts deserve a larger and fairer share.

... the Center believes that if art education ever is to become a meaningful part of the curriculum, its content must be broadened and its requirements made more rigorous. The Center believes that no child is fully educated or adequately prepared to live in an increasingly technological world without understanding the meaning and beauty transmitted by the arts.

LEILANI LATTIN DUKE, Director, Getty Center for Education in the Arts, "Preface," *Beyond Creating: The Place for Art in America's Schools,* 1985, pp. iv and v.

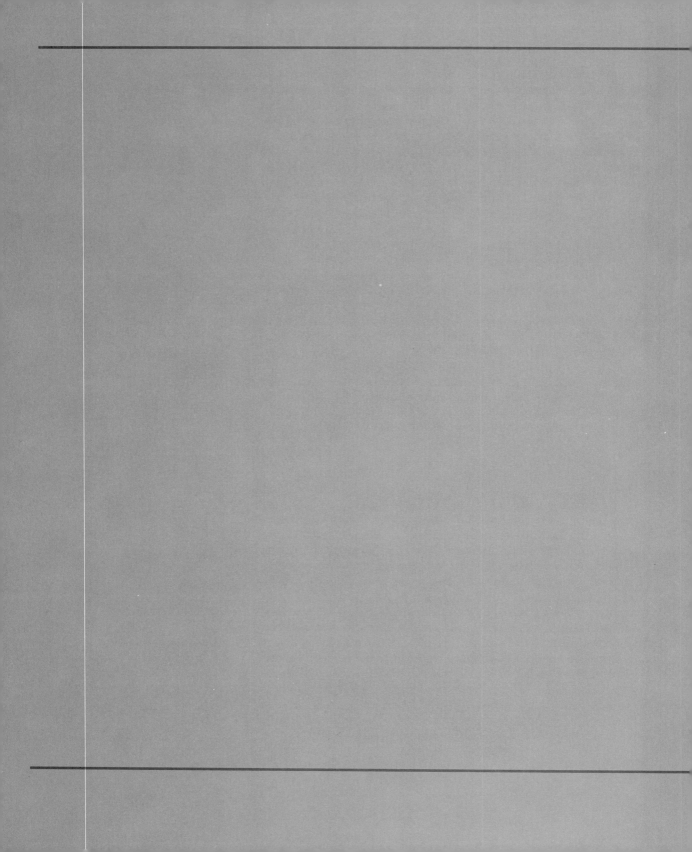

5

THE VIEW AHEAD

What becomes of arts education in the first quarter of the twenty-first century will depend fundamentally on how persuasive a case can be made for it, the powers that can be won over to it, and what resources it can command during the final decade of the twentieth century. Arts education must prove its worth in American classrooms. That is its ultimate test. But to be given access to those classrooms—to be given the expertise, the curricula, and the materials required—implies more than just teaching well. Acquiring the accouterments of a basic subject points to the need for a political agenda and for advocacy.

Policy and control

Quite surprisingly, the Arts, Education and Americans panel gave considerable attention to matters of policy in arts education in 1977. Before this time, not much had been written on the subject. Today, policy is a subject of much concern and debate within the field.

The panel report stated that "America's complex, multi-leveled policymaking processes remain responsive to demands and requests," but that "it is still the squeaky wheel that gets the grease" (CTOS, 242). The panel took the position that arts education has no enemies, but that the field needs "more and more ardent friends in order to win a position in which it can realize the potential we believe it holds for the individual and for the nation" (CTOS, 242).

Here the relationship between policymaking and advocacy becomes evident. Advocacy is the act of implementing policy; policy is what is advocated. Kathryn Bloom, director of the now defunct JDR 3rd Fund, explained to the panel that

> policymaking grows from the conviction that you
> have a concept you can believe in, that there are some
> specific ways in which you can concentrate on how to

change the content of instruction, and that there is a plan for every orderly process of change (CTOS, 212).

In the SPECTRA program organized by the Cultural Copuncil of Santa Cruz, children expand their imaginations and creativity through the arts.

In other words, pronouncements of belief alone do not constitute policymaking. The "making" of policy encompasses putting the idea into practice. As Bloom put it:

If appropriate policy is made, what follows is obvious: the arts have parity with other subjects in the curriculum, so that when the total budget is conceived, the arts are considered equal to science, math, and other areas of instruction. That means we must pay more attention to overall goals in education than we do now (CTOS, 212).

Policymaking, then, is central to any agenda for excellence in arts instruction.

The Federal Government

In the course of the study ten years ago, the panel became aware of the increasing involvement of government at

all levels in policymaking affecting arts education (CTOS, 217). On the federal level, the report traces the beginnings of interest in arts education in 1962, the year President John F. Kennedy appointed August Heckscher as his special consultant on the arts, through the proliferation of policies and programs within the U.S. Office of Education and the National Endowment for the Arts (CTOS, 217-226). Their conclusion in 1977:

> The federal government is able today to exert significant influence through its funding requirements and decisions. However, it has not attempted to demand basic changes in existing arts education programs (CTOS, 226).

This statement is not entirely true. The Arts and Humanities Program at the old Office of Education had enticed school districts to integrate the arts into general education at the elementary level. Much later, OE's Arts in Education Program supported school arts education programs that encompassed several arts and incorporated a consortium of

In an interrelated arts workshop, students at the Roosevelt Elementary School experience and respond to various styles of music using lycra body socks.

PHOTO BY JOHN MCLAUGHLIN

community arts agencies. These grant programs deliberately urged the field in specific directions. Then, too, while the provisions for the various title programs of the Elementary and Secondary Education Act in no way focused on the arts, their effect was to promote the use of the arts (and any subject, for that matter) to assist disadvantaged children, to help in the process of integration, to evolve new approaches to learning, and to enable research and development. Arts programs funded under ESEA were therefore necessarily innovative.

In the late 1970s, the National Endowment for the Arts did not exert any overt influence to change existing arts education programs, beyond suggesting the use of artists as adjunct resources. This is decidedly not the case today. As we have seen, the NEA has become more prescriptive in its policies governing its Arts in Education Program. The guidelines for this newly revised program fully intend to change arts education programs on the local level, making arts curricula basic in education, substantive and sequential, and of verified quality. As the NEA and the state arts agencies become more involved in curriculum-based arts education, they will necessarily command increased control over policy in the field. This is frequently the case with funding agencies. Sources of patronage—private individuals, foundations, government, and corporations—often exert a strong influence over policy in arts education.

The new program guidelines state that "study of the arts should include substantive components, such as the development of artistic skills and knowledge, art history, criticism, aesthetics, and analysis, as well as experiential and appreciation components." This curricular conception appears to follow the Getty model, particularly in stressing academic aspects of art and casting production or creation in a seemingly subordinate role. According to the endowment's description, the program addresses a number of objectives, among them encouraging "state and local education agencies to develop and implement sequential arts education curricula," "assisting the career development of excellent teachers and professional artists involved in education," and encouraging "accountability for quality arts education programs through short, intermediate, and long-range planning and evaluation."

Those are general prescriptions that will propel the field for years to come. Their effect will be to broaden, deepen, systematize, and standardize arts education curric-

ula. Although the field is left some latitude in interpreting the meaning of concepts such as "substantive," "sequential," "excellent," and "accountable," the basic policy has been etched in stone. Even with modest funding, the field will clamor to comply. This is policymaking with clout. Funding agencies can exert that kind of power and control. The government, in this case working together with arts educators, sets a policy that can alter the theory and practice of the field, and the field jumps through its hoop. This is a muscular way to assure change. Today, much of the impetus for arts education policy is coming from the NEA, and its role in arts education, if altogether too limited financially, is clear and forceful.

State Governments

In 1977, the panel noted that changes in the configuration of arts institutions "are creating a broader, more vibrant constituency for the arts, one which has the potential for influencing other institutions, such as the schools. The next step," they said, "must be to bring that constituency's strength to bear on education" (CTOS, 242). There is evidence that this step is now taking place, particularly with state arts agencies. The principle of state support for the arts is well entrenched. What is new in the late 1980s is that this support is now being translated into state support for arts education. The state arts agencies, acting under the provisions of the new NEA Arts in Education Program guidelines, are beginning to assert a leadership role on behalf of arts education at the state level. But the constituencies that support public arts have not yet brought their influence to bear on the improvement of arts education. Support of public arts has not yet translated into support for educational arts. But the leadership of the state arts agencies may help to alter this condition. The threatened demise of curriculum-based arts instruction puts the stability, and perhaps the future, of the arts themselves on the line. If that is true, then the arts community has little choice but to bring the power of their constituency to bear on arts education.

Of course, policymaking in arts education continues to be made by state departments of public instruction. Administrators of these state education agencies are key determinants of the quality of arts education. As the panel noted, "in arts education the human equation can be of major im-

portance" (CTOS, 244). If the state superintendent of public instruction maintains a concept of basic education that encompasses the arts, arts education will probably flourish. Unfortunately, if the chief state school officer has a narrower concept of basic education, the arts can as easily be consigned to extracurricular status.

Back in 1977, John Goodlad told the panel that "very few school administrators in the United States have a commitment to the arts or any understanding of what an arts program in the school would look like" (CTOS, 163). This statement can be applied all the way down the line, from federal officials to state commissioners of education, to school principals and superintendents. Quite often, their attitudes depend on the place of the arts in their own educational background. If an administrator has been "educated" without any arts, he or she generally will not value the arts or provide students with adequate programs of arts instruction. It is as simple as that. The endorsement of the arts by school administrators as an educational priority is a crucial factor if quality programs in the arts are to be attained. But while educational administrators can exercise important *influence*, it must be recognized that school boards, state education departments, and state legislatures have the *authority* for governing arts education programs.

While the panel noted that "the integration of the arts into a state's educational policy statements does not necessarily guarantee integration of the arts into the actual process of education" (CTOS, 228), such goal statements do offer local programs some support and impetus. Yet we learn from a report of the Council of Chief State School Officers that as of September 1985, "only 13 states specified the arts within formal statements of educational goals."[1] We also learn from the council that

> the shift of funding and authority from federal to state to local education agencies during the latter 1970's and into the 1980's threatened existing state curriculum standards and guidelines for a well-rounded, basic education. And as both state and local interpretations of an appropriate "basic" education became subject to increasing economic pressures and the nationwide movement for educational reform, the case for the arts in the schools looked grim.[2]

In the arts, leadership and support at the local levels of education is often soft and uncertain. For this reason,

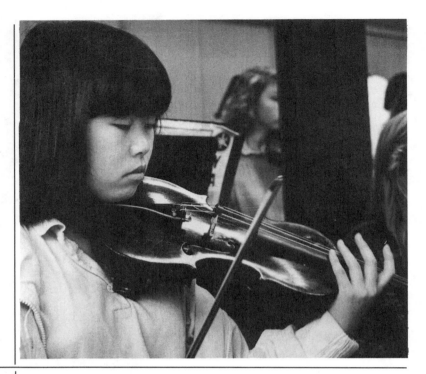

Challenge and concentration engage this student in learning the art of musical performance on the violin.

strong state and federal support is of far more critical importance in arts education than in most other subjects. Today, arts education is still subject to these economic pressures for educational reform, pressures that drive the curriculum toward a narrow academic profile. As E. D. Hirsch, Jr., makes clear, "the national culture . . . depends on a highly diverse vocabulary of communication rather than a coherent system of fundamental values and principles."[3] Today's students, he says, are being deprived of the cultural vocabulary that is "the foundation for literate national communication."[4] Hirsch makes a strong case for a broader education that spans the entire culture. "Otherwise," he says, "we are in danger of falling victims to technological intimidation."[5]

Back in 1977, the panel connected the problems of education with one of the age-old problems of the world—the gulf between policy and practice (CTOS, 228). It is not unusual for states and local school districts to say one thing about arts education but to actually do another. In matters of official policy, they will generally be supportive of the arts, but that support often begins to look wafer thin in terms of program allocations. The panel decided that "what

is much more important than any goals statement is the commitment of money in a budget" (CTOS, 228). They adhered to the old adage: put your money where your mouth is. Today, budget allocations for arts education are far more indicative of a school system's policy toward arts education than any proclamations about the arts or even lists of program goals.

In Arts Education Today

Where is the field of arts education now in matters of policy? In 1986 the arts education profession claimed that arts education professionals "have been bypassed by the image and policymaking machinery of the advocacy movement." They admitted that the field sought recognition from these advocacy groups in order "to re-establish our identity as an important unit of the national arts enterprise." This approach, they said, "has been a dismal failure."[6]

Again the villain in the view of some arts educators has been the so-called "advocacy establishment" which has usurped policy in the field to serve its own interests, all the while locking the arts education profession out of deliberations. One theory put forward to explain this alleged affront is the affinity of arts agencies and arts presentation organizations with wealthy and socially prominent individuals. "This situation," we are told, "may be partly responsible for the fact that the professional arts education community, which is certainly not comprised of the wealthy and powerful, has never been considered by the advocacy movement as an equal partner in the national arts enterprise."[7]

Again, this situation can be viewed in a far different light. With the Artists-in-Schools Program, the NEA and the state arts agencies were operating around the edges of arts education, and they knew it. They were determined not to get involved in mainstream arts education, which they felt was not their province or responsibility. Indeed, many artists and administrators of presentation organizations deliberately wanted the NEA to stay out of education. Back in 1978, the reactions of some members of the National Council on the Arts to the recommendations of its own Task Force on the Education, Training, and Development of Professional Artists and Arts Educators were remarkably telling. Harold Prince, a council member at that time, summarized the feelings that prevailed. He wanted that report limited to

the training of artists. In recommending that the provision for arts educators be eliminated, he said, "It seems to me that we have gone way beyond any mandates we may have." He expressed concern that "we may vitiate our forces by encompassing such a suggestion." In referring to the report's plea for what he called "audience development," Prince said, "Essentially what it does on an elementary and secondary school level is expose, in a more exciting way, a lot of students to the arts. Well, we're not here for that." He went on to say that there were "other agencies" to deal with those issues and that this kind of involvement "far exceeds what I consider to be our priorities."

This anecdote shows the tenor of arts education at the endowment then and now, a mere nine years in time, a millennium in philosophy. It should also be clear from this statement that there was little support within the endowment at that time for setting policy in arts education or for getting involved in it in any substantial way. The NEA was content to be involved modestly through its Artists-in-Schools Program, and certainly had no intention of overtaking the whole of arts education with that program or any other of its initiatives. In truth, members of the National Council on the Arts were leery of becoming more involved in arts education because they knew that that area alone could drain the endowment of funds they coveted for the arts. They did not believe it was the endowment's mandate to assume this responsibility. To them such a move would have been comparable to the Salvation Army giving all its funds to the American Cancer Society.

There is no question that, in national arts policy questions at the NEA, arts educators in those days had very little say. But the further claim—that the endowment ran away with policy in the field or that they decreed policies that undermined curriculum-based arts education—would be difficult to corroborate in fact. If the endowment's policy in support of artists-in-schools overtook some school districts, it might well have been because of the vacuum in policy from within the arts education field itself. The arts education community has often failed to act, and inaction is indicative of indecisive policies and hesitant beliefs.

The professional arts education associations admit the naivete of the arts education community in matters of policy. They have said that "more general awareness of the broad dimensions of policy as applied to arts education is necessary as a basis for future action." Arts educators, they

Policies entail choice—they are things that we choose based on intents and purposes. The term "policy," therefore, is limited to what can be chosen and is within our capacity to control. Further, the idea of policy entails a choice among alternatives, i.e., policy arises only when there is some conflict of goods. Choice is necessitated most often by scarcity of resources such as time, materials, finances, and personnel, and a need to achieve the optimal composition of conflicting goods.

DAVID B. PANKRATZ, "Toward an Integrated Study of Cultural and Educational Policy," *Design for Arts in Education*, Vol. 89, No. 2 (Nov.-Dec. 1987), pp. 12-13.

have declared, "can no longer afford the low level of policy awareness currently evident among teachers of the various arts." And they feel compelled to explain that policy involves "the promulgation of our concepts of what arts education should be and how these concepts relate to the development of American culture."[8]

In 1970, the Music Educators National Conference (MENC) made a number of policy pronouncements with its statement of goals and objectives. The statement began, "MENC shall conduct programs and activities to build: a vital musical culture, an enlightened musical public."[9] This was a policy pronouncement, but such pronouncements have little meaning if they are not translated into strategies and actions. In 1984, MENC adopted three new goals:

1. By 1990 every student, K-12, shall have access to music instruction in school, and the curriculum of every elementary and secondary school, public or private, shall include a balanced, comprehensive,

In elementary art classes, children like this one learn how to express themselves creatively.

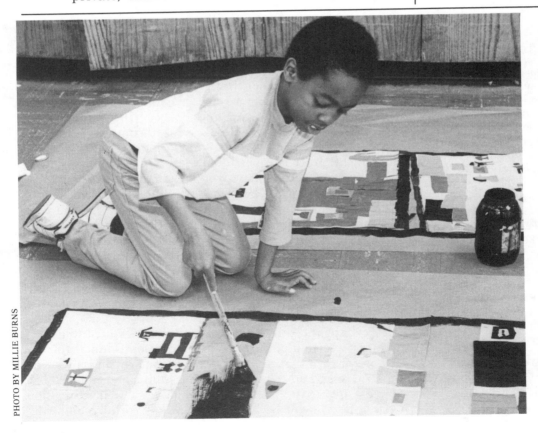

and sequential program of music instruction taught by qualified teachers.

2. By 1990 every high school shall require at least one unit of credit in the arts for graduation.

3. By 1990 every college and university shall require at least one unit of credit in the arts for admission.

In like manner, the National Art Education Association (NAEA) has adopted similar goals:

1. All elementary and secondary schools shall require students to complete a sequential program of art instruction that integrates the study of aesthetics, art criticism, art history, and art production.

2. For graduation from high school, every student shall be required to complete at least one year of credit in one of the fine arts.

3. For admission to a college or university, every student shall be required to have at least one year of credit in visual art.

Again, if such policy pronouncements are to effectively move the field and induce change, they must be backed by carefully planned strategies and actions.

One other observation can be made from reading these policies. One could wish that such policies were representative of arts education per se, rather than just music or art (or dance or theater). A quick analysis of these statements reveals that the first goals in each case promulgate specialism, while the second goals assume a more generic view of arts education. It is more of the latter that is needed, but who will make such policy pronouncements for arts education? By their own reckoning, the field admits the problem. The arts education associations say that "[One] of the first strategic goals for the arts education community must be to become more active and effective in the policy arena."[10] And the proclamation of the Interlochen (Michigan) Symposium, "Towards a New Era in Arts Education," held in November 1987, recommends "that the need for a national organization to serve as umbrella spokesman for arts education be addressed."

Perhaps the solution is for all the arts education associations to form a National Arts Education Council for the purpose of formulating policy across the arts and initiating the strategies and establishing the support to make those policies operative. Then, too, the field of arts education needs a permanent body to constantly scrutinize and eval-

Arts councils have worked for twenty years to promote arts experiences as arts education—nothing more, nothing less, nothing else. This financial and promotional self-interest has impaired the ability of the arts education community to justify its importance in the often hostile atmosphere of policy development. Without support, many of our best teachers leave the field in disgust and frustration. Not only must they fight educationalists for time, resources, and even their own existence; they must also contend with neglect, disdain, and even competition for basic fiscal support from other parts of the arts community.

SAM HOPE, Executive Director, National Office for Arts Accreditation in Higher Education, from "Access to Policy," *Vantage Point*, No. 8, 1986, p. 5.

uate the policy influence of funding agencies. These agencies often issue policy statements that have considerable impact on the field. A funding agency commands attention, whether through studies, conferences, and reports, or through the particular programs and projects it chooses to support. The asserted policy and the legitimacy an agency's prestige affords it are far more indicative of its influence than is the amount of funding it provides. Sources of patronage tend to be somewhat arrogant, unmalleable, and unresponsive to the public. They intimidate a field.

Sources of patronage need to be monitored and reminded of the consequences of their influence. They should be encouraged to form and to maintain policies in consensus with the field. Scattered and disjointed efforts should be discouraged. Funding agencies need to be made aware of their possible contributions to and their responsibilities toward a national agenda for arts education. They must be made true allies of that concerted effort. As a policy arm, a National Arts Education Council could serve the arts education associations and the profession at large in an essential way, providing a forum for discussion of important issues, publishing policy papers on important problems to help guide the field, and otherwise drawing the profession and its support system together so that they operate more efficiently and effectively.* In this way, then, the field asserts some control over policy formation and its own destiny.

> In the years that arts councils and advocacy groups have been active in the arts education arena, access to their strategic policy planning has been restricted to their grantees. Teachers and organizations concerned with rigorous instruction in the arts disciplines but funded outside the arts council/advocacy system have been consistently ignored.
>
> SAM HOPE, Executive Director, National Office for Arts Accreditation in Higher Education, from "Access to Policy," *Vantage Point*, No. 8, 1986, p. 5.

Advocacy

Well ahead of *Coming to Our Senses*, the ripple effects of arts education advocacy began to wash the educational shores. The Alliance for Arts Education may have thrown the first stone into the still waters of arts education.

*As this book was going to press, the Ad Hoc National Arts Education Working Group met to consider formation of a National Coalition for Education in the Arts (NCAE), to serve just such purposes.

In the middle years of the seventies, national, state, and local meetings of the Alliance for Arts Education were devoted to the subject of advocacy. Arts education was in the throws of serious curtailments at the time due to inflation and declining school enrollments, both of which affected school budgets adversely. The field desperately needed supporters to defend and plead its cause and to fight to maintain programs. The arts education field initiated the advocacy movement as a strategy to save itself by persuading the unwashed of the value of arts education. (It is important to remember that in the early years of the AAE—established in 1973—representatives of the arts education associations, often the executive directors, served on AAE's National Advisory Committee.)

Then, in late 1975, the U.S. Office of Education made a small grant available to the four professional associations representing the arts education profession in the United States for a project known as the "Arts Advocacy Project." The four associations—the Music Educators National Conference (MENC), National Art Education Association (NAEA), National Dance Association (NDA), and the American Theatre Association (ATA)—held five seminars with educational associations outside the arts to discuss ways in which they

Through dance instruction, fourth grade students at the Brunswick Acres School in Trenton, New Jersey use their bodies to explore straight, curved, and twisted shapes.

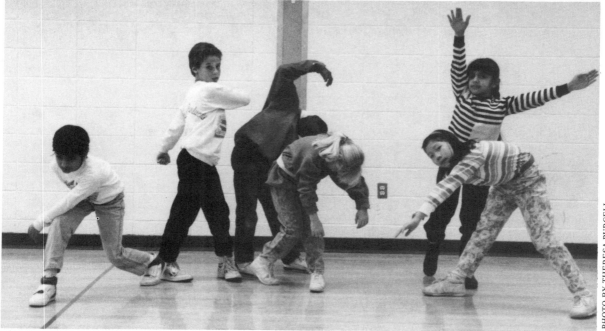

might be more direct advocates for the arts in education. These associations—National Elementary School Principals Association, American Association of School Administrators, National Association of Secondary School Principals, Council of Chief State School Officers, and National School Boards Association—are all closely involved with educational administration and with educational policymaking. One of the outcomes of these sessions was a publication called *Arts Education Advocacy*, which contained statements in support of the arts by representatives of these associations.

Given the momentum the arts education establishment built for advocacy on every level, it is surprising—even jarring—to hear them damn it now as some kind of aberration invented and perpetuated by organizations not beholden to their interests. Indeed, much of the briefing paper presented by eight arts education groups in January 1986 is devoted to an attack on the advocacy movement. In a section entitled, "New Players in the Game: The Rise of the Advocacy Movement," the paper declares:

> Because the governmental arts council system and its allies in the private sector tend to rely primarily on the techniques of promotion for generating support, we have designated this phenomenon the "advocacy movement. . . . " The techniques of advocacy, by doing little to change real values and, in fact, by obscuring real values, have significant potential over the long term to harm both the intellectual and financial base for both the arts and arts education.[11]

Foundations, corporations, and other private sector advocacy groups are assailed for showing "no evidence [of] considering the traditional arts education community as a full partner in the national arts enterprise."[12] But it is the state arts council system that is singled out as "too frequently working against the interest of artistic literacy and, especially against the economic well-being of those committed to curriculum-based instruction."[13] The paper says:

> The potential for problems between the arts council system and the arts education community is obvious. In most cases various degrees of enmity exist because the arts council system has conveyed to policy makers the message that the arts can be taught more easily and inexpensively by an arts council-endorsed

artist in a short-term residency subsidized by arts councils, or through one or two trips a year to a concert hall, theatre, or museum. The arts education community feels that unilateral promotion of these methods of arts education leaves school boards with the question of why regular, curriculum-based programs are needed."[14]

The paper presents what it calls the "basic arguments" being advanced by the advocacy movement:

1. The nation's needs in arts education are not being met. The current system is a failure.
2. The first priority is to provide exposure to "the arts."
3. The basic focus should be on general arts experiences supplemented by presentations of "artists."[15]

The profession is angry because during the past ten years, the professional arts education community at the elementary/secondary level has been confronted with an advocacy movement that ignores the history and achievements of professional teachers.[16]

There is no doubt that the frustration of the profession here is very real, but it has created an "advocacy establishment" that is a straw man. The events that transpired 10 years ago can be interpreted quite differently. At the height of the profession's own advocacy attempts, the schools continued to lay off arts teachers and curtail arts programs, particularly in the cities. But school systems, sometimes reluctantly, did maintain some kind of a curriculum in the arts. They took heed precisely because of the profession's advocacy efforts. They heard the prompting of education associations and the urging from such sources as *Coming to Our Senses*, and they recognized the well-established historic place of the arts in the curriculum. Financially strapped systems did what they could afford. They leaned on the available governmental programs. If they could no longer support a curriculum-based arts education program taught by arts specialists, they took the next best thing—arts experiences provided by community-based artists and arts organizations, subsidized by government funding. If such a program had not been available, school systems might have reverted to nothing. Some, in fact, did just that.

As John Goodlad reminds us, however, parents generally want it all. They do not want a bare-bones curriculum.[17] Some financially strapped school systems opted for a com-

*"Please, Daddy. I don't want to learn to·use a computer.
I want to learn to play the violin."*

bination of curriculum-based delivery supplemented by artists-in-schools. In radical situations (particularly in elementary schools) in which most arts specialists were excised, or in systems that never had arts specialists to begin with, there may well have been some school administrators and school board members who thought they found a good, cheap deal that might even quell the public. In some cases, it might have been harder for a school system to curtail programs severely if an alternative were not readily accessible. But did the state arts agencies encourage school systems to drop ongoing arts education programs for a free ride? In truth, they never had the resources to make such a promise. At its height, NEA's Artists in Education program only reached about 10,000 schools a year out of the 79,000 elementary and secondary public schools in the United States—less than 13 percent.* And in those schools, the sin-

*According to the National School Boards Association, there were 50,865 elementary, 12,535 middle and junior high, and 15,591 high schools in the United States during the 1986-87 school year, or a total of 78,991 public schools. The National Endowment for the Arts claims that fewer than 12 percent of schools have had artists.

gle-focused "arts" program reached only a fraction of the school population for a fraction of the school year. The NEA's education program, until just recently, was never a national agenda for arts education. It never professed to be. (The arts education profession complained about that, too.) What is clear and true is that the Artists in Education program was exploited and misused, not by the government sponsors or even because of them, but *by some school administrators and school boards.* The rotten apple was right inside the schools, far closer to home for arts education than the arts establishment—and maybe, therefore, far more uncomfortable. Unfortunately, the arts education profession was not completely successful at its own advocacy campaign. They failed on their own doorstep.

The profession's claims against the so-called "advocacy movement" or "advocacy establishment" do not stand up to the facts. Even the name is a misnomer. Is it advocacy to claim that the current arts education system is a failure? It might better have been labeled the "adversary movement," but in any case, the name is mute because the adversaries were right in the schools, not outside. To begin to acknowledge this would help to mend the estrangements

This child is intrigued by a Winslow Homer seascape which he is studying as part of an art history class given at the Caledonia School in East Cleveland, Ohio.

caused by accusations against a movement that never existed as such. With such frictions and delusions of hurt, no wonder arts educators were sometimes bypassed in state and national arts deliberations. One could hope that with the Endowment's current entry into the field with the mainline interests of arts education in tow, arts educators might lay talk of conspiracy by the advocacy movement aside once and for all. Arts and arts education are really one universe. They exist in mutual benefit. Their interests quite naturally coalesce. The field of arts education may be surprised to find that it is far closer to the arts than it is to education. It is education that has been inhospitable. When a student's music education at the third grade level changes from thrice-weekly lessons by a school music specialist to a three-week residency once a year by an artist, that policy was altered by educational administrators and members of the school board. In such a case, they are the ones who are antagonistic to curriculum-based arts education. Let's put the blame—and the responsibility—where it belongs.

Fortunately, across the United States in large school systems and in small, there are substantial numbers of school administrators who believe that the arts are indispensable to a quality education. There are superintendents and principals who have gone far out on the limb in support of the arts in their communities. They know, as do some school board members, that the arts are basic to any well-rounded schooling. There are, happily, educational leaders who are enlightened supporters of a comprehensive education and who treat the arts like any other serious subject in the school curriculum. These leaders do not make the arts scrounge for support. Assuredly, that support is there for the arts just as it is for English and science. But, taking the entire country into account, by and large, support for substantive and comprehensive programs of instruction in the arts, K-12, is insufficient, and, as a consequence, far too many arts programs are compromised to a fragmentary, meager, and second-rate level. That is why advocacy is so necessary in the arts, but almost unheard of in English, science, mathematics, and history.

Another ramification here bears attention. Efforts are needed to resurrect advocacy and restore the terminology to the status it deserves. Talk against the so-called "advocacy establishment" has made it increasingly difficult for organizations to befriend arts education. To cast advocacy as anything but a welcome and essential activity is a disser-

I believe the Artists in Education (AIE) program of the NEA ... would be far more effective in promoting the interest of arts education if it were administered as a challenge-grant program and made available only to schools or districts that have strong arts programs already in place—at least in art and music—or to schools that undertake specific steps to remedy specific deficiencies. The NEA's record shows that challenge-grant programs work. The record also shows that the Artists in Education project does not lead to the establishment or significant improvement of sequential arts programs. It has often served to provide minimal arts experiences where school arts programs are weak or nonexistent, but this effort is counterproductive. The AIE program only makes it easier for schools to avoid any serious attempt to improve. It removes the incentive to develop a sequential arts program by providing what seems to some administrators to be an inexpensive alternative.

PAUL R. LEHMAN, then President, Music Educators National Conference "The Professional Connection," *Vantage Point*, No 8, 1986, p.14.

Appreciation of the arts is by and large developed through the educational system. The beginnings of attitudes and opinions about the importance of the arts have the same locus. We cannot hope to establish the centrality of the arts to this society or their value to the individual without a clear recognition of this fact. More support for the arts in education is needed, especially at the local level.

from "Findings and Recommendations," *The Arts and Public Policy in the United States*, The 67th American Assembly, 1984.

vice to the field. We must encourage such support on a massive scale, from mayors and governors, state legislatures, state arts and state education agencies, cultural institutions, businesses and corporations, and other groups that can assert influence over the schools. Such extraordinary efforts are necessary if the arts are to be accorded the educational status they deserve. And when policies are initiated that are not supportive of the field, they should be identified as adversarial or counterproductive. In this way, the field is spared a considerable amount of confusion.

A national agenda in arts education

In 1987 the Ad Hoc National Arts Education Working Group, a group of some 30 organizations representing most of those who have proprietary interest in arts education, issued a policy statement entitled "Concepts for Strengthening Arts Education" (see Figure 1). With this statement, the group, which was co-convened by the American Council for the Arts and the Music Educators National Conference, attempted to get all the players in the field to agree on broad and basic policy. This policy statement represents an attempt by the field to form new alliances and alignments and to partake in new kinds of transactions across the arts and between key members of the arts, arts education, and education communities.

This set of concepts represents the beginning of establishing an agenda for arts education in the United States: "This is what we believe, now this is what we are going to do about it." A decade ago, the panel said:

> There is no longer any doubt that the arts, in all their life-giving vitality, are part of our national resources. To let them go undeveloped and unused in education is not only irresponsible but, in the deepest sense, unpatriotic (CTOS, 243).

The arts community is learning to be more aggressive in its quest for equanimity in the school curriculum. At the

CONCEPTS FOR STRENGTHENING ARTS EDUCATION IN SCHOOLS

To increase the level of artistic literacy in the nation as a whole, the arts must be taught with the same rigor, passion, and commitment with which they are created and presented to the public. The primary responsibility to educate students rests with teachers, school administrators, and ultimately, local school boards who represent the public. But we all have a stake in this undertaking: artists, arts organizations, professional and community schools of art, arts teachers and administrators, those who teach the next generation of artists and teachers, and all those who believe the arts should be an integral part of people's lives.

We will work to establish the arts as an equal partner in the educational enterprises. The arts and arts education communities define common goals and discover the role each will play to further a vision of the future that includes the arts at the center of American values and practice.

Together, we advance these philosophical and operational concepts:

1. The arts should be taught as disciplines to all students. This includes student involvement in creating, studying, and experiencing the arts.

2. Regular instruction in the various arts must be a basic part of the curricula in all elementary and secondary schools; such instruction must be integrated with the highest quality arts experiences both in schools and in theatres, concert halls, and museums; such experiences must be integrated with instruction as part of comprehensive curricula.

3. Arts curricula should be for the development of skills in and knowledge of the arts. In addition, learning about and experiencing the arts can develop critical and creative thinking and perceptual abilities that extend to all areas of life. These benefits are best imparted through instruction in the basic skills in and knowledge of the arts.

4. The arts relate naturally to much of the content of the total educational curriculum. For this reason, all teachers should be encouraged to incorporate arts skills and knowledge into their instruction in order to enliven, broaden, and enrich all learning.

5. The curricula of teacher education programs in general should have a stronger arts component as part of the pedagogical preparation of all teachers.

6. Pre-service and in-service training of both teachers and artists should be augmented to include significantly greater experience of one another's working methods. Arts education benefits when arts teachers have high levels of artistic skill and knowledge of the arts, and when artists develop teaching abilities and knowledge of child development.

7. Resources are often already available through individuals and arts organizations and in elementary, secondary, and postsecondary education to form the foundation for quality arts education programs in each local community. These resources must be identified, integrated, utilized, and expanded.

8. The local focus for decision-making about arts services and arts education, including local control over curricula, must be respected. Within this framework, ways must be found at the local level to meet or exceed the goals and standards established by professional arts education associations and accreditation authorities. This should include criteria for school programs, certification of personnel, the participation of arts organizations, and for artist and teacher preparation programs.

9. Arts education programs, which are designed to increase cultural literacy, will build audiences and strengthen community volunteer and funding support for cultural, visual, and performing arts organizations and institutions. Therefore, these organizations should allocate significant resources and efforts in support of arts education.

10. We must establish for arts education a coordinated policy-making process that includes the arts and arts education communities. Over time, this will vastly increase our ability to affect the policies of others whose support is needed to make the arts and the study of the arts more central to the educational mission of communities throughout the country.

11. Basic research, model projects, and advocacy efforts are critical to establishing a consistent and compelling case for increasing the economic base of support for arts education in schools and in the

community at large. While the primary responsibility for increasing budget allocations in support of education programs rests with local school boards and administrators, we all must recognize our share in this responsibility as members of the larger society. We must build a powerful community constituency at local, state, and national levels among arts and arts education organizations to initiate a step-by-step process for change.

PARTICPATING ORGANIZATIONS
Ad Hoc National Arts Education
Working Group

Alliance for Arts education
Alliance of Independent Colleges of Art
American Association of Museums
American Association of theatre for Youth
American Council for the Arts
American Symphony Orchestra League
The College Music Guild
Dance U.S.A.
High Fidelity/Musical America
International Council ofFine Arts Deans
Kennedy Center Education Program
Maryland Institute College of Fine Arts
Music Educators National Conference
National Art Education Association
National Assembly of Local Arts Agencies
National Assembly of State Arts Agencies
National Association of Jazz Educators
National Association of Schools of Art and Design
National Association of Schools of Dance
National Association of Schools of Music
National Association of Schools of Theatre
National Band Association
National Dance Association
Naitonal Guild of Community Schools of Art
National Music Council
Opera America
State Arts AdvocacyLeague
Very Special Arts
Young Audience

Interlochen Symposium, "Towards a New Era in Arts Education, the 150 delegates, comprising representatives of the fields of education, arts, and arts education, issued a proclamation that stated, in part:

> American schools, K-12, should provide arts education for all students every day. Instruction in the arts should encompass visual arts, music, dance, theatre, and creative writing. Arts instruction should be accorded resources of time, money, and personnel equivalent to other basic subject areas, and the same level of expertise. Every school should have an in-school sequential arts program that serves all the children.

The delegates then agreed on a series of strategies to accomplish these fundamental goals for arts education. These strategies include formation of new and broader coalitions in support of the field, development of new informational resources, and agreement about a broad range of issues concerning such matters as curricula in the arts, the length of the school day, the amount of arts instruction, graduation requirements in the arts, and the need for evaluation. The Interlochen meeting provided further evidence that the field is pulling together and that it is determined, perhaps for the first time, to submit itself to the painful process of consensus in order to determine and set forth exactly what it wants. Unless the field is clear about its objectives, it cannot command action on its own behalf.

To get better and bigger, the arts education field has to get wiser. There is no other recourse if we are going to wedge a new presence in American education. This means that the profession must recognize its problems and deficiencies openly and forthrightly and go after them with a vengeance. It is no longer enough to spend our major professional time and resources on public relations. We have to resist parading the exceptional suburban arts programs across the country as if they are the standard. If everything in arts education is fine, where is the motivation to come to its rescue? Then, too, we have to avoid reacting to every criticism of the field is if it is an attack requiring defense. The fact that most Americans can no longer carry a tune is an indictment of American education, not music education. Given the necessary resources, a quality arts education program can be provided in every school system. In this respect, the arts do not differ from any other subject area.

Where there is a vast difference is in how the arts are perceived in terms of what is important in American schooling. In this regard, the purpose of a national agenda in arts education is to alter that perception in order to establish the parity of the arts with other major areas of human knowledge. This is a crucial first step in the vast effort that will be required to rescue the arts for America's children.

In conclusion

We are on the forefront of turning America's surge of interest in the arts into firm policies to guide the nation's school systems. America's children—all 40 million of them

In an exercise of free-wheeling thought, children at the Arkansas Art Center invent vehicles out of a variety of materials using their imagination and their "mind's eye."

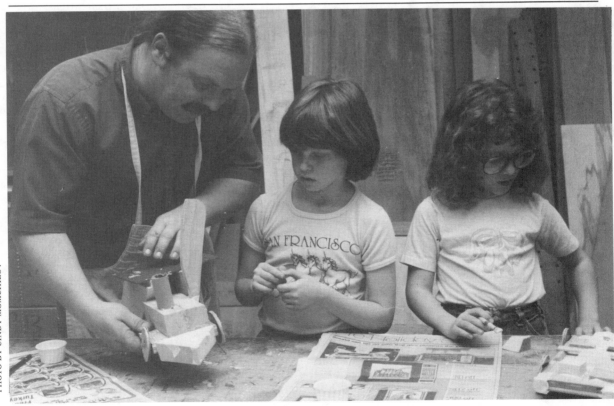

PHOTO BY CINDY MOMCHILOV

in the public schools—should be able to grow up to participate fully in their culture. As it is now, the arts are a neglected heritage in too many American schools. By and large, America's children are impoverished. That is a national disgrace. Can we persuade those who control the school system of their wrong-headedness? Can we mobilize the resources? Can we find the way?

Given the fact that large numbers of the youth of future generations are growing up today in urban school systems in which the arts are sorely disregarded, even spurned, the prospects for the arts in American society tomorrow are bleak. If we are not to despair for our culture, present alarms must be translated into redefinitions of what constitutes a great civilization, a fine education, and the good life. We can no longer permit our schools to sell out to the goal of mere employability, our businesses to aspire only to what is expedient, our culture to be satisfied with just the easy and the sensational.

The arts are short-changed in many schools today. The consequences are many children whose possibilities are squandered and whose insights are impeded. But worse, the sheer numbers of these future citizens and their personal barrenness confronts us with prospects of a diminishing cultural future. *Coming to Our Senses* presented us with the alternative to enter the mind through the human sensorium—our capacity to hear, to see, to move, to say, to feel. That is a far more profound idea than it has ever been given credit for. The arts can awaken the learning mechanism because they touch the true inner being, that aspect of the self that is not body, the part that lies outside the domain of science—call it the soul—the wellspring of dreams, caring, daring, and dedication. They are one of the all too rare ways by which humans can experience emotional thrill and fulfillment, powerful stimuli for motivation and inspiration. Because the arts can break the cycle of disaffection and despair that engulfs so many of our inner city children, these children need the arts more, not less, than suburban youth. Yet we know that disadvantaged children often lack even modest access to study of the arts.

If the distribution of the food supply throughout the United States was as erratic as the apportionment of arts education in American schools, the specter of starvation would prompt immediate attention, and the problem would be solved. But starvation of the mind and spirit is evidently a quite different matter altogether. We tend to excuse the fact that some children are well fed artistically and others

For once, and for all time, let us dismiss the notion that the primary worth of education in the arts is to entertain. Let us return to those loftier principles known to Aristotle and Plato—that *responsiveness* to the arts is a primary condition of being human. There has never been a better climate in which to accomplish this change; there has never been a greater motivation than the impending maturity of a technological world. Will the future see a society desensitized to humanistic qualities, or will we witness a true renaissance of human sensitivity? The answer is up to us.

BENNETT LENTCZNER, Dean, College of Visual and Performing Arts, Radford University, Radford, Virginia, from an unpublished position paper, Fine Arts Leadership Conference, Lynchburg, Virginia, October 1987.

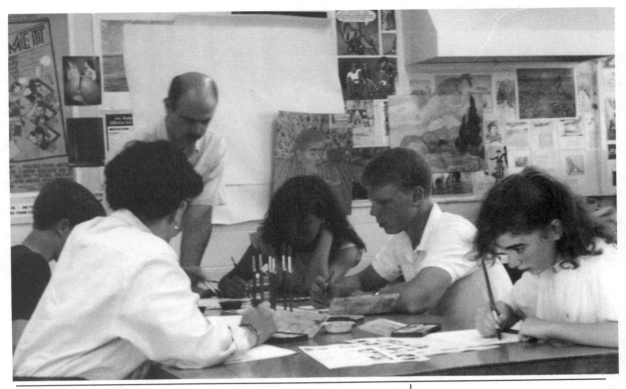

go without, and we accept this choice as the rightful juris-
diction of local school boards. If a school board does not
want the arts, it is because it does not value them or cannot
(or will not) afford them. But should we permit such local
discrimination and deprivation? Artistic deficiencies have a
detrimental affect on the cultural health of the nation. When
we dilute or delete arts programs, we unravel the infra-
structure that assures the cultural future of America. By
denying children the arts, we starve our civilization. Our
citizens lose their sense of cultural cohesiveness, their pride
in identity, their ties to the human greatness of the past,
and some of their own potential for the future. The hungers
of the human being—whether visceral or intellectual or
emotional—are ignored at our own peril. This is too big and
too important an issue to be left entirely to the whim of
local school districts. The fact that some parents and school
board members do not happen to value the arts is not suf-
ficient cause for schools to neglect them. There must be a
way to assert a higher order of wisdom, whether promul-
gated at the state or the federal level.

We do not need more and better arts education to de-

These high school students at Cold
Spring Harbor High School in
New York are learning to express
themselves through the medium of
watercolor painting from art
teacher Howard Nepo.

velop more and better artists. We need more and better arts education to produce better-educated human beings, citizens who will value and evolve a worthy American civilization. The human capacity to make aesthetic judgments is far too scantily cultivated in public education. As a result, Americans seldom recognize that most of the decisions they make in life—from the kind of environments they create in their communities, offices, and homes to their decisions about the products they buy and the clothing they choose to wear—have an aesthetic component. That component is too seldom calculated when mayors make decisions on public housing (it has been said that we build slums and call them apartment houses), when zoning boards make decisions about appropriate land use, when boards of education approve the architecture of new schools, and when legislators vote on environmental and other issues—the list could go on and on. When the aesthetic component is ignored, we denigrate life. We abuse people with dehumanizing environments, bombard them with insensitivity and ugliness, and deprive them of the comforts and satisfactions they need for their psychological well-being.

But there is a far more important reason for schools to provide more and better education in the arts. Quite simply, the arts are the ways we human beings "talk" to ourselves and to each other. They are the languages of civilization through which we express our fears, our anxieties, our curiosities, our hungers, our discoveries, our hopes. They enable us to express our need for understanding, love, order, beauty, safety, respite, and longevity. They are the means we have invented to listen to our dreams, filling our space and time with what our imagination and feelings tell us. They are the universal ways by which we still play make-believe, conjuring up worlds that explain the ceremonies of our lives. They are the imprints we make that tell us who we are, that we belong, and that we count. The arts are not just important; they are a central force in human existence. Each citizen should have sufficient and equal opportunities to learn these languages, which so assist us in our fumbling, bumbling, and all-too-rarely brilliant navigation through this world. Because of this, the arts should be granted major status in American schooling. That is a cause worthy of our energies.

6

FOUR
EDUCATORS
RESPOND

Betty Allen

Why should we have to be reminded ten years later that we have not yet come to our senses? In many ways we are the most fortunate people in the world. We have unparalleled material wealth, yet we cannot seem to grasp the true necessities of life. We cannot seem to find the time or the place for the intellect, the emotions, and the creative urge. As a professional singer, all my life I—and perforce music—have been beyond the pale. I was made to feel useless, frivolous, set apart from the serious matters of the world. I fought to make my presence and my music felt. The prevailing attitude seems to be that material things are all that are important.

But I believe that there is more to life than assuring that one is fed, clothed, and housed. The arts are not inimical to these practical needs; if they are included in the educational curriculum, we will have young people who are more creative, more literate, and more self-motivated. Charles Fowler sums up my feelings with this statement: "If it is presented through an adequate curriculum, regarded with academic respect, and taught with expertise and vitality, arts education can provide credible and commanding cultural alternatives that will win just as much allegiance from the young [as popular and commercial culture]. And in the process, students acquire knowledge, skill, and understanding that permits them to become part of and to take their place in the traditions of their society."

I am very unhappy with the apathy, cynicism, and plain mistrust evident in the people who guide our students. Children today are different, but life itself is different. The family structure is not what it once was. Support systems are not in place, and everyone fixes the blame on someone else. The students suffer. But the teacher says, "It's not my fault." The principal says, "My hands are tied." The superintendent complains of red tape. The school board says, "We are in control, but we get no cooperation." The board of education says, "We have overspent; the dollars are not there." The mayor says, "I'd help any way I could, but we need state aid." The governor says, "Where are the federal dollars?" And so the blame is passed. To paraphrase the new chan-

cellor of the New York City Board of Education, Dr. Richard Green, let us stop pointing fingers and apportioning blame; let us turn our hand to positive action for young people! In short, let us *do* something.

This sounds simplistic; but if we could begin to put high standards back into our teaching, on a local level, and use every method known to incite and excite young people, we could not help but succeed. I know that our youngsters are bright and interested when they are engaged. They see the finest artists on TV and in the movies. The very latest production methods and most startling new ideas are being propounded. But how can they feel challenged in an educational system that breeds apathy and exudes an aura of indifference? Some teachers are only interested in serving up the same material chewed over and spat out again. There are those who teach but really do not wish to be in the classroom and have little respect for the genuinely interested and hungry minds before them. As role models, we need top-notch teachers who do their jobs with joy and enthusiasm. If we do not engage our young people by exposing them to the best of values, they will be lost to the worst of values, which are packaged as a much more seductive and beguiling gift.

At the Harlem School of the Arts (HSA), a small, multidisciplinary school for 1,100 pupils, we are trying to stimulate education through the arts for a small number of public school children. Some come to us daily, and others attend after school and Saturdays for supplemental arts classes and individual lessons. The public school program began in 1977 when Dorothy Maynor, the school's founder and then director, received a $300,000 grant from the CBS Foundation to fund a program for children to show how the arts could stimulate education and aid classroom teachers.

Today, some 300 children attend HSA for four hours a week, taking classes that they do not generally receive in the public school system. The most dedicated teachers work with the HSA faculty to focus on topics that are pertinent to classroom teachers. Over the years, our students have become more demanding and better motivated, and their self-worth has received an incredible boost. New aspirations and ambitious ideas emerge. Nothing is routine, and the attitudes and high standards of the professional teachers at HSA produce a different caliber of work. Our artist-teachers work closely with the teachers from the public school system, who, in their very participation, show a re-

newed spirit and a reinvigorated belief in what they are doing.

The Harlem School of the Arts has aided over 1,000 young people since the inception of its public school program. The school is a part of their education in the same way that museums, libraries, theaters, concert halls, and religious bodies are a part. What we are doing is in a sense missionary work. Our entire program attempts to overcome the worst faults of today's society: passivity, lack of ambition, lack of imagination, the constant need to be entertained, and the dreadful values espoused by popular or cult figures. I believe that society needs reading, writing, thinking, questioning human beings. The arts develop these qualities. Hundreds of classes like ours—and the efforts of other schools, institutions, and individuals calling for high standards and hard work—must and will pay great dividends.

Excellence does not denote elitism; it is truly possible to be democratic and excel. Quality should go hand in hand with quantity. For two generation we have denied our young people arts education in the mistaken belief that in order to succeed with the basics we had to cut back on the "frills." Years later the basics are still losing out, and the arts experience has also been missed. The arts should be taught to all, and they should be considered a basic tool of educators.

Today, people are finally beginning to see that the arts are indeed necessary. Our experience has shown that arts education—as an intrinsic part of the total education—produces improvements in academic subjects as well as in behavior, demeanor, and even hygiene. The arts refine sensory experiences into abstractions and then translate these abstractions into symbols. It is true that written language is at the peak of the learning hierarchy, but art and music also bear their own symbol systems and language. Learning them enhances the child's ability to handle other symbol systems.

Arts courses have an immediate and powerful appeal. They cut through the expectations of failure that plague so many inner-city schools. Teachers at HSA are able to build on more positive feelings than these, and they can guide students to greater understanding, discipline, and mastery. This, in turn, carries over into the rest of their school activities. The results are clearly visible, and I wish many more would advocate just such a course. There is no right time to begin. We've only to begin.

BETTY ALLEN is executive director of The Harlem School of the Arts in New York City.

Donald Corbett

Charles Fowler's comments about the current state of arts education in America are both accurate and insightful. It is difficult to offer a general response, however, because each arts education discipline is inherently unique. Consequently, I will offer my observations on a few sections of the document by enhancing or clarifying statements from the perspective of music education.

Fowler gives a defense of arts education by identifying music as one of the seven basic intelligences that psychologist Howard Gardner refers to in *Frames of Mind: The Theory of Multiple Intelligences*. This landmark work is widely cited in music education and adds a new dimension of support for music as basic to education. Other psychologists provide an equally compelling argument for arts education: the theory of hemispheric dominance. This concept, simply stated, describes the psychological functions of the cerebral cortex. The left hemisphere is involved in analytical and logical thinking (verbal and mathematical skills), while the right hemisphere is more holistic (spatial orientation, artistic ability, body image, and recognition). Education as currently practiced is almost exclusively aimed at developing the left hemisphere, a serious omission if we are to realize the full potential of human intelligence.

Fowler's comment that arts participation among white students is twice that among blacks is particularly disturbing in music education. It is doubtful that the participation of black students in school music groups even approaches the quoted percentage on a national scale. In integrated public high schools there continues to be a scarcity of black students in bands, orchestras, and choirs. Further, there are almost no Hispanic and Oriental students in such groups (with the possible exception of Orientals in school orchestras). The high cost of musical instruments and the limited availability of school rental instruments are obviously inhibiting factors for minority students. In choral music, the importance of diction in singing poses difficulties for minority students who audition for select groups. Those with even minor diction problems are almost always relegated to secondary vocal groups, which are less likely to perform the

more challenging masterpieces appropriate to our musical culture.

And finally, the music taught in the schools focuses largely on the literature of a western European heritage. This music is unfamiliar to many Hispanic and Oriental students, and they have little motivation to learn it or excel in performing it. If music education is to assume a vital role in multicultural education, these are all issues that merit the profession's immediate attention.

The statistics that show how many students fail to complete high school are both troubling and embarrassing for a society that prides itself on its universal public education. It is a scandalous indictment of current educational practice that one out of every three students leaves high school without a diploma. It seems obvious that legislating more academic requirements for graduation cannot be our only answer. More science, math, and foreign language may only compound the problem. Samuel Sava's observation about at-risk students seems particularly appropriate. He calls attention to the problems associated with eliminating all the curricular extras and bearing down on the three Rs by acknowledging that this may be precisely the wrong medicine. He stresses the emotional and psychological aspects of learning as well as the rational and says that "what many at-risk students need above all is a taste of success—proof that they *can* perform well in a school-related endeavor." Music could be most helpful to these students.

There is a considerable body of research evidence indicating that schools which stress arts involvement are schools with happier and higher-achieving students. These students are less likely to be tardy or absent, and they have a high level of self-esteem. A December 23, 1987, ABC Evening News report by Betsy Aaron showed the remarkable academic attainments of students at St. Augustine High School in the South Bronx when the school altered its curriculum to allow 30 percent of the school day to be devoted to musical experiences. This change in emphasis resulted in a corresponding positive change in the students' self-esteem and goal orientation. It is unfortunate that many educators seem unaware of the positive benefits that can accrue in the school environment by emphasizing experiences in the arts.

Music Educators National Conference has long maintained that music instruction in schools should be comprehensive, sequential, of high quality, and taught by a specialist. If music is to be considered "basic" to the curric-

ulum, the nature of such instruction may be beyond the capabilities of most elementary classroom teachers. State certification requirements for classroom teachers include few, if any, hours of preparation in the arts. It is unreasonable to expect that an elementary classroom teacher with no training in music would be capable of developing comprehensive and sequential musical experiences for students. We would not expect teachers to be teaching math, science, or history in elementary schools without substantial preservice training in those disciplines. If music is to be basic and taught with any degree of rigor to all students, we should expect nothing less than adequate preservice preparation of the potential classroom teacher.

The conflict between "doing" art and "learning about" art is debated often in music education. Fowler calls attention to the fact that directors of music groups frequently include consideration of style, history, culture, and theory in their rehearsals. It seems reasonable that the more students understand about the composition being studied, the more meaningful the composition will become, and the subsequent performance should be enhanced. (This assumes that the literature being rehearsed is of high enough quality to merit such considerations.) Music educators maintain that an important reason to have music in the curriculum is to ensure that the finest examples of our musical heritage are transmitted to the young. Forward-thinking leaders in the profession continue to advocate this position. Fowler's caveat about making the arts too "academic" in the way they are taught and learned and causing them to lose their refreshing difference is worth noting. Music is best taught not with paper and pencil, but through performance preparation.

On the other hand, the profession is now developing nonperformance classes that address the needs of the large number of students who must meet new high school graduation requirements in fine arts and are not members of performing groups. The issue of how best to serve these students should dominate the profession for some time to come.

Evaluation is central to any discipline being taught in the schools. Music educators must define what is to be taught and then determine what has been learned. In spite of their fears and concerns, music *can* be evaluated. Is it any wonder that music groups appear suspect to educators when they are often evaluated solely on the basis of attendance and attitude? We have only limited evaluation tools

in music because we have not made a significant effort in the past to develop criteria or methods of evaluation. Once we do make that effort, we will find that we can and will be able to evaluate learning outcomes in music. The matter of evaluation is a major priority for MENC.

The implication that school system administrators are often anti-arts is somewhat foreign to my thinking. I have never met or heard of a senior school administrator who did not want his or her system to provide a comprehensive education for all students. In my view, the real culprits in any school district with a weak arts program are inadequate funding and scheduling. As long as schools maintain a six-period day, the arts will continue to be crowded out of the curriculum. It is equally apparent that as long as state departments of education prescribe extensive graduation requirements in all disciplines and only limited (if any) requirements in the arts, we will have weak arts programs. An administrator's first obligation to students is to schedule and fund the courses necessary for graduation. We must continue to insist that sufficient additional money remains to provide students with a more comprehensive curriculum that includes the arts. Our future in arts education is inexorably tied to this nation's ability to define what is important enough to be transmitted to future generations and its willingness and ability to provide adequate funding for its schools. If we are to engage in advocacy for the arts, I would hope that we support general education, ensure that the .arts are taught as a basic discipline, and demand the funding necessary for a truly comprehensive education for all children.

DONALD CORBETT is president of Music Educators National Conference.

Jerome Hausman

Looking at *Coming to Our Senses*, Charles Fowler concludes that "the brutal fact is that American education has not come to its senses in those intervening years, not nearly." "Worse yet," he says, "we are further away from that august agenda today than we were in 1977 when the panel report was published."

There's a problem! On the one hand, there are the mounting rhetoric and global assertions about the importance of the arts in education; on the other, there is the sense that on the "firing line," in the lives of our students nationwide, we still face a substantial void in which students' aesthetic perceptions are shaped more by the material forces of commerce than by the ideas and values arts educators espouse.

We are experiencing what Samuel Hope has called "the sacralization of arts support: The process of sacralizing arts support ultimately demeans art and its purpose and sets in train a progression to cultural shallowness, this because development of a secular religion of arts support based upon what art is not makes it increasingly difficult for society to deal with art for what it is" ("Promotion: Past Failures, Present Urgencies," *Design for Arts in Education*, November/December 1985).

To be sure, there are some new players in the effort to advance the arts in education: the National Endowment for the Arts, state arts agencies, the J. Paul Getty Trust, and the American Council for the Arts. There is also what Fowler has called "a new and more compelling rationale" for making the arts basic to American education. What persists, however, are some of the same implicit assumptions and tactics that have sustained the present malaise. Ironically, the "new players," with their lengthier and more "articulate" rationale, may unwittingly be adding their weight to the very difficulties they are trying to alleviate. The tactics our "advocates" are using may be obfuscating the real issues of day-to-day operations in the schools.

At the heart of educating students in any of the arts is an accountability to art forms, processes, and techniques.

Those who teach must themselves have the skills, understanding, and commitment appropriate to what is being taught. One need not be a practicing professional artist or scholar in order to teach, but one does need to have an understanding of artistic insights and values and a passion for conveying them to students. Happily, we do have professional art, music, dance, and drama teachers who are committed to such activity. They are few in number. They need our support.

The introduction of well-meaning "advocates" who are not themselves art educators has brought with it a reliance on organizational thinking and more generalized promises. Attention is being shifted from the individual idiosyncratic insights appropriate to teaching particular art disciplines to a more general focus on "what everyone should know." What we are witnessing is the bashing of the professionals for their alleged cultural shortcomings. Poorly supported arts specialists are being blamed for failings in the larger system. The educational reform movement is bringing new calls for discipline and standards that can be codified and outcomes that can be measured. The emphasis is on more centralized planning and control. All of this takes place under the aegis of a "curriculum" that prescribes what students should learn.

Another thrust is taking shape that, I believe, makes more sense. It is a thrust that stems from something we all know: Excellent teachers are at the center of a sound educational program. Moreover, it is the teacher who gives direction to what happens in the classroom. Lynne V. Cheney, in *American Memory: A Report on the Humanities in the Nation's Public Schools*, observes: "Let teachers and faculties decide what textbooks they will use and hope that when individuals and small groups choose, they will do so by asking a few important questions: Is this a book a child might love? Does it tell him or her about things that really matter?"

The process of coming to our senses should bring us to a point of honoring the strengths of our dedicated arts education professionals: our teachers of music, dance, drama, and the visual arts. Like all educators, they should be challenged to create and be accountable for developing the richest possible learning situations involving their own discipline and understanding. In *Beyond the Four Walls* (a study conducted by the United Federation of Teachers, written by Diane Harrington), it is observed: "In every case, it

is the teachers themselves who describe their roles as 'professional.' They talk about 'how it used to be'; about their sense of empowerment, of being freed to do what they always wanted to do; about their own growth and its benefits to their students. Their passion reverberates powerfully from school to school, classroom to classroom. As one teacher says, 'It is a process of healthy and effective interaction that allows a teacher to act with dignity, self-esteem, and pride in his or her professional role'" (p. 5).

One does not have to look very long or hard to note that we are faced with a crisis in our schools. Look at dropout rates, personal problems, and test scores. One need only visit ghetto schools in New York or Chicago or Cleveland or Detroit or Los Angeles—or some of our suburban or rural schools—to see first-hand the magnitude and depth of the problems. Most emphatically, I would assert that the arts provide important substance for education that is required to begin to ameliorate this crisis. What teachers of the arts can do with this substance does not lead to a single scenario; each professional shapes his or her own program using available skills and resources.

Dedicated and committed visual arts, music, dance, and drama teachers struggle every day against forces that would inhibit or exclude learning in the arts. These professionals need help on the firing line, in the trenches, as they seek ways to bring particular insights and values into the lives of their students. They need time, teaching materials, instructional space, and access to cultural resources and arts professionals. Teachers in all of the arts should come together to share their ideas about the creation and study of forms that make sense in the lives of their students. The arts curriculum they develop should stem from deeply held beliefs and passions. It should have shared ownership and commitment. It should seek to harmonize and synthesize ideas in which people are interested and to which they are dedicated.

Educational priorities should have less to do with technocratic, top-down prescriptions that give formal emphases to prescribed system-wide learnings that are to be sequenced and tested. The curriculum or plan should start with things about which teachers and their students can get excited. The emphasis should be on more individual, situational initiatives that are in keeping with the personal, open-ended nature of teaching in any of the arts. Of course, teachers will be held accountable in their curriculum con-

text. But as Suzi Gablik puts it: "If the human receptivity for harmonies is to be addressed and reawakened, it must be done by creating a deliberate expansion of consciousness that takes us beyond the visual automated pattern of social identifications and cultural conditionings. We do not have to work at maintaining our culturally imposed consensus trance: The hard work is in trying to overcome it and experience a quantum jump in awareness" (*New Art Examiner*, December 1987, p. 31).

JEROME J. HAUSMAN is the director of the Urban Gateways Center for Arts Curriculum Planning and Evaluation and adjunct professor at the School of The Art Institute of Chicago.

Kathryn Martin

As we study Charles Fowler's reassessment of *Coming to Our Senses*, we are confronted with the Herculean effort that will be required if the arts are to achieve the status we would like them to have in our elementary and secondary schools. Although they are essential to our being, the arts have somehow failed to be established as essential to our educational system. As Fowler says, the arts have had all kinds of moral and philosophical leadership over the last ten years, both from professional organizations and from state and federal government agencies. Unfortunately, however, there has been minimal action beyond the talking stage.

The absence of the arts in our schools has a negative impact on students at every level of education and on society as a whole. Through the arts we develop the security and the sensitivity that enable us to respond rather than to react. The consequences of neglecting the affective realm of our lives suggest imminent disaster. To grasp the magnitude of this problem, look at this nation's cities. In urban areas we find the highest crime rates, the highest dropout rates, and many other negative records. What happens to

the affective domain of students in urban elementary and secondary schools—if they go to secondary school at all? To be human, to be creative requires the ability to convey our feelings in a meaningful way, to be in touch with the affective realm of our being. The stimulation of this ability is most necessary, yet most neglected, in the depressed economic areas of our cities. There, feelings run rampant, reaction prevails, and the resulting insensitivity and indifference are reflected in the numbness of those who most need the arts. By perpetuating cultural deprivation, we perpetuate an at-risk society.

Clearly, every community, regardless of size or location, faces the problem of at-risk students. Smaller cities and rural towns are not exempt. The density of the problem in urban areas, however, tacitly demonstrates the urgency of defining strategies for helping at-risk students that may well focus on the arts.

Fowler suggests that the first wave of educational reform focused on improving the quality of public education and the second on improving the nation's teachers. He suggests that the third wave should focus on the students, "how to activate and inspire them, how to induce self-discipline, and how to help them to discover the joys of learning, the uniqueness of their beings, the wonders and possibilities of life, the satisfaction of achievement, and the revelations that literacy, broadly defined, provides."

Simply stated, if we are to focus on the student, the arts must be included, particularly in those parts of our cities with the highest number of at-risk students. The at-risk student comes from the lowest socioeconomic background, has little encouragement or preparation at home, and seldom, if ever, has support and positive reinforcement. As Samuel Sava points out, our way of dealing with at-risk students has been to give them a double dose of the three Rs. We do this at a time when these children need to find success *somewhere* in order even to apprehend the concept of succeeding *anywhere*.

Today, by so often relegating the arts to the periphery of education, we are severely limiting the potential for success in the very areas of this nation where we most need to provide a chance for success. By reducing opportunities for those students who are the most at-risk, as educators we are in fact contributing to the increasing dropout rates by not enabling children to develop the self-confidence that comes from the satisfaction of achievement. As Sava says,

this satisfaction often comes from achievement in the arts—singing, playing an instrument, drama, painting, dancing.

Why have we as educators, as advocates for the arts, and as citizens failed to take advantage of the at-risk student's interest in the arts? In urban areas there is always dancing, music, and to a certain extent acting. We are surrounded by "boom boxes" blaring music and students wearing Walkmen. It goes without saying that the three Rs are important, but we must find other ways to deal with our obsession with raising achievement test scores. We must offer opportunities for children to succeed in areas besides the three Rs, where they have so frequently experienced failure or limited success. Continuous emphasis on the three Rs at the expense of the affective realm often results in repetitive, rote approaches to learning, rather than approaches that stimulate the growth and sensitivity that are fundamental to inquiry.

Fowler's statement that "in many ways the arts are the glue that holds society together" implies enormous responsibility for each of us who is in a position to affect and improve the status of the arts in education. For one thing, those of us in higher education must do a better job of preparing teachers, both generalists and specialists. We must work with educators in the field to identify ways of delivering inservice training that is useful to teachers already in the classroom. Most important, we must emphasize and focus on what the child needs.

There is room for all the professional organizations and federal agencies to be involved in arts education. In fact, there is a desperate need for them to speak with a unified voice, forgetting the turf issues of the past, and to focus on the needs of the child and the preparation of teachers for the future. The National Endowment for the Arts under chairman Francis S.M. Hodsoll has taken a most positive stand for discipline-based sequential arts education. In my estimation the NEA must assume an even stronger leadership role, given the vacuum in arts education at the Department of Education. Pilot programs and planning initiatives must be coordinated so that the results are available, not lost in file drawers. Plans must not only be designed and discussed, but also put into action. If arts education is to continue as a priority, then the Arts Endowment must find ways to address the problem of the limited curriculum—often totally lacking in arts education—offered where the arts are most needed, in the urban areas of our nation and

in rural areas as well. The NEA must progress beyond the possibilities and potential of the arts before enthusiasm wanes and excitement no longer exists. The condition of the arts in many American schools today requires much more than advocacy.

For those of us who believe in the importance of the arts in American education, our goal is not just an increase in the number of arts practitioners. We are not campaigning simply to ensure first-chair instrumentalists for our symphonies, actors for our professional stages, or dancers for our dance companies. We are campaigning for an educational system that addresses the person, and not only as he or she is reflected through test scores.

We are promoters of an arts-in-education process that includes classroom teachers as well as arts specialists and that also involves artists and arts institutions. It reflects the belief that quality does not come without expertise. The process, and the ultimate program or curriculum, includes a balance between the creation of art and the appreciation of art, recognizing that it is a disservice to either not to include both. And the core of this arts-in-education process recognizes that discipline-based arts education *cannot* mean a duplication of all that is wrong with the simplistic responses often required in other discipline-based instruction. As Fowler says so profoundly, it is the creative activity that is unique about the arts, not the factual aspects. The process of the arts is important precisely because there are no right answers.

But as arts educators we must not abdicate our responsibility for accountability and for the establishment of appropriate sequential goals. We must achieve a balance between the creative process and "finding the right answers." If we do not, we will lose the qualities that contribute to and stimulate thinking, analysis, and synthesis in the creative process, the qualities that undergird our rationale for the inclusion of the arts as a fundamental part of education.

Beyond a doubt, achieving the desired status for the arts in the elementary and secondary schools suggests a Herculean effort. But do we have a choice? Are we willing to chance an at-risk society?

KATHRYN MARTIN is dean of the School of Fine and Performing Arts at Wayne State University.

NOTES

CHAPTER 1

1. *Americans and the Arts* (New York: Associated Councils of the Arts, 1974).

2. John I. Goodlad, *A Place Called School: Prospects for the Future* (New York: McGraw-Hill, 1984), p. 142.

3. Ibid., p. 143.

4. *Americans and the Arts 1984* (New York: Philip Morris Inc., 1984), p. 28.

5. This point is made in *K-12 Arts Education in the United States: Present Context, Future Needs* (Reston, Va.: Music Educators National Conference, National Art Education Association, National Dance Association, American Theatre Association, and National Associations of Schools of Music, Schools of Art and Design, Schools of Theatre, and Schools of Dance, 1986), p. 7; and by Terry Baker in "Working Effectively with Public Schools," in *Arts and Education Handbook: A Guide to Productive Collaborations*, ed. Jonathan Katz (Washington, D.C.: National Assembly of State Arts Agencies, 1987), p. 50.

6. Ernest L. Boyer, address to a symposium on "Arts Curricula in Transition," Columbia University, New York, July 6, 1986.

7. William J. Bennett, *To Reclaim a Legacy: A Report on the Humanities in Higher Education* (Washington, D.C.: National Endowment for the Humanities, 1984), p. 11.

8. Ibid.

9. David Hornbeck, "Preface," in *Arts, Education, and the States: A Survey of State Education Policies* (Washington, D.C.: Council of Chief State School Officers, 1985), p. 4.

10. Susanne Langer, *Problems of Art* (New York: Scribner's, 1957), p. 9.

11. Elliot W. Eisner, *Cognition and Curriculum: A Basis for Deciding What to Teach* (New York: Longman, 1982), p. 74.

12. Howard Gardner, *Frames of Mind: The Theory of Multiple Intelligences* (New York: Basic Books, 1983).

13. Ibid., p. 358.

14. Ibid., p. 356.

15. Ibid., p. 359.

16. W. Ann Reynolds, address to a conference on "Techniques and Strategies for Improving and Promoting Arts Education," sponsored by the National Endowment for the Arts and the National Assembly of State Arts Agencies, Los Angeles, September 25, 1984.

17. *Course Offerings and Enrollments in the Arts and the Humanities at the Secondary School Level* (Washington, D.C.: National Center for Education Statistics, 1984).

18. Ibid., p. xvii.

19. Ibid., p. xiii.

20. Ibid., p. 44.

21. Ibid.

22. Ibid., p. xvii.

23. Ibid., p. 37.

24. Ibid., p. 25.

25. Ibid., p. 23.

26. Henry E. Putsch, "AICA Survey of Current Trends in Art Education," in *Art Education in the Schools: Strategies for Action* (Washington, D.C.: Alliance of Independent Colleges of Art, 1984), pp. 26-27.

27. This information was reported in the Illinois State Board of Education's Teacher Service Record Analysis.

28. Task Force for Fine Arts, *Report of the Task Force for Fine Arts of the Baltimore City Public Schools* (Baltimore: Baltimore City Public Schools, 1986), p. 15.

29. Ibid., pp. 17-18.

30. Ibid., p. 19.

CHAPTER 2

1. National Commission on Excellence in Education, *A Nation at Risk: The Imperative for Educational Reform* (Washington, D.C.: U.S. Department of Education, 1983), p. 5.

2. Ibid., p. 10.

3. Ibid., p. 26.

4. *Making the Grade: Report of the Twentieth Century Fund Task Force on Federal Elementary and Secondary Education Policy* (New York: Twentieth Century Fund, 1983).

5. Among these corporate-supported reports are: *Action for Excellence* (Denver: Education Commission of the States, 1983); *Investing in Our Children: Business and the Public Schools* (New York: Committee for Economic Development, 1985); *Literacy at Work: Developing Adult Basic Skills for Employment* (Washington, D.C.: Northeast-Midwest Institute, 1985); and *Reconnecting Youth*, a report of the Business Advisory Commission (Denver: Education Commission of the States, 1985).

6. *Investing in Our Children*, pp. 21–22.

7. Goodlad, *A Place Called School*, pp. 286 and 336.

8. Ernest L. Boyer, *High School: A Report on Secondary Education in America* (New York: Harper & Row, 1983), pp. 85 and 94.

9. *Academic Preparation for College: What Students Need to Know and Be Able to Do*, Report of the Educational EQuality Project of the College Entrance Examination Board (New York: College Board Publications, 1983), p. 10.

10. Mortimer J. Adler, *The Paideia Proposal: An Educational Manifesto* (New York: Macmillan, 1982); "The Condition of Art Education," *Art Education* 36, No. 1 (January 1983).

11. William J. Bennett, *First Lessons: A Report on Elementary Education in America* (Washington, D.C.: U.S. Government Printing Office, 1986), p.35.

12. Ibid.

13. Goodlad, op. cit., p. 286.

14. Ibid., p. 287.

15. Adler, op. cit., p. 24.

16. "Summaries of Break-out Sessions," *Discipline-Based Art Education: What Forms Will It Take?* (Los Angeles, California: The Getty Center for Education in the Arts, 1987), p. 60.

17. *A Nation At Risk*, op. cit., p. 16.

18. *U.S. Children and Their Families: Current Conditions and Recent Trends*, a report of the Select Committee on Children, Youth, and Families, U.S. House of Representatives (Washington, D.C.: U.S. Government Printing Office, 1987), p. 28.

19. Daniel Patrick Moynihan, *Family and Nation* (San Diego: Harcourt, Brace, Jovanovich, 1986), p. 93.

20. *U.S. Children and Their Families*, op. cit., pp. 13 and 28.

21. C. Emily Feistritzer (ed.) *The American Teacher* (Washington, D.C.: Feistritzer Publications, 1983), p. 60.

22. "Attendance Improvement; Dropout Prevention," *Youth Advocacy* (Rochester, New York: Statewide Youth Advocacy, Inc., 1984).

23. *The Dropout Report* (Brooklyn, New York: New York City Board of Education, 1983).

24. *Racial and Ethnic High School Dropout Rates in New York City: A Summary Report* (Brooklyn, New York: ASPIRA of New York, Inc., 1983).

25. Maxine Greene, "Creating, Experiencing, and Sense-making: The Art World in the Schools," an unpublished paper (New York: Columbia University symposium on "Arts Curricula in Transition," July 1986), p. 5.

26. From Jim Naughton, "I.F. Stone and the Ancient Mystery," *The Washington Post*, March 10, 1988, p. C2.

CHAPTER 3

1. *Course Offerings and Enrollments in the Arts and the Humanities at the Secondary School Level* (Washington, D.C.: National Center for Education Statistics, 1984), p. 33.

2. E.D. Hirsch, Jr., *Cultural Literacy: What Every American Needs to Know* (Boston: Houghton Mifflin Company, 1987), p. 98.

3. Some of this material is adapted from a paper of mine entitled, "Toward a Democratic Art: A Reconstructionist View of Music Education," J. Terry Gates (ed), *Music, Society, and Education in the United States* (University, Alabama: University of Alabama Press), in press.

4. Hardiman, George, and Andra Johnson, "The Condition of Art Education," *Art Education*, Vol. 36, No. 1 (January 1983).

5. Goodlad, *A Place Called School*, p. 185.

6. This information comes from a survey sponsored by the Michigan Alliance for Arts Education, Jeannine M. Galetti, project director, April 1985.

7. Recommendations from *Toward a New Era in Arts Education. The Interlochen Symposium*, (New York: American Council for the Arts, 1988).

8. Goodlad, *A Place Called School*, p. 142.

9. *Beyond Creating: The Place for Art in America's Schools* (Los Angeles: J. Paul Getty Trust, 1985), p. iv.

10. Ibid., p. 3.

11. This statement is extracted from chapter 12 of *The Crane Symposium: Toward an Understanding of the Teaching*

and Learning of Musical Performance, ed. Charles
Fowler (Potsdam, N.Y.: State University College of Arts
and Sciences, 1988, in press).

12. Thomas Ewens, "Beyond Getty: An Analysis of *Beyond Creating: The Place for Art in America's Schools*," in *Discipline in Art Education: An Interdisciplinary Symposium*, ed. Thomas Ewens (Providence, R.I.: Rhode Island School of Design, 1986), pp. 40–41.

13. Ibid., p. 49.

14. Eisner, *Cognition and Curriculum*, pp. 73–74.

15. *Academic Preparation in the Arts: Teaching for Transition from High School to College* (New York: College Board Publications, 1985), p. 62.

16. Ibid.

17. Ibid., p. 2.

18. Goodlad, *A Place Called School*, p. 219.

19. Ibid., p. 2.

20. Ibid., pp. 219–220.

21. *Arts, Education, and the States: A Survey of State Education Policies*, p. 28.

22. Ibid.

23. Ibid., p. 6.

24. Carnegie Forum on Education and the Economy, *A Nation Prepared: Teachers for the 21st Century* (New York: Carnegie Corporation, 1986).

25. Holmes Group, *Tomorrow's Teachers* (East Lansing, Michigan: The Holmes Group, 1986).

26. Lynne V. Cheney, *American Memory: A Report on the Humanities in the Nation's Public Schools* (Washington, D.C.: National Endowment for the Humanities, 1987), p. 24.

27. Lee Shulman from "Building a Community of Shared Interests—A Wingspread Conference," June 21–23, 1987.

28. *K-12 Arts Education in the United States.*

29. Ibid., p. 8.

30. Alexis de Tocqueville, *Democracy in America*, Vol. 2, trans. Henry Reeve (New Rochelle, N.Y.: Arlington House, 1965), pp. 51–52.

31. *Course Offerings and Enrollments in the Arts and the Humanities at the Secondary School Level*, p. xiii.

32. *K-12 Arts Education in the United States*, p. 5.

33. National Ad Hoc Arts Education Working Group, pamphlet, "Concepts for Strengthening Arts Education in Schools"

(New York and Washington, D.C.: American Council for the Arts and Music Educators National Conference, 1987).

34. See *Arts and Education Handbook: A Guide to Productive Collaborations,* ed. Jonathan Katz.

35. "Concepts for Strengthening Arts Education in Schools."

36. *Arts, Education, and the States,* p. 29.

37. Ibid., p. 20.

38. Hirsch, *Cultural Literacy,* p. 96.

39. *Arts, Education, and the States,* p. 21.

CHAPTER **4**

1. *The Interrelationship of Funding for the Arts at the Federal, State, and Local Levels,* Eighteenth Report by the Committee on Government Operations (Washington, D.C.: U.S. Government Printing Office, 1983), p. 29.

2. Ibid.

3. "Program Solicitation No. PS 87-06 for an Arts Education Research Center" (Washington, D.C.: National Endowment for the Arts, July 1983), p. 5.

4. Ibid., p. 36.

5. Laura H. Chapman, *Instant Art, Instant Culture: The Unspoken Policy for American Schools* (New York: Teachers College, Columbia University, 1982), p. 121.

6. Frank Hodsoll, speech, New Orleans, October 27, 1983.

7. Frank Hodsoll, "Foreword," *Toward Civilization: A Report on Arts Education* (Washington, D.C.: National Endowment for the Arts, 1988).

8. Ibid., p. 29.

9. Ibid.

10. One evidence of NASAA's role is its publication, *Arts and Education Handbook: A Guide to Productive Collaborations,* ed. Jonathan Katz.

11. In 1976, the California State Department of Education published "Promising Programs in Arts Education"; in 1978, the Alliance for Arts Education published "Programs that Work"; in 1979, the U.S. Office of Education published "Try a New Face: A Report on HEW-Supported Arts Projects in American Schools."

12. See Terry Baker's account of the educational change process in *Arts and Education Handbook: A Guide to Productive Collaborations,* ed. Jonathan Katz, pp. 51–57.

13. *Toward Civilization*, chapter 7.

14. Ibid., chapter 8.

15. Ibid.

16. Ibid.

17. Samuel Lipman, address to a seminar on "Arts Education Beyond The Classroom," sponsored by the American Council for the Arts, New York City, March 1987.

CHAPTER **5**

1. *Arts, Education, and the States*, p. 5.

2. *Options and Opportunities in Arts Education* (Washington, D.C.: Council of Chief State School Officers, 1985), p. 6.

3. Hirsch, *Cultural Literacy*, p. 102.

4. Ibid., p. 108.

5. Ibid.

6. *K-12 Arts Education in the United States*, p. 25.

7. Ibid., p. 13.

8. Ibid., p. 25.

9. "Goals and Objectives in Music Education," *Music Educators Journal* 57, No. 4 (December 1970), p. 24.

10. Ibid., p. 28.

11. *K-12 Arts Education in the United States*, p. 10.

12. Ibid.

13. Ibid., p. 11.

14. Ibid.

15. Ibid., p. 12.

16. Ibid.

17. See chapter 2 of Goodlad, *A Place Called School*, pp. 33–60.

ABOUT THE
AMERICAN COUNCIL FOR THE ARTS

The American Council for the Arts (ACA) is one of the nation's primary sources of legislative news affecting all of the arts and serves as a leading advisor to arts administrators, educators, elected officials, arts patrons and the general public. To accomplish its goal of strong advocacy of the arts, ACA promotes public debate in various national, state and local forums; communicates as a publisher of books, journals, *Vantage Point* magazine and *ACA UpDate*; provides information services through its extensive arts education, policy and management library; and has as its key policy issues arts education, the needs of individual artists, private-sector initiatives, and international cultural relations.